The Animal Mind

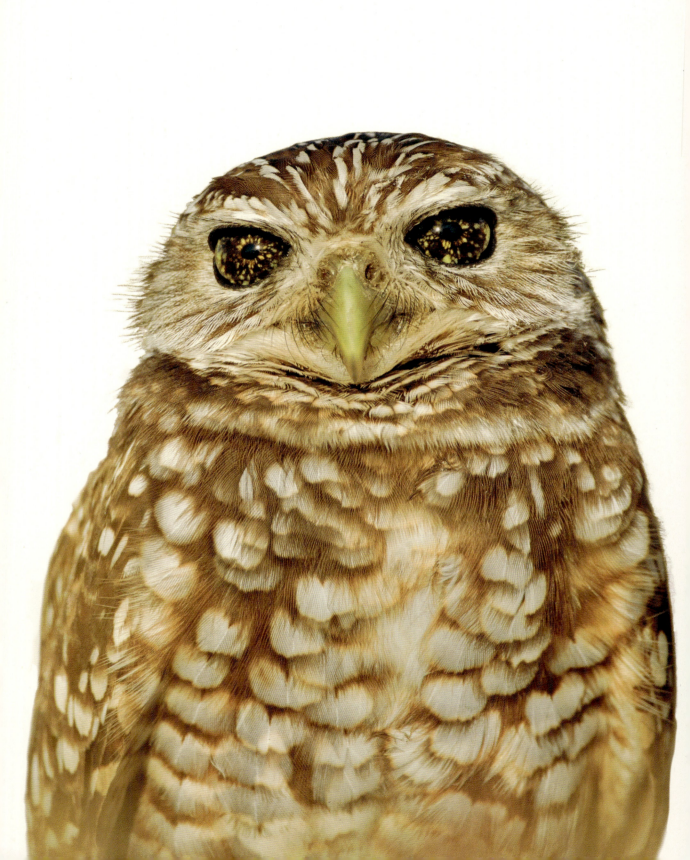

The Animal Mind

Profiles of Intelligence and Emotion

MARIANNE TAYLOR

ABRAMS, NEW YORK

CONTENTS

||||||||||

6 INTRODUCTION

12 CHAPTER 1
BRAINPOWER
Learning and Memory

16 Common chimpanzee • 19 Clark's nutcracker • 22 Asian elephant
25 Common bottlenose dolphin • 28 Domestic pig • 31 Common raven
34 European herring gull • 36 California twin-spot octopus

40 CHAPTER 2
CALCULATION
How Fast, How Far, How Much?

44 Gibbon • 49 European storm petrel
53 Giraffe • 54 Big brown bat • 59 Great white shark
63 Domestic horse • 66 Australian emperor dragonfly

68 CHAPTER 3
COMMUNICATION
Sing, Dance, Jump-Yip

72 Blue whale • 75 Black-tailed prairie dog • 78 Common zebra
80 Superb lyrebird • 83 Western honeybee • 86 Sperm whale
89 Domestic dog • 93 Common bottlenose dolphin • 94 African gray parrot

96 CHAPTER 4
BONDING
Better Together

100 Army ant • 103 African wild dog • 106 Australian magpie
108 Lion • 114 Vulturine guineafowl • 119 Jaguar • 120 African bush elephant

126 **CHAPTER 5**
CONSCIOUSNESS
Knowing Me, Knowing You

130 Ant • 134 Giant manta ray • 137 Western lowland gorilla
140 Eurasian magpie • 143 Fancy rat • 144 Common bottlenose dolphin

146 **CHAPTER 6**
WINNING
Strategy and Tactics

150 Common cuckoo • 152 Spotted hyena • 155 Slave-making ant
156 Gray wolf • 162 Bluestreak cleaner wrasse

164 **CHAPTER 7**
RESILIENCE
Mental Fortitude

168 Honey badger • 171 Common raven • 174 Snow leopard
179 Least weasel • 183 Bar-tailed godwit • 186 Emperor penguin

188 **CHAPTER 8**
CARING
Above and Beyond

192 Cape buffalo • 197 Brown-mantled tamarin • 198 Humpback whale
203 Laysan albatross • 204 Spiny plunderfish • 208 Domestic chicken

210 **CHAPTER 9**
CULTURE
Look, Listen, and Learn

214 Japanese macaque • 218 Fruit fly • 221 Common chimpanzee
222 Orca • 226 White-crowned sparrow • 229 Bonobo

232 Select Bibliography • 235 Photography Credits
236 Index • 238 Photographer Directory • 240 Acknowledgments

INTRODUCTION
Mind out of matter

It can be tough being a human. We look around at the accomplishments of our fellow animals, and see ourselves falling short by measure after measure. We can do many different things, but ultimately we cannot run fast enough, climb high enough, sing sweetly enough, or live long enough to qualify as world-beaters, and for an animal with an ego as large as ours, that's hard to accept. Yet there is one category in which we really do top the tree, and not just by a little but by a huge margin—the relative size and complexity of our brains.

Thanks to those big brains, we have developed elaborate languages and cultures, and we can demonstrate profound compassion and dazzling creativity. With our planning and problem-solving skills, paired with our dextrous hands, we can remodel the very fabric of the world around us, and build every conceivable tool to extract resources from the most unpromising places. We even have the foresight to appreciate that our biologically ordained, relentless gathering of resources may not, in fact, be the best strategy for the longevity of our species and our world. Hopefully, we will prove capable of putting those planning and problem-solving skills to work in order to reverse the harm we've done and become better custodians of the Earth.

From brain to mind

The human brain, that most mysterious of organs, sits within a protective dome of bone. Just like the brains of our fellow vertebrates, it is wired into the sensory organs—and, more distantly, to all other parts of the body—through the electrical circuitry of nerve cells, or neurons. Beyond the brain, these neurons are organized into nerves that penetrate bodily

tissues. The nervous system is a two-way street, carrying information from body to brain, and instructions from brain to body. We might make a conscious decision to do something with our body (say, reach for a cup of tea), or we might do something with it unconsciously (drop the cup because it's scaldingly hot). But in both cases, the instruction for that physical action comes from our brain. Plenty of the nervous-system processes that occur in an animal's body are controlled by areas of the brain that never connect with consciousness.

However, our human experience is that it's the conscious region of the brain that makes the decisions that drive us through our days and our lives; although we often experience strong urges that we might label "instinct," our consciousness provides the "executive function" that enables us to evaluate and, when necessary, override those urges. It's difficult to link conscious thought and executive function to specific processes or physical structures, and today there is increasing interest (much of it from studies of the bodily effects of trauma) in the idea of the entire body being conscious and sentient on some level. However, most neurobiologists agree that conscious thought originates primarily from the cerebral cortex, that mass of convolutions that makes up the upper and outer surface of the brain. The folds and fissures of the cerebral cortex enable it to house about fifteen billion neurons in a relatively small space. From the squishy gray matter of our physical brains comes the mass of emergent properties that we call our minds. Even when our bodies are entirely inactive, we can explore, learn, grow, deduce, and provide ourselves with new experiences, all thanks to the power of these minds.

Our minds, even more so than our brains, are fallible. They may lead us astray, via egomania, cognitive dissonance, or self-delusion. Our minds are also responsible for our tendency to anthropomorphize, or ascribe human motives and emotions to nonhuman minds. We suppose that animals' basic feelings and desires are the same as ours—that we

can make sense of their behaviors by evaluating them in the context of our own thoughts and experiences. The result is an assumption that animals are held back by minds that are simply inadequate, inflexible versions of ours. Rarely do we stop to think about the possibility of animal minds that are brilliant in ways that ours simply are not, or minds that demonstrate their brilliance in ways that are hard for our own minds to grasp and measure. Minds that are not deficient but different, and indeed perfectly optimized to suit a way of life and way of thinking entirely unlike our own.

This is where science comes into play. We cannot help but turn our curious gaze toward the natural world, and what we see when we set our prejudices aside and force our self-serving minds to be as objective as they can be, is humbling. And the deeper we look—the more we apply our minds to studying theirs—the more complex and diverse animal "mindedness" we discover, not just in the obviously big-brained and more humanlike species, but throughout the animal kingdom, from ant and octopus to squirrel, songbird, and even our beloved pets.

A goldfish can quickly learn to drive a water-filled "car," and this supposedly featherbrained creature can rapidly establish (and remember) the best route for piloting its vehicle through a maze. The squeaks of alarmed prairie dogs, which sound comical but far from complex to our ears, in fact constitute an elaborate language that includes the use of both "nouns" and "adjectives" for describing approaching predators. Orcas address one another as individuals, and exist in a system of cultures that are so distinctive that their differences are guiding these creatures' anatomical evolution. Species as disparate as chickens and vampire bats form close friendships, and work hard to keep them. The brain of a raven weighs ½ ounce, compared to the 14-ounce brain of a chimp, but these species have demonstrated similar cognitive power across a range of tests, proving

Prairie dogs jump and yip at the same time, causing others to do similar. This kind of contagious behavior is, according to Dr. Catriona Morrison of Leeds University in the UK, a sign of high-level empathy.

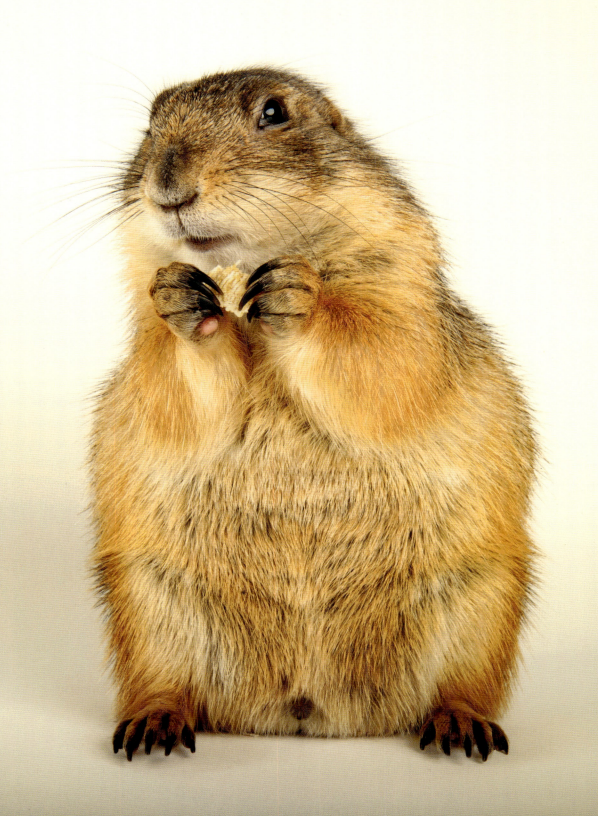

that it's not (just) how big a brain is that matters when it comes to processing power, but the development and structure of its components, and how they're organized and interlinked.

Purpose-built minds

We're not only learning just how bright some animals are, we're also becoming aware that their minds can put ours to shame in specific aspects. An appealing little Arctic crow known as the Clark's nutcracker has powers of recall that easily outstrip those of the most highly trained human "memory athlete." Migrating animals of all kinds bring together an amazing array of sensory and observational data to plot a pinpoint-precise course over thousands of uncharted miles to an unknown destination. And some animals are extraordinarily accomplished tricksters, using mind games, behavioral mimicry, ingenious active camouflage, and bait-and-switch teamwork to manipulate and defeat others.

Sometimes when we examine animal thought processes we discover things we weren't even looking for. One notable example is a study on Australian magpies that began as an investigation of their daily movements, but turned into a study on compassion and teamwork once these clever birds began freeing one another from the tracking devices that the researchers had fitted to their bodies. Was it simple curiosity that led them to explore and manipulate something new in their environment, or did they perhaps see the devices as alien and potentially harmful to their companions, and act out of an urge to help? This brings us to the fascinating subject of Theory of Mind—the ability to understand other living things, of our own species or another, by ascribing mental states to them. Whether or not animals

possess a Theory of Mind is a recent and very fertile field of research for those interested in animal intelligence and emotion. If an animal can understand the mental state of another—that it is afraid, suffering, confused—what will it do with this information? It could choose to manipulate the situation for its own benefit, or it might choose to be compassionate, as the Australian magpies appear to be.

The question of compassion prompts a consideration of the emotional aspect of the animal mind. Emotional responses, arising from fundamental needs such as the urge to stay safe, eat, procreate, and find physical comfort, are powerful drivers of behavior for humans and animals alike, and can dramatically shape our mindsets. And what about emotional attachments to others? Clearly, animals form powerful and enduring affectionate bonds with one another that may or may not be backed up by familial relationships. They may also, especially in domestic environments, form bonds with other species too. But do they *feel* the pull of those bonds in the profound way that we do? Well, why would they not? Yet how can we know for sure? And how should this influence our treatment of them when we take on the role of carer and custodian? This book explores the breadth and depth of animal brainpower, animal thought, animal emotion, and animal creativity. We look into the hows and whys of some of the most remarkable behaviors demonstrated by a great variety of species, from the great to the tiny, and the familiar to the mysterious. It's through explorations like these that we come to understand how animal minds of all kinds have evolved over time—furnishing their bearers with ever more refined abilities to meet their particular environmental challenges—and how these minds continue to adapt to help their owners survive and thrive in a fast-changing world.

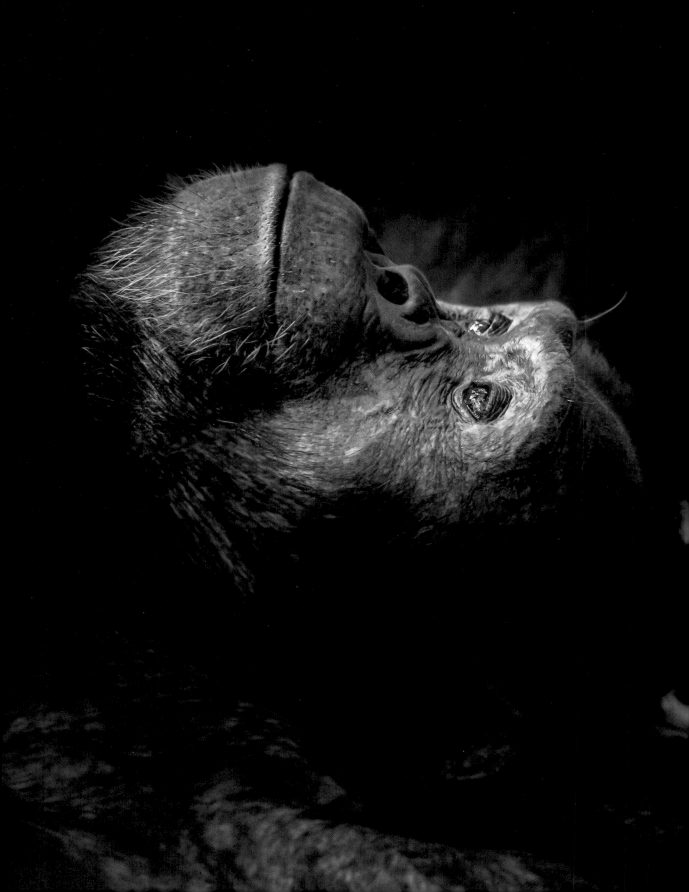

1

BRAINPOWER
Learning and Memory

BRAINPOWER LEARNING AND MEMORY

We experience and make sense of our world through the nonstop activity of our brains. This process takes place on many different levels, but although we are animals with physiological needs, it is often our emotions that drive our actions most strongly, and color our perceptions most vividly. Nevertheless, just as we require that need-driven motivation to do all the things that will enable us to survive and lead a rewarding life, we also need our nonemotional, raw cognitive brainpower to work alongside those "baser" drives. Most of the markers of what we consider to be "intelligence"—in ourselves, other animals, and the computing machines that we build—are the various elements of cognition.

Cognition can be defined as the process of using our perceptions, experiences, memories, and powers of logical reasoning to build knowledge and understanding. For effective cognition, we may need to do any or all of the following: pay attention where needed, perhaps to more than one thing at the same time (and avoid distraction); analyze and spot key patterns in the perceptual data delivered by our senses (sometimes rapidly); categorize the data that we've collected; store important details in our short-term memory; draw on relevant information stored in our long-term memory; remain open and alert to signs that we need to switch tracks in our thinking (and ready to carry out that switch efficiently); and pull all of that together to apply reasoning and gain insight (in other words, see the logical way through to a solution, rather than rely on trial and error). It is a lot of work, but it gives us great power and agency as we navigate our world, and over the centuries, many have argued that our exceptional cognitive ability—thanks to our exceptionally complex brains—is one of the traits that sets us apart from "the animals."

We know better than to try to separate ourselves from our own animal-hood today, at least not in such bald terms. This is, after all, the era of gorillas that are capable of learning sign language from us and then using it to describe their own history back to us; of documented

tool use in creatures as diverse as octopuses, finches, and crickets; and of the revelation that whales in a pod can take up one of multiple roles to form a coordinated team that hunts prey with remarkable effectiveness. Many animals can, quite obviously, learn, think, plan, remember, and rationalize to a high degree, and their cognitive skills are as vital to their own survival and richness of life experience as ours are to us.

Although we are increasingly interested in emotional intelligence and social intelligence in our own species, traditionally when we have investigated animal intelligence, it is cognition that is of most interest to us. Perhaps this particular interest is driven by emotion and ego more than logic—we want to maintain our sense of separation and superiority, and certainly don't want any other animal species to topple us from the top of the cognitive tree. However, these views are constantly challenged by our studies of animal cognitive powers. In fact, we are not the best at every type of cognitive task—our brains are not structured in the most efficient way possible—and our judgment and ranking of other animals' intelligence has often proved faulty. Some of the specific cognitive skills that are so essential for us are simply irrelevant for many other animals because their way of life is so different. Instead, they may often possess a skillset that goes way beyond what our brains are capable of. This, in turn, has inspired us to expand the directions we have taken in our efforts to model cognitive processes artificially, and build machines with artificial intelligence.

When it comes to studying animal cognition, we humans really do need to engage our large brains and set our large egos aside—we must undertake a clear-eyed, unemotional, cognitive analysis of the evidence. We're beginning to do exactly that, and the rewards are coming thick and fast. What we gain are insights and understanding that open up a different emotional experience: a connectedness with, and respect for, our fellow living creatures in all their cognitive diversity, each adapted to a no less diverse array of ways to live.

COMMON CHIMPANZEE *PAN TROGLODYTES*
Quick thinker

Do you consider yourself the sort of thinker who does well at strategy games like The Prisoner's Dilemma, wherein the outcome depends on the choices made by both you and your opponent? If so, you should pit yourself against a common chimpanzee. Making the best strategic choices results in an optimal, equilibrious state, and this hangs on learning from your opponent's previous decisions, to predict what they will do next. When pairs of chimps play this kind of game, they reach this point well before pairs of humans do. The ability to so quickly adapt their play style by observing their opponents' actions suggests an advanced level of social cognition—a valuable asset for an animal that lives in a highly dynamic social setup.

Chimps have also bested humans in a working-memory task, involving correctly remembering the positions of a series of nine numbered boxes. A good performance (in this context, good means both quick and accurate) depends both on rapidly committing the positions to memory, and the subsequent reliability of that memory. The chimps and their human opponents performed equally well but the chimps were faster, and even after months of practice the humans still could not match their speed. Their impressive working memory is matched by a human-rivaling ability to figure out solutions to tricky physical problems, such as spitting water into a deep, narrow cup to float the peanut at the bottom upward and into reach.

Applying these cognitive talents to act swiftly and efficiently appears to be a hallmark of chimp behavior. They possess excellent spatial memory, with wild chimps reliably picking the most efficient route from A to B (or C to D, and so on) when they traverse their extensive forest territories. Their ability to quickly learn and anticipate how other chimps will behave is instrumental in many aspects of their lives, from defending their territory effectively against intruders to planning and executing a group hunt. Chimp life is far from conflict-free, with frequent disputes between group members of different hierarchical rank. However, the noise and violence of a confrontation masks the careful thought that has gone into deciding whether that confrontation is a strategically intelligent move. Chimps may lack the high emotional intelligence of their gentler cousins the bonobos, but their array of cognitive talent serves them well socially.

We might think of chimps as excitable and emotional, but they can be exceptionally cool-headed, too, and, in certain cognitive tasks, their methodical approach means they perform better than we do.

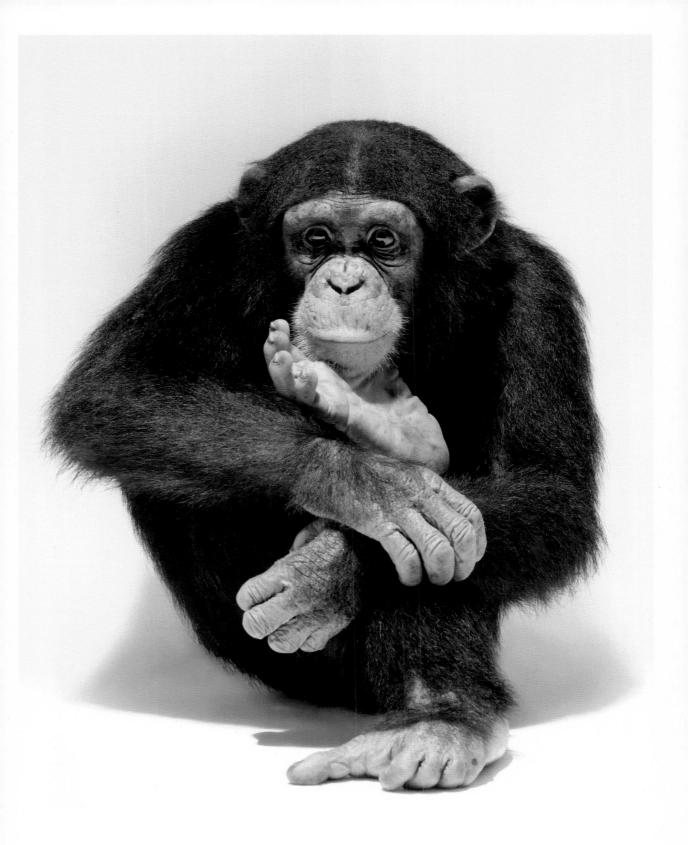

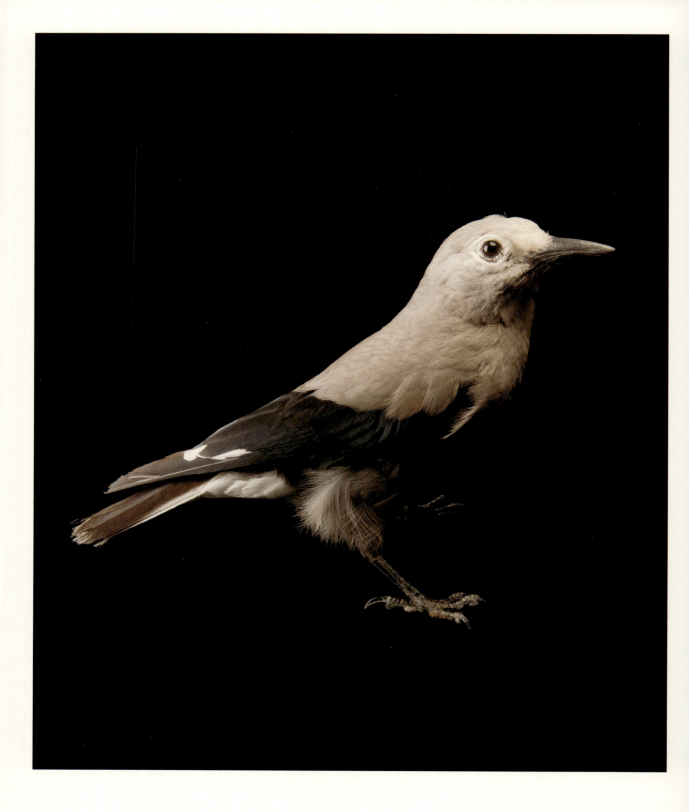

Extreme specialization is risky in evolution. In severe winters in poor pine-seed years, the super-specialized Clark's nutcracker may have resort to plan B, and migrate south to a warmer area.

CLARK'S NUTCRACKER *NUCIFRAGA COLUMBIANA*

A phenomenal memory

People who live in snowy climes are well aware of the necessity of being prepared. Before the worst of the winter sets in, they're busy shopping, hunting, harvesting, cooking, bottling, pickling, drying, freezing, storing—laying down a larder that will see them through periods when it's not pleasant, or even safe, to be outside searching for the next meal. Without these skills, our species—originating in southern Africa more than two hundred thousand years ago—could never have made a success of life in places so far from our warm and plentiful homelands.

Imagine for a moment, though, that you cannot have that larder on your own premises, safely under lock and key. Instead, you must store your precious supplies outdoors, available to all and sundry. What might you do to improve the chances that at least some of those supplies will not be found and eaten by other humans, and other animals in general? The most obvious step would be to hide them. But nothing can be so well hidden that it's impossible to find. So you might also break your hoard up into many smaller stashes, each hidden in a different place, so that the loss of a few will not spell total disaster. Now, imagine that you've done that, but that you have nowhere to keep a record of where you've hidden everything, except your own, fallible brain. Are you going to make it through the winter now?

This is the problem faced by the Clark's nutcracker, a dapper little gray-and-black crow that lives in mountainous parts of western North America. When fall arrives, so too does a huge glut of its favorite food—the seeds of whitebark pine and pinyon pine trees. These trees dominate the landscape thereabouts, and as the summer ends they bear copious cones, each full of fat seeds, tucked between the woody scales. The nutcracker is built well for getting at them—it can smash its way into a cone by gripping it with both feet while battering away at the scales with its long, strong bill. When it accesses the seeds, it can swallow one every two seconds, and store up to one hundred of them in the loose, pouch-like skin of its throat. If it were a bear or a dormouse, it might simply stuff itself with seeds right away, gain vast amounts of body fat, and then sleep through the winter in a cozy den. However, it is a bird, and hibernation is not, by and large, an avian winter-survival tactic. The nutcracker has other plans. Rather than swallowing the seeds, it carries them away and hides them in the soil. Just as

you'd expect, it makes numerous small stores, containing just a few seeds each, so that the losses are minor if a few of the stashes are raided by squirrels or other sneaky thieves. This style of food storing is called "scatter-caching" and the Clark's nutcracker is the absolute master of it.

An individual nutcracker may hide ninety thousand or so of these tiny seeds every fall, over a 15-mile radius, with just four or five seeds per cache. That means it makes as many as twenty thousand separate caches through this extensive area, condensing all of this work into the few weeks before the snow comes and it needs to start returning to the caches to eat the seeds. What it stores is often, in fact, a much bigger larder than it requires to see it through until spring and beyond—while its diet does broaden to include insects and other foods in the warmer months, the nutcracker still subsists mainly on pine seeds, but plenty of its stores are still full by the time the next crop of seeds appears. It retrieves some seeds from its stashes and loses some more to squirrels, but a fair proportion of the seeds remain completely undisturbed and may end up germinating. In this way, the nutcracker helps to maintain and spread its own habitat; indeed, its presence is necessary for whitebark pine forests to thrive.

A purpose-built brain

Even those of us with enviably tidy and well-organized homes are self-aware and humble enough to know that our powers of recollection could not rival those of this little crow. We might wonder whether the rediscovery of stored seeds is down to chance—after all, there are *so* many individual stores that surely some would be stumbled upon by chance by a clueless but desperately hungry nutcracker? However, the bird's abilities are beyond question. Studies have shown that it's able to remember exactly where a stash is, even up to nine months after the event (although a significant drop in recall rate does begin to occur after about six months).

Research has revealed that these birds rely on a pair of distinctive physical markers (a particular rock and a particular stump, for example—anything elevated that won't become completely covered by snow) in the vicinity of a cache. They can then pinpoint the cache by remembering the angles formed between its location and the markers. This technique, triangulation, is one that we humans use when we're navigating to a particular spot, but we do it deliberately rather than instinctively—though can we say for sure that the birds are using "pure instinct" rather than conscious thought when they triangulate?

To understand what may be going on in the brain of a Clark's nutcracker, we can look to studies on another scatter-caching bird, the black-capped chickadee. This

small, perky bird, familiar to many a garden birder in North America, hides hundreds of seeds in multiple locations every fall, and as it does so, its brain actually grows new neurons and new neural pathways, causing the brain's overall size to increase by some 30 percent. This incredible change occurs primarily in the hippocampus, a region of the brain associated with forming memories. More remarkable still is that "old" neurons are discarded in the process. We can infer (though we can't know for sure) that the cells that are lost are those that hold old—and thus useless—memories of caches that are now empty. It's highly likely that nutcracker brains go through a similar process.

Studies on the visual recall of Clark's nutcrackers, however—carried out on a diverse range of pictures—have shown that these birds do not excel at this more general type of memory task. The nutcrackers were able to memorize about five hundred different images, which sounds impressive, but they were defeated by the humble domestic pigeon, which could manage about eight hundred. This result underlines how very specialized the nutcracker's memory system is: specifically adapted to recalling seed caches. Of course, remembering the exact whereabouts of pine-seed stashes is not a casual interest for these birds. Failure to do so means death, pure and simple. This "evolved specialized cognitive capacity" shows us that a brain can be pushed to incredibly specialized extremes through evolution, just like the pair of ultra-efficient kidneys that allow a desert-dwelling fennec fox to survive without water, or the extra-large, fast-pumping heart inside a cheetah that allows it to accelerate from zero to 60 miles per hour in 3 seconds. Most crows are highly adaptable generalists in their diet and, accordingly, their behavior; they have impressive brains and demonstrate well-developed and varied cognitive skills. The Clark's nutcracker is as brainy as other crows its size, but its brain is primarily a seed-cache-remembering organ. As it grows from hatchling to adult, and lives out its life span of fifteen years or more, it commits high levels of bodily resources to building and maintaining that extremely energy-expensive neural tissue, but this is an investment essential to survival. Fortunately, the pine seeds themselves provide energy in abundance—pound for pound, they are more calorific than chocolate.

ASIAN ELEPHANT *ELEPHAS MAXIMUS*
Fluid dynamics

We humans are excellent tool users, but not just because of our brains. We are also blessed with a dextrous pair of hands—inherited from our ancestors as tree-climbing equipment, but repurposed by us for all kinds of object manipulation. It's hard to imagine a less nimble set of digits than the front foot of an Asian elephant, but elephants have a nifty alternative. An elephant's trunk is long and powerful, capable of felling a hefty tree, but it also has delicacy, and over time an elephant builds precision control over its movements. The trunk can also suck up and squirt out a volume of water. You can't mold water but you can direct it and, like any child at bathtime, the Asian elephant has learned that water can be used to move other things around.

The "floating object" task involves challenging an animal to add extra water to a narrow, partially water-filled tube, to bring a floating treat into reach. A dozen zoo elephants in Oklahoma and Washington were tested with this task, but perhaps surprisingly, eleven of them failed to complete it. The twelfth, though, Shanthi, solved the puzzle immediately (in other words, using insight rather than trial and error) and quickly earned herself a marshmallow by topping up the water tube.

A follow-up looked at whether the elephants could learn this task from one another, and whether they showed a predisposition for this kind of social learning. One of the Oklahoma elephants, Chandra, was given a little basic training from her keepers in how the task worked, and quickly picked up the idea. When her fellow elephants watched her complete the task succesfully, they showed increased interest and persistence when they interacted with the tube themselves.

Elephants, like most other large herbivores, are regularly plagued by flies. However, they are capable of wielding their own highly effective fly-swatters—tree branches. If offered a branch that isn't quite suitable, an Asian elephant will modify the tool, by shortening it, removing side branches, and generally crafting it into the most effective shape. Elephants also have the cognitive insight needed to move and even stack up objects on the ground, creating steps they can then use to get at out-of-reach treats. We may admire elephants most for their deep social bonds and empathic nature, but observations like these reveal that, in their careful and deliberate way, they are also very capable of figuring out tricky problems all by themselves.

The hand–brain link opens up all kinds of opportunities for humans to manipulate their world, and the trunk–brain link does the same for elephants.

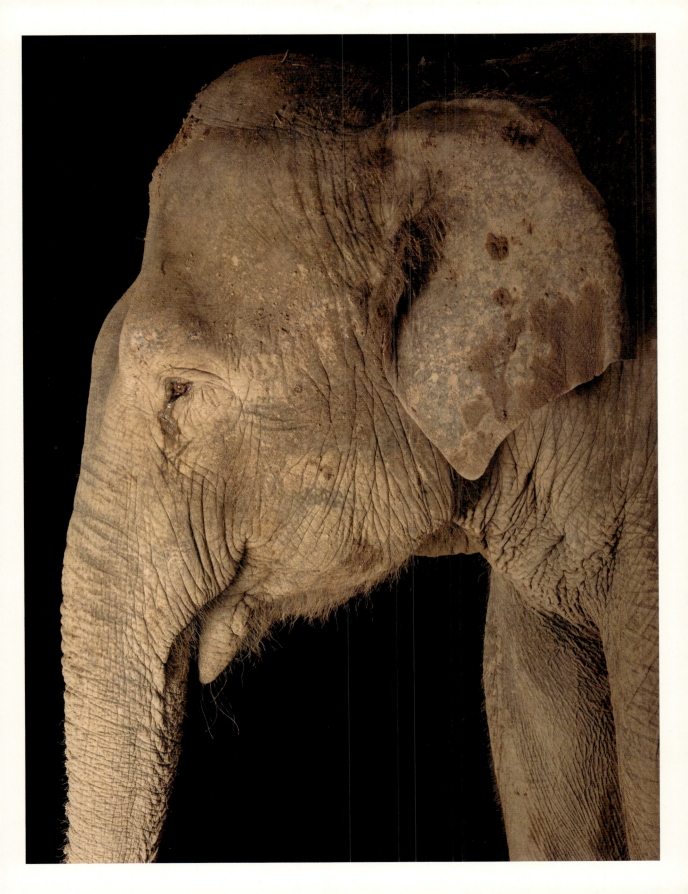

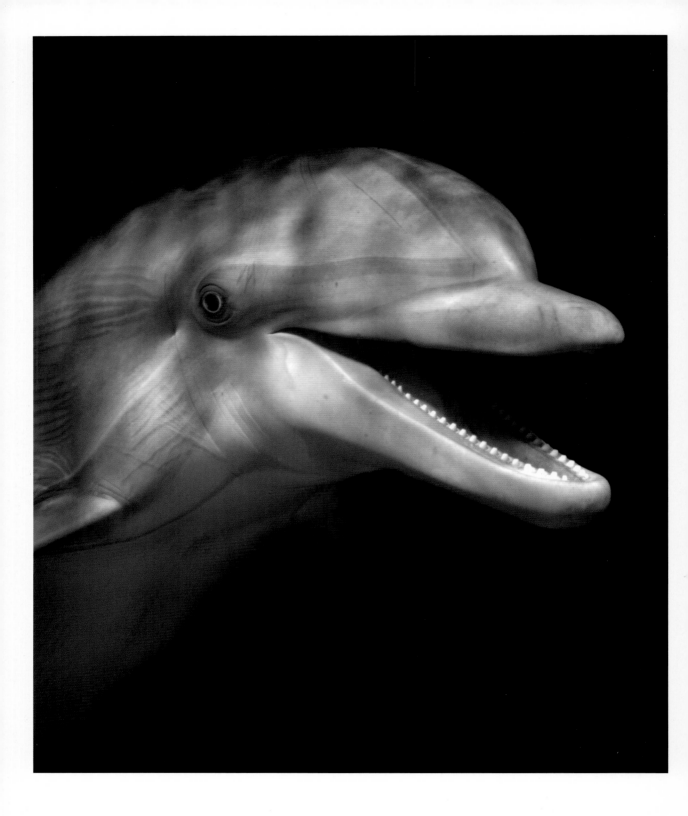

The bottlenose dolphin's 3½-lb brain features a frontal cortex more complex and neuron-packed than any land-dwelling mammal (besides *Homo sapiens*).

COMMON BOTTLENOSE DOLPHIN *TURSIOPS TRUNCATUS*

Every day's a learning day

The much-loved author Douglas Adams said that humans thought themselves cleverer than dolphins because of their many visible achievements, while all that dolphins ever did was "muck about in the water having a good time." He went on to explain that dolphins, of course, considered themselves cleverer than humans for exactly the same reason, and in his stories it turns out that it's the dolphins that are right.

Dolphins and their fellow cetaceans, like all mammals, evolved on land. A few mammal groups switched lanes over their evolutionary history and made a return to the water. Within the order Carnivora—home of lions, tigers, and bears, as well as wolves, weasels, hyenas, and mongooses—two groups did so with great success: otters and seals. However, the cetaceans, although they are mostly meat-eaters, are not part of Carnivora. Instead, they descend from a very different lineage known as Artiodactyla, the even-toed ungulates, comprising cows, sheep, pigs, and the like. When paleontologists uncovered the ancestry of cetaceans, they presented the world with one of evolution's biggest surprises, and showed us what remarkable changes natural selection can bring about, given enough time.

As it turns out, the cetaceans are the most superbly adapted of all water-dwelling mammals—their hooves, and indeed their hind legs, long lost in evolutionary history, and a body built for grazing and galloping traded in for a sleek and streamlined deep-diving, speedy underwater-hunting machine. They emerged at a fortuitous time, not long after the meteor strike that killed the dinosaurs had also wiped out most large marine creatures, and thus created niches for a new generation of big sea creatures. We marvel at how convergent evolution has shaped them into such fish-like forms, at how they use sonar to find their way (and their lunch) underwater, at their long lives, deep social bonds, and at their gigantic brains, obvious intelligence, playfulness, and skillful manipulation of the objects in their environment. Dolphins experience the world very differently from us, but they seem to have slipped into similar roles—of innovators, curious creators, cooperators, and mischief-makers. The species that we know the best is the common bottlenose dolphin, not least because its behavior is especially complex, and because it seems to enjoy and actually seek out human company on occasion.

Because of their formidable intelligence, common bottlenose dolphins have been much studied, both in the wild and in captivity. The use of trained dolphins as crowd-pleasing exhibits at (often poorly run) water parks is now generally frowned upon and is falling out of favor, but several research institutes still keep common bottlenoses in much more sensitively managed conditions, allowing marine biologists to study their cognition and psychology. Every year, impressive and sometimes disquieting (to us) new behaviors come to light. One such demonstration of exceptionally devious intelligence comes courtesy of the not-for-profit Institute for Marine Mammal Studies (IMMS) in Mississippi.

The invention of economics

The bottlenose dolphins kept at the IMMS are trained to keep their own tanks tidy. If a piece of litter—say, a scrap of paper—falls into a tank, the dolphin occupant retrieves it and presents it to a trainer, and is rewarded with a fish. This system is clearly an excellent piece of mutual cooperation that benefits dolphin and trainer equally. Or it was until Kelly came along.

In her approach to this system, this dolphin showed a mind that many a ruthless business person would be proud of. The key to her innovation was the realization that any piece of litter, big or small, was worth the same in the litter–fish exchange system. So, before long, when a piece of paper landed in her tank, she hid it under a rock. Then, when she spotted a trainer coming, she tore off a tiny corner and offered it to them, receiving a fish in return. In this way, she was able to use one piece of litter to "purchase" multiple fish.

Her next innovation took a more sinister twist. It wasn't just litter finding its way into the dolphin's tanks, and one day Kelly discovered a dead gull. She duly brought it to the side when a trainer came by, and swapped it for a fish. However, she didn't eat the fish but used it to attract more gulls instead, which she then caught and killed, and swapped for yet more fish. We should perhaps be grateful that Kelly resides at the IMMS, rather than being in a position to scam ordinary people out of their hard-earned belongings.

The common bottlenose dolphin's brain is bigger than our own. Then again, the dolphin itself is a considerably bigger animal, but its neocortex also contains more folds and fissures than our brains do, and it has a higher neuron count. It's therefore not surprising that these animals are extremely clever, and their elaborate social system (whereby cooperation is good for the individual, but sneaky manipulation can be just as good) means that they are clever in some startlingly human-like ways, too. Kelly had no difficulty grasping the social contract of fish-purchasing between herself and her trainers, nor in seeing and exploiting its inherent weakness.

Mind-reading

Common bottlenose dolphins are tool-users—within one population off Western Australia, females in the group famously use basket sponges torn from the seabed to protect their noses while they search for bottom-dwelling fish (which are extra-rich in nutrients), and pass this skill on to their daughters. This species also has its own highly sophisticated, multitiered language, which we'll be exploring later in this book (see page 93). Linked to advanced communication ability is the concept of metacognition—consciously thinking about one's own thoughts, or regulating one's own state of mind.

This level of insight and analysis is clearly indicative of very sophisticated cognitive skills, and is a component of what psychologists call Theory of Mind. This is the capacity to ascribe varied mental states to others—your awareness that the people around you are experiencing as rich and complex an inner world as you are. Thanks to Theory of Mind, we are mind-readers (to some extent), able to anticipate how people might analyze and react to things that happen to them. Through this comes the awareness that others (of your own species or sometimes another) have thoughts and beliefs of their own, which you can compare to your own. Your thinking may be influenced by theirs, or you may discover that they hold what you know to be false beliefs, perhaps alongside other beliefs that are true. The question of whether animals possess a Theory of Mind is one of great interest to biologists and neuroscientists, and it can be investigated in various ways.

The "false belief" task tests this aspect of metacognition by having the experimental subject (human or animal) observe a "communicator" pointing out which of a selection of boxes contains a hidden treat. This signal has been pretaught to the subject and has been proven to be reliable. The communicator then exits, and a second person, the "experimenter," enters and moves the boxes around. When the communicator returns, they repeat the signal, indicating the box that has been moved into the position originally occupied by the one with the treat. Having seen everything unfold, the subject theoretically knows that the communicator is demonstrating a false belief. They should therefore reject the signal, and go to the box that's been moved to claim its reward. Most human children will pass this task by the age of five. False belief studies with a common bottlenose dolphin in 2006 appeared to show that the dolphin was also capable of working through the logic involved and passing the task, but critics argue that there were ways that he could have cheated. The answer is to devise some new study setups, but if Kelly has taught us anything, it is that if there's a way to cheat, a common bottlenose dolphin will work it out.

DOMESTIC PIG *SUS SCROFA DOMESTICUS*

Dig for victory

Pigs can make lovely pets. However, humans also eat about 1.5 billion domestic pigs every year, even though we're also discovering more about their rather sophisticated cognitive abilities. It could be argued that we have a duty to learn more about them, in order that we treat them with greater understanding and compassion.

Pigs find most of their food by "rooting"—shoving their strong but sensitive snouts into loose or soft earth to find roots, invertebrates, and other edible material. They also use their snouts to dig pits in which they bear their young. In 2015, an ecologist visiting a zoo in Paris was surprised to observe a Visayan warty pig (a wild species from the Philippines, closely related to the wild boar from which domestic pigs descend) using a piece of hard bark to tackle some firmer soil and dig out her nesting pit much more efficiently. This was the first documented observation of tool use in a pig species, and it sparked increased interest in studying the brainpower of domestic pigs.

A few years later, researchers at Purdue University in West Lafayatte, Indiana, trained four domestic pigs to play a simple Pong-like video game, using their snouts to move a joystick and steer a moving cursor to hit a target, with three levels of difficulty. Although a snout is hardly the ideal tool for maneuvering a joystick, all four pigs were successful at the most basic level of the game, and two of them did well at the most challenging. Success meant a food reward, but some of the pigs chose to keep playing simply to receive fulsome praise from the trainer. This study therefore revealed more than just the ability of the pigs to master a challenging mental and physical task of coordination—their motivation was also influenced by social factors. There was considerable variation, too, in how much the trainer's engagement encouraged the performance of each of the pigs, demonstrating differences in porcine personality.

Other studies have shown that pigs perform at least as well as dogs on tasks such as object discrimination, memorizing routes to find food, and consistently associating words and phrases with specific objects and actions. The outcome of these studies is a growing awareness that the pigs we raise may require high levels of mental stimulation to develop happily in a farmed environment, in addition to having their more basic needs met.

Approval from a human trainer proved an even more powerful motivator than a food reward, when domestic pigs were tasked with learning a new skill.

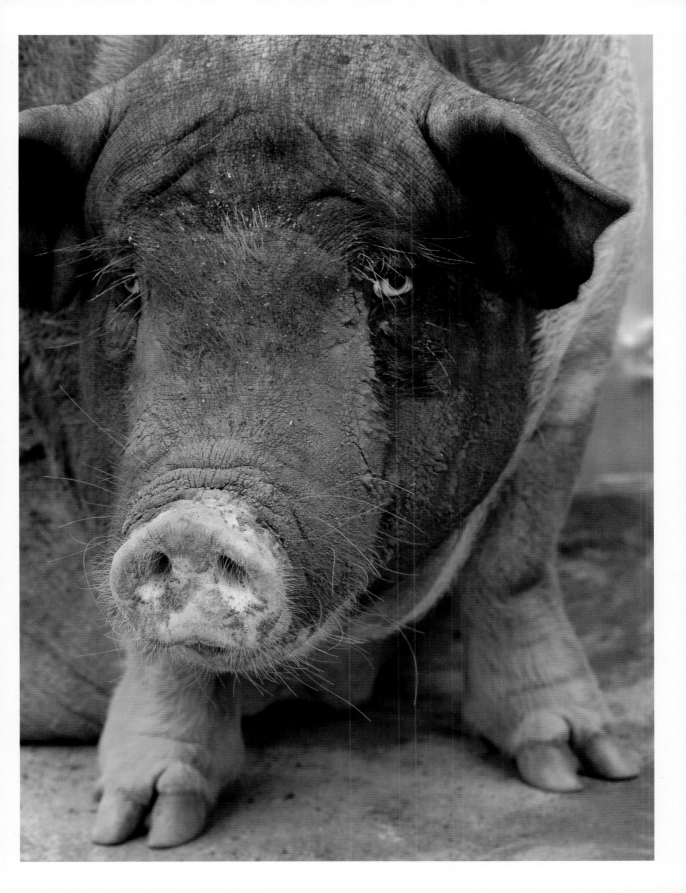

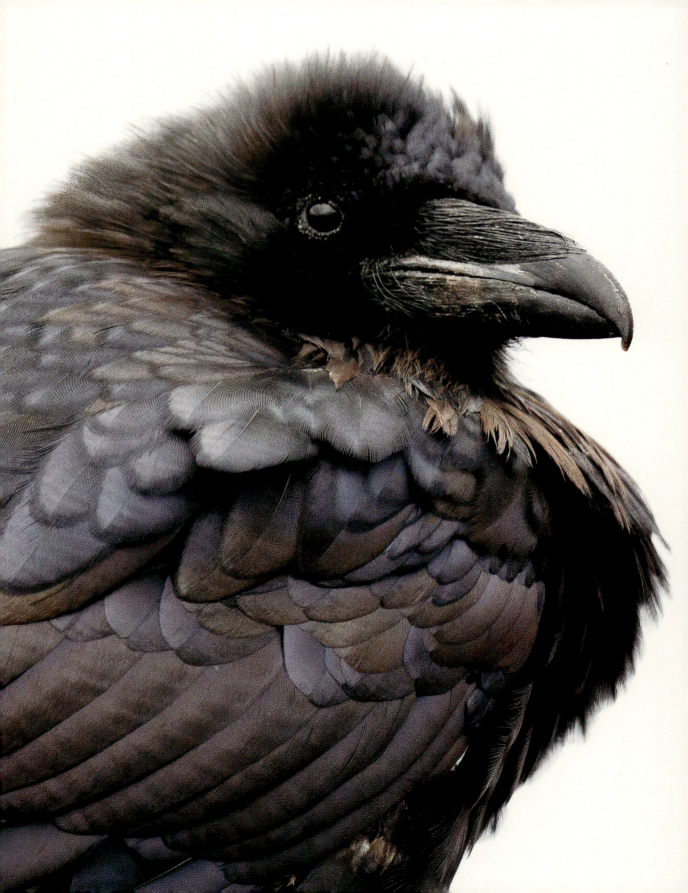

COMMON RAVEN *CORVUS CORAX*

No need for trial and error

Some of the sounds birds make simply blend into the sonic backdrop of our day-to-day lives. If we live by the sea we soon learn to tune out the yelp of local gulls, and in the countryside and suburbia we can soon sleep through the five A.M. springtime flutings of thrushes, robins, and the like. However, the deep croaky note of a raven tends to arrest our attention no matter where we are. If we hear a common raven, we might be almost anywhere in the northern hemisphere—North America, Europe, a vast swathe of Asia right across to the Bering Strait, and even perhaps northwestern Africa. This big, beautiful bird with an unmistakable voice is the world's most widespread and largest species of crow, and is rightly famous for its immense intelligence.

Look up when you hear that ultra-bass "cronk" and with a bit of luck you'll see it—or more likely see them, because common ravens tend to go two-by-two. A pair, deeply bonded for life, will helter-skelter across the sky on wide wings, with their distinctive diamond-shaped tails fanned out to steer them through a series of coordinated lifts and tumbles. If another bird gets involved, say a passing peregrine falcon, the aerobatics are ramped up several dozen notches, as the two ravens fly rings around their agile opponent. Even a fleeting encounter like this provides pretty compelling evidence that these energetic, playful, bold, and team-spirited beings are something special in the cognitive department. And, should you be lucky enough to meet a tame raven that's worked with a human trainer to learn a trick or two, you'll be left in no doubt whatsoever.

Common ravens are, however, still "only" birds, and there isn't much room inside their 2-inch-long craniums for anything *that* special, is there? What we find in that cranium certainly doesn't look much like the bulbous and deeply wrinkly object that resides inside our own skulls. We assume that the most cognitively powerful animal brains will be those that most closely resemble the human brain, so conclude that raven brains (or any bird brains) are not up to much. Well, a human being *would* say that, but a raven would beg to differ.

The capacity to beg to differ may not be one of the criteria by which we judge intelligence, but we know that ravens possess other more measurable abilities—memory, problem-solving, insight, and self-recognition, for example—in more abundance than we can readily dismiss. Their intelligence is easily on a par

The first thing you notice about a raven might be that formidable pickaxe of a bill, but then the inquisitive spark in its eye will lead you to wonder what it might be thinking . . . or planning.

with that of the mammals out there that do possess the most human-like brains. Yet the brains of ravens, as with other birds, lack a convoluted cerebral cortex—the wrinkly layer of "gray matter" that covers the surface of the brain, and the "seat of intelligence" in mammals. The more convoluted or folded the cerebral cortex is, the more brain cells (neurons) can be packed into the available cranial space (hence the disparaging nickname "smoothbrain," for a person who doesn't appear to be very bright).

Different parts of the cortex handle different functions, with the front region (the prefrontal cortex, covering the brain's frontal lobe) being the area concerned with advanced cognition. If the human brain is our benchmark, then a deeply folded prefrontal cortex is an anatomical requisite for cleverness. So how is it that a raven possesses cognitive powers that easily measure up to (and in some areas, exceed) those of the great apes, when it lacks this vital piece of neurological equipment? The answer is that bird brains and mammal brains develop in a different way. To understand this, we need to take a close look at the pallium—the surface of the brain in vertebrates, and the structure from which the folds of the cerebral cortex arise in mammals.

Complexity without convolution

As a human embryo develops, the two hemispheres of the pallium become increasingly layered and folded, and differentiate into the cerebral cortex, along with other structures, including the hippocampus. When fully developed, our brain weighs just under 3 pounds, contains about 86 billion neurons, and makes up about 2 percent of our total body mass. The entire brain is only about 6 inches long, but if we were to unfold our cerebral cortex and lay it out completely flat, it would cover about 15½ square inches. Smaller mammals tend to have proportionately bigger brains than larger mammals, but studies have shown that, between species, absolute brain size is generally a better indicator of intelligence than brain size relative to body size.

So birds seem to have a double dose of unintelligence predictors going on—a small brain, with no folded cortex. However, when we delve into the avian pallium, we discover that the neurons it contains are much smaller than those in a mammalian brain. These mini-neurons are densely packed into the pallium, adding up to an incredibly high total neuron count—in some cases up to four times that of a similar-sized mammal. For example, the goldcrest (an exquisitely tiny ⅕-ounce songbird found in Eurasia) has 455 neurons per gram of its brain, compared to 168 neurons per gram in the brain of a ½-ounce house mouse. In the case of the common raven, which is also a songbird, or passerine (albeit at the opposite end of the size scale), the total neuron count is higher than you'll find in the cerebral cortex of many a clever primate.

The result is an almost frighteningly clever bird. It can, for example, infer the thoughts of a fellow raven, noticing whether the other bird is observing it or not, and modifying its behavior accordingly. It appears to be able to communicate with its peers about events occurring in other places. It can also understand delayed gratification, happily choosing a token that can be exchanged later for a special treat, in preference to a lesser treat that's offered immediately, even if there's a long delay; in one study, the wait was 17 hours between receiving the token and having the opportunity to swap it for the high-value treat. Ravens can also solve physical problems (for example, using tools to reach a hidden treat) without the need for trial and error—they quickly figure out what needs to be done, then consistently do it.

At the start of this account, we met a pair of common ravens delighting in their aerial prowess. The wonderful avian ability to fly is connected to the wonderfully efficient avian brain, and to the many other aspects of bird anatomy that set them apart from mammals, as well as from the reptiles that are their closest cousins. When the theropod dinosaurs from which birds evolved first began to repurpose their insulating feathers as tools of flight, the many advantages afforded by this fledgling skill exerted a very strong selective pressure on their populations to become better and more efficient fliers. Natural selection favored a more lightweight body, so any anatomical features that increased mass without increasing flight efficiency began to fade away—heavier individuals flew less well and so survived less well; it was the lighter individuals that survived in greater numbers, passing their traits to the next generation. Over many, many generations, teeth disappeared, as did various bones, while other parts of the avian skeleton became fused, infused with air sacs, or reshaped into more delicate forms. Certain bird lineages were also under selective pressure in terms of intelligence, but the demands of flight meant that a heavyweight brain was not advantageous to survival. Lineages like that of the common raven were therefore squeezed along an evolutionary path that powered up brain efficiency without a costly weight increase.

Today, we're beginning to give the intelligence of birds the respect that it deserves. As for the capabilities of the common raven, our understanding is still in its infancy, but intense research is ongoing, as it is with other clever crow species. Also under the bird-brain spotlight are parrots such as the kea of New Zealand—a notoriously mischievous South Island mountain-dweller that enjoys nothing more than dismantling the cars that visit the beauty spots of its home range. Once regarded as a nuisance, the kea is now a tourist draw in its own right, as "kea playgrounds" full of mazes, puzzles, and other brain-teasing equipment have been created to divert the birds' rampant curiosity and give visitors the chance to see what these brainy birds can really do.

EUROPEAN HERRING GULL *LARUS ARGENTATUS*
Seeing eye-to-eye

If you've ever settled down to enjoy an ice cream outside an English seaside cafe on a sunny day, only to lose it to a winged marauder that's swooped in and snatched it away with its large yellow bill, then you know and possibly dislike the European herring gull. Many otherwise idyllic esplanades are punctuated by signs warning you not to feed the gulls, as this only encourages their fearless thievery. Beachgoers were delighted to read reports on a recent study that showed that this would-be snack thief is discouraged if you hold steely eye contact with it at all times. (Just remember that another one is probably sneaking up behind you as you do so.)

This eye-gaze finding came courtesy of Madeleine Goumas, at the University of Exeter in the UK. She went on to examine another aspect of our relationship with herring gulls that was investigated by researchers, via a study in which some lucky wild urban gulls were given the opportunity to help themselves to two identical granola bars. With each trial, the human "serving" the treats (wearing sunglasses to avoid accidental human–gull eye contact) handled one of the bars first, within view of the gulls. It transpired that the food that had been pre-touched by human hands was a lot more appealing to the gulls—80 percent of the test subjects opted to eat it first.

These observations reveal that, disconcertingly, urban gulls watch us and note what we do. They know that the food we carry is probably something that they would like, and they know how to time their approach for the best chance of relieving us of it. Given this level of scrutiny, we should perhaps not be surprised to discover that herring gulls can also learn to tell us apart as individuals—much more easily than we can tell them apart. You might see this in any seafront town in the UK, where there will always be a few human residents who ignore the signs and feed the gulls on a regular basis. When they see a "feeder" approaching, the gulls react with excitement, converging upon that one individual and yelling loudly. Herring gull numbers have declined steeply in the UK over the last few decades, suffering the consequences of a collapsing fishing industry, among other problems. However, these versatile birds are not going down without a fight, and are putting their own keen gaze and clever deductions to good use as they strive to thrive in the human environment.

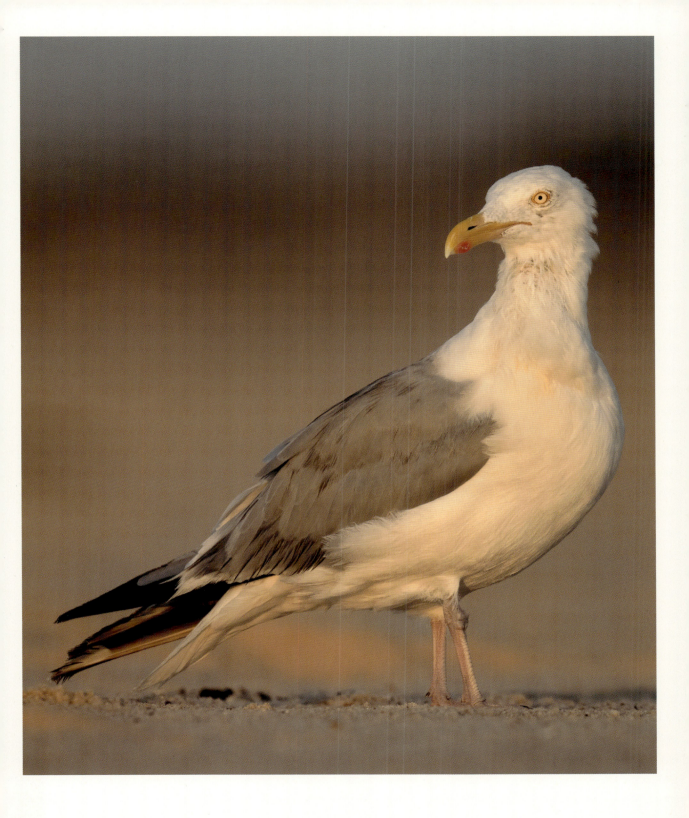

Herring gulls keep a close eye on humans, and it serves us well to return that eye contact if we don't want to become victim of a fly-by robbery.

CALIFORNIA TWIN-SPOT OCTOPUS *OCTOPUS BIMACULOIDES*
Tactile tentacles

Octopuses don't look very sentient at first glance, and the California twin-spot octopus is no exception. A smallish, compact species, it seems no more than a soft, fleshy bag with a mass of tentacles attached. We can only discern its eyes once we realize that the big, scowling blue-and-black markings (the "twin spots") on either side of its head are not its eyes but just eye mimics, deceiving predators into thinking the octopus is more fearsome than it really is. The real eyes sit behind these spots and blend in with the rest of the animal's coloration, and it's difficult to attribute any expression or feeling to them. This creature's way of life is entirely alien to us, and its life span—just a couple of years—seems too short for any meaningful mental development to occur. Being so unlike us, octopuses and other cephalopods certainly fall foul of our species-ist prejudices.

However, those who've taken the time to get to know octopuses—watching what they do, both in the wild and in captivity, and presenting them with brain-stretching challenges to see what they're capable of—have been telling us for years how intelligent they are. And not just relative to other marine invertebrates, but relative to other life on Earth. Can it be true?

Octopuses are very curious, using their tentacles to fully explore their environment. They and their fellow cephalopods stand out among invertebrate sea animals in being active hunters rather than passive filter feeders or static trappers of passing prey. They are omnivorous, with a variety of feeding techniques, so their tendency to investigate and manipulate serves them well. However, they are also preyed upon by many other animals, so they also depend on an array of evasive techniques. They can move rapidly, change their color scheme to match their background in an eyeblink, and can squeeze their soft, pliant bodies into surprisingly tight spaces as required.

A startling demonstration of the latter was provided in 2016 by a common New Zealand octopus named Inky, who squeezed out of his tank at the National Aquarium of New Zealand when a keeper accidentally left his tank lid ajar. The wily cephalopod crossed the floor of the room, located a narrow drainpipe that led to the sea, and made his escape. Whether this was an intentional escape back to his true home, or simply curiosity-driven exploration can't be known, but Inky's keepers did describe him as unusually intelligent. Octopuses possess distinct

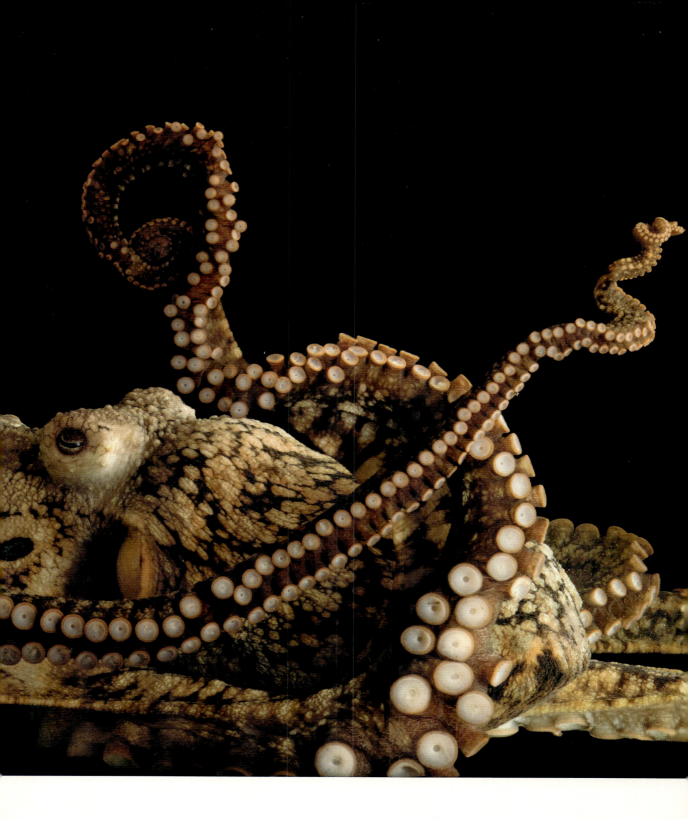

Just like an elephant's trunk and an ape's hands, an octopus's tentacles are remarkably dextrous tools at the service of an equally impressive brain.

personalities, varying in how outgoing and adventurous they are, and how active or passive, as well as how strongly they react to unusual occurrences. They are also playful. A convincing demonstration of this came courtesy of octopuses at the Seattle Aquarium in 1999, when a couple of researchers dropped an empty pill bottle into their tank to see what they would do. Two of the octopuses began to move the floating bottle around by squirting water at it, directing it toward one of the tank's inbuilt water jets, which pushed it back toward the octopuses—a game that they continued to play for half an hour.

Octopuses' liking for (and skill at) manipulating objects enables them to complete tasks such as unscrewing the lid from a jar to get at a food reward. It can also cause unexpected problems. In 2009, a small female California twin-spot octopus at Heal the Bay Aquarium (previously Santa Monica Pier Aquarium) caused great damage by dismantling a valve in her tank, with the result that 200 gallons of seawater flooded the aquarium's newly laid floor. Thankfully none of the living exhibits were harmed, and the culprit (nameless, though some visitors suggested she be christened Flo after the event) was forgiven. However, mindful that octopuses have a very good memory, the keepers secured the valve with clamps and tape to prevent a repeat performance.

Space and time

Octopuses naturally investigate all objects, not least because they're constantly in search of new places to take shelter. They are too soft-bodied to dig into the seabed substrate like many marine animals that rely on instant hiding places, so they look for crevices in something solid instead. They'll spend much of their time in a favorite shelter, retreating there to escape danger, or just to relax and perhaps enjoy a meal they've just caught. Suitable spots are most likely to be in rock or a coral formation, but octopuses have also been known to use a range of other objects, both natural and artificial, as shelters, and even to repurpose and relocate found objects. In 1990, scientists reported octopuses collecting halved coconut shells, cleaning them out, carrying them to a new location, and then positioning them cut side down on the seabed before squeezing inside—a fascinating finding that was key to opening our eyes to their brainpower.

Octopuses live alone and establish a home range, which they know intimately—as evidenced by studies in which they are deliberately moved off-course. The octopuses will return to their shelter not by retracing the same path, but by taking the most direct route, suggesting that they build and maintain some kind of mental map of their range, perhaps informed by various kinds of sensory data. They use different parts of the range in different ways. When hunting, they switch between vision and touch, depending on the topography and the

kind of prey they're seeking. The ability to remember and use this kind of information over time (temporality) is considered by some biologists to be a measure of consciousness.

Cephalopods are mollusks, counting among their cousins the gastropods (slugs and snails), as well as bivalves such as mussels and cockles. All mollusks keep their neurons in the form of paired clusters called ganglia, and most have many tiny ganglia distributed through their bodies. Only in cephalopods are many ganglia combined to form a large brain, and only in cephalopods are there distinct brain regions in charge of memory and learning.

One of the limitations researchers face when studying octopuses is they are short-lived. Even the biggest species are unlikely to see their fifth birthdays, and two years is a good life span for the little California twin-spot. In most species, the limitation on life span is imposed by the way that they breed, and here we discover a profound example of animal altruism. Males' bodies begin to deteriorate soon after mating, and producing her one and only family brings about the female's end too. When she lays her eggs, she stays close to them, keeping them aerated and defending them from predators, and abandoning all other activities, including looking for food. By the time they're ready to hatch, she is close to death. The process of reproductive maturity and subsequent degeneration is governed by hormones rather than any conscious decision—it can be prevented by deactivating certain glands, allowing octopuses to live much longer than their preprogrammed life span—but the suggestion of noble self-sacrifice only serves to endear this fascinating and intelligent animal to us.

2

CALCULATION
How Fast, How Far, How Much?

CALCULATION HOW FAST, HOW FAR, HOW MUCH?

Our planet, our solar system, and the entire galaxy-filled universe, are all subject to the laws of physics, and the mathematical formulae that encapsulate those laws. All living things have to operate within the confines of this framework. Want to defeat Earth's gravitational pull and take flight? Then your lift and thrust must overcome your weight and drag. Want to find your way back to where you were born? You need to have some way of locating that place on the globe. Want to beat the odds in life? It will help if you can understand how probability works.

The importance of mathematics and physics is rightly acknowledged in educational programs of all kinds. Even researchers working in the most human of the humanities subjects need to apply statistical tests to their findings to determine whether they are genuine or attributable to pure chance. Conscious mental mastery of everything involving numbers comes easily to some of us in the classroom, and very far from easily to others. However, as physical beings moving through space and time, interacting with other physical entities, we learn about physical laws through an active experiential process as well. From an early age, we learn how to coordinate complex muscular movements so effectively that soon no conscious thought whatsoever is needed to execute a jump across a stream, catch a fast ball, or gently maneuver a spoonful of food into an open mouth. Those who cannot develop these skills, or who lose them, face great challenges in day-to-day life.

We could describe the whole process of catching a ball—from assessing its speed and trajectory, to the precision timing of our hands moving to intercept it, as well as the way our muscles retain a particular degree of "slack" to absorb the impact without jarring our joints—as a series of mathematical equations, but this kind of calculation happens without

any conscious thought about numbers at all. Can we even describe it as a calculation? We often conceptualize brains as computers, and we know that the human brain has vastly more raw computing power and speed—never mind efficiency—than any super-computer yet built by human hands. Yet so much of the calculating work that our brain does is unconscious, and when we do calculate consciously it seems to take far longer and be far more error-strewn than the work of even the simple computer inside a pocket calculator. So we have a hard time seeing ourselves as the master calculators that we really are, and an even harder time seeing that same ability in animals.

Understanding how animals calculate obliges us to consider the differences between biological brains and human-built computers, as well as their similarities, and to consider the brain-bearing animal as the complete biological system that it is, with myriad influences—from physiological needs to emotional states—affecting its every conscious and unconscious decision. For example, our motivation to catch that fast-flying ball may be simply so that it doesn't smash into our face, in which case dodging out of its path is a valid alternative. Or we may be fielding in a baseball team that needs just one more out to win the game (and our coach has hammered home the message that catches win matches!)

Catching and dodging fast-moving objects are vital life skills for predators and their prey respectively. Animals may also need to calculate how long they can go without breathing, how high a fall they can survive, exactly where to go (and how much time to commit) to track down the distant source of an intriguing sound or delicious smell, and even how many of their offspring they should feed and how many to allow to starve, to maximize their genetic investment in the next generation. In a way, for us and for all animals, life is merely math.

GIBBON HYLOBATIDAE
Strong-arm tactics

We humans tend to overlook the gibbons, even though they're our closest living cousins in the wild besides the great apes. We even insult them by calling them the "lesser apes"—that is, when we're not mistaking them for monkeys. Gibbons are certainly a lot smaller and fluffier than other apes, and their genome shows that their lineage separated from ours about seventeen million years ago. However, gibbons parted ways from their ancestral monkey lineage another twelve million years before that, so they are much closer relatives to us than monkeys are. Their ape traits include lacking an external tail, and possessing highly mobile shoulder joints, making them skilled at dangling by their arms (more about that shortly).

There are about twenty species of gibbon living today—all in Southeast Asia, crammed into a relatively small part of the world, from Bangladesh southeast down to Borneo and Java. They are forest animals, and many species have suffered tremendous declines, thanks to extensive deforestation. All apes evolved as tree-climbers, but only humans have become adapted to life in open countryside—sadly for the other apes, our return to the forests has primarily been motivated by a wish to chop them down, to grow food on the cleared ground, and to use the wood for other purposes. However, life without trees is not doable for our gibbon cousins.

There are various ways of getting about in the "cluttered" environment of a rainforest mid-story. Some mammals run along and leap between boughs and twigs, while others climb slowly and deliberately, maintaining contact at all times with three out of four limbs. They may grip with squeezing digits or hooked claws—and in some cases a prehensile tail as well. Bats and birds that live in dense forest tend to have relatively short and broad wings, which means a lower top speed than their longer-winged relatives, but great agility, enabling them to dodge their way around branches. And then there are the gibbons, who locomote using a unique and incredibly impressive method known as brachiating.

Look at a gibbon as it sits on a branch and returns your gaze, and you'll notice several things—its frowning, serious face (its expression accentuated in many cases by contrasting-colored eyebrows), its cheek frills, its tendency to fold itself up small when resting. Watch it on the move, though, and you'll be struck by how remarkably long and strong its arms are, and its fingers too. The arms of a gibbon are about one and a half times longer than its legs (and it's not a short-legged

With hooks for hands and enviable upper-body strength, gibbons are extremely well adapted to an unusual locomotory style.

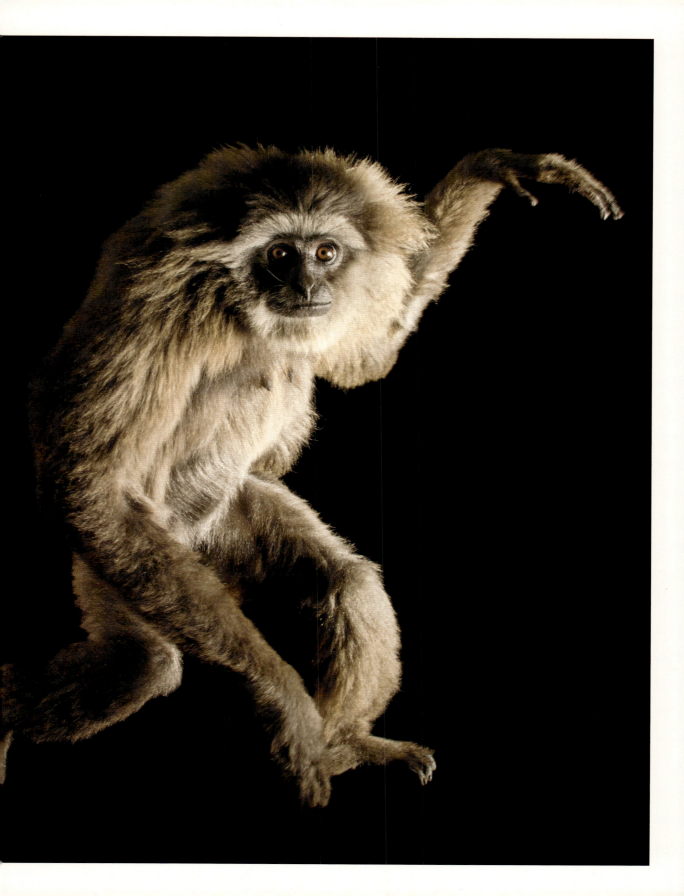

animal by any means) and they make up about 16 percent of its body mass. The larger species have a "wingspan" of about 5 feet. If we gave a woman of my height—5 feet 2 inches—the proportions of a gibbon, her outstretched arms would span almost 10 feet from fingertip to fingertip, and day-to-day life would be rather challenging (though she'd no longer need help getting things down from the top shelf).

Brachiating means traveling by hand-over-hand arm-swinging alone—the legs dangle below and have no involvement in the process beyond helping with momentum. Common chimpanzees, bonobos, and all species of orangutan use it to get around, and young gorillas use it too, although their hefty full-grown relatives tend not to. Humans, despite being hindered by long, heavy legs and relatively weedy arms, can train to become reasonably competent brachiators as well, but no great ape can brachiate with anything like the skill and speed of a gibbon.

In full flight, a gibbon can move through the trees at almost 34 miles per hour, and it is often momentarily afloat in midair, between its first hand releasing its hook-like grasp of one branch and its outstretched other hand taking hold of the next. Even more remarkably, it can leap from a standing start, swinging its arms as it pushes off from its hind legs, and hurling itself through open air to cross gaps between trees of up to 30 feet, perhaps more. Here is where its specialized anatomy really earns its keep, allowing the gibbon to absorb such jarring impact with ease, thanks to those strong fingers, flexible shoulder joints, and powerful arms, as well as maintaining its forward momentum. Its legs are strong and its feet grippy, so a big leap may end with all four limbs making contact and the grip being secured with both hands and feet, though most of its usual motion uses arms alone.

No other nonflying, tree-dwelling animal can move at the speed of a brachiating and leaping gibbon. Being smallish animals, gibbons have many more predators to contend with than great apes do, and this skill enables them to evade leopards, snakes, and eagles alike, while traveling quickly and efficiently between feeding grounds.

The biomechanics of a gibbon's amazing leg-propelled leap can be figured out on paper (or, if you're sensible, with the help of a computer) through a series of mathematical formulae, which take into account the animal's body weight (and what proportion of that is muscle tissue that's actually engaged in the process), the angle of takeoff, the acceleration, and the final velocity. Those who have crunched these numbers have found that a gibbon leaping upward from a hind-leg push off, aided with a forward swing of its arms, outperforms all other leaping primates and a good many other skilled animal jumpers in the speed it generates and the distance it covers.

Swinging for the win

This is rather a puzzling finding. As we've seen, gibbons are very arm-dominant, but the other great jumpers in the mammal world have much bigger and clearly stronger hind limbs than forelimbs. Just look at a kangaroo, or a jerboa, or even a four-footed runner but amazing jumper like a hare, serval, or show-jumping horse. How does the gibbon jump so well when its body is built for arm-swinging? It turns out that, even though it pushes off from a crouch with its hind legs, the simultaneous big forward swing of its arms helps greatly to drive its center of gravity forward, and contributes all of that extra energy. And there's an awful lot of energy involved—more than is known in any other leaping animal, and five times more than the bounciest human can muster. The gibbon has overcome anatomical limitations by investing its energy in developing and executing a highly effective technique.

The cerebral cortex of the gibbon's brain shows a much enlarged precentral gyrus (one of the prominent brain ridges) compared to other apes and to monkeys. This region is concerned with control of voluntary motor movement, and its expansion in gibbons shows how crucial fine motor control (sometimes at dizzying speed) is to these animals' lives. But are they born already furnished with this degree of control?

The answer is very much "No." The hardware—in terms of body and brain anatomy—is in place but it takes time, practice, and memory to build the software skills to use that anatomy fully and safely. Gibbons, like other apes, are clever and quick to learn. However, they are rather lacking in social cognition, and are much closer to monkeys than to other apes in their puzzle-solving skills. Their brains are optimized to learn and master a limited skillset—swinging and leaping.

Margin for error

The training begins from birth—as a passive participant, a newborn baby gibbon hangs on to its mother's belly and, through her, gets to know what an adult gibbon can—and cannot—do. Once it's able to hang, climb, and move on its own, the baby practices swinging on a single branch and then moving—at first cautiously—between branches, under its mother's (and sometimes also father's) supervision.

By adulthood, the gibbon's body size hits a "sweet spot" of being large enough to generate power for its leaps, but small enough to land without breaking branches and falling. Nevertheless, falls do occur, and may be fatal. In fact, studies on adult wild gibbons show that many bear one or more healed fractures, mostly to the limbs, probably from falls. The gibbon's mind and body might be as well adapted as they could be to this way of life, but the evidence indicates that extreme performance carries an inescapably extreme degree of risk.

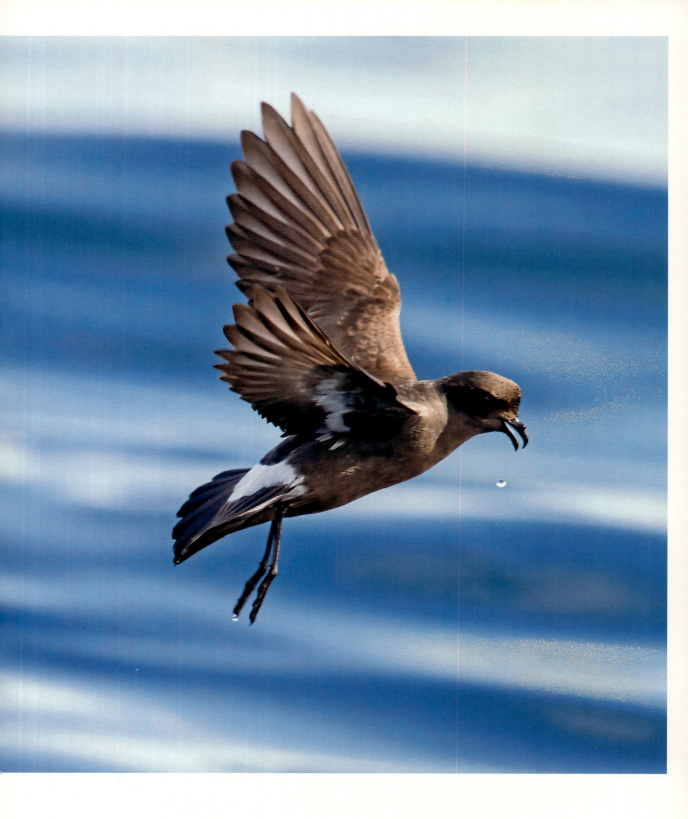

Storm petrels have prominent nostril tubes, as befits a bird that follows its nose around the world.

EUROPEAN STORM PETREL *HYDROBATES PELAGICUS*
Little but mighty

The little ferry rocks in a not entirely soothing side-to-side motion as it heads out into the open sea, leaving the small Scottish harbor town of Stornoway behind. The crossing to Ullapool should take just shy of three hours. A group of birders have grabbed the seats in the observation lounge and are eagerly scanning the wild Atlantic ahead. They are sure to see gannets, fulmars, and auks, and with luck there'll also be skuas and shearwaters. The real prize, though, is a bird so tiny that only the luckiest will spot it in its sea-hugging flight, dipping between the towering wave crests and looking like it could be pulverized by them at any moment.

The European storm petrel is one of nearly twenty species in the family Hydrobatidae—the northern storm petrels. Together with the similar-looking austral storm petrels (family Oceanitidae, ten species), they are the smallest but in many ways most impressive of all seabirds. When you see these birds close-up, their diminutive size and fragility is even more striking. They flutter rather than zoom and soar like many other seabirds. They dip down to the water level and dangle their long, delicate legs, touching the waves with their little webbed feet. It's this behavior that earned them their common name: petrel, from Peter—after St. Peter, who walked on water.

The other part of their name—storm—reflects their ability to deal with wild sea weather. Indeed, storm petrels are often encountered in very heavy weather, and as far from land as you can get. No fleeing to safe harbors for these seabirds; when they're not breeding they're roaming the seven seas in true pelagic style. They are also, like most seabirds, far longer-lived than similar-sized land birds. Tracking their lives is possible because they usually return to the same breeding colony—often even the very same nesting burrow—year after year. This makes it easy for researchers to trap them, ring (band) them, and check the details of any that have been ringed already. The oldest known European storm petrel in the UK was given its ring in Orkney in the summer of 1979, when already an adult. It was still going strong when it was trapped again in 2017, making it at least thirty-nine years old at the time.

When an adult storm petrel has fledged its young for the year, it heads out to the high seas, and may not touch down on dry land again for months. It is comfortable swimming so can rest by floating on the water when conditions are calm enough,

but a great deal of that time is spent on the wing, and it may cover a huge distance in its off-duty months. Even during the breeding season, a European storm petrel makes regular foraging trips out to sea, up to 190 miles from its nest site, while its slightly larger cousin, Leach's storm petrel, has been tracked making breeding-season foraging trips of more than 1,200 miles. This species heads out to deep water beyond the continental shelf to stuff itself with krill, copepods, and other fat-rich plankton, as well as any bits of carrion it might encounter. Its stomach contents will later be regurgitated into the mouth of its solitary chick. Storm petrel chicks can gain weight quickly, but they can also survive unfed for more than a day, allowing their parents to make lengthy trips and maximize foraging efficiency once they reach the rich, deep waters.

Navigation and pathfinding

As we've seen, a storm petrel can track down a slick of floating fish guts over a considerable distance, thanks to its (unusually for a bird) very acute sense of smell. These birds, along with albatrosses, shearwaters, and other petrels, belong to the order Procellariiformes. They are known as "tubenoses" because of the shape of their nostrils, and their brains have large olfactory bulbs to analyze the scents thus collected. Tubenoses use their sense of smell to find scavengeable food at sea, but also to find their way to their nests on coasts and islands (which the smaller species will approach only after dark, to avoid bigger, more predatory birds).

So smells clearly help guide these birds when they're close to food or home, but when they're not breeding they will roam thousands of miles from land, across watery wastes that offer no navigational landmarks whatsoever. They don't fly a set route as migratory birds (in the traditional sense) do—they are roamers. So when it's time to return to the colony and breed, what data do they analyze in order to plot an accurate route?

Navigation in animals is an enduring and complex mystery that holds special fascination for us, even as we grow ever more distant from any innate or traditional navigational skills that we may have inherited from our long-distant ancestors. For those of us who cannot reliably retrace even a short journey without the help of satnav, the ability of a lone bird with a $7/100$-ounce brain to find its way home across such huge, unfamiliar, and featureless distances (while contending with wild weather and other hazards) is quite astounding.

But if you abandoned a human in a featureless wilderness for a while (on land rather than 1,200 miles out at sea—let's not be too cruel), they would likely begin to notice and understand certain patterns and rhythms. The sun rises and sets at

predictable times and in predictable directions, changing only gradually over time. The positions of the constellations shift in a slow cycle, relative to the Earth, as does the arc of the moon. Perceptions derived from other senses might sharpen too. Our human, out exploring their environment, might get to know local individual birds, so would be able to tell that they were close to home when they heard a particular song. Certain smells could also take on greater significance. There's even evidence that humans have a latent ability to sense the Earth's magnetic field—an incredible navigational aid if its potential could be unlocked, and one that's used extensively by traveling birds.

Research into how migratory birds navigate has now established certain details. They are known to use straightforward visual landmarks, and the importance of these is clear when you compare the efficient migratory tracks taken by experienced birds against the more haphazard routes followed by those making the journey for the first time. There's also evidence that, in some species at least, there's a genetic predisposition to move in a particular direction around migration time, when the shorter daylight hours arrive. Then there is magnetoception. The bills of some birds contain crystals of magnetite, which respond to magnetic fields. Even more interestingly, photoreceptor cells in the retina of the migratory European robin have been found to contain the protein cryptochrome 4, which facilitates a sensitivity to blue light that may well enable the bird to perceive magnetic fields—an eye compass, effectively.

Migrating birds can also navigate by the stars. This is indicated by the fact that so many species migrate at night (yet not on cloudy nights), but we are only just beginning to understand how they actually do it. A series of elegant experiments carried out by Cornell professor Stephen Emlen, involving indigo buntings and a planetarium, showed that these northern hemisphere birds do not orient themselves by referencing the movements of particular stars or constellations, but instead by the way that all stars rotate around Polaris, the North Star (a point in the night sky that remains fixed relative to the Earth's rotation).

But when it comes to seabirds, it turns out that sense of smell as a pathfinding tool is a great deal more significant than we had supposed because, if temporarily deprived of this sense, their navigational ability is drastically impaired. Seabirds like storm petrels can smell much more than food and home as they cross the sea—they inhabit a world of myriad and complex scent trails. We can infer that their ability to detect and compare the different aromas of different zones of the sea gives them a comprehensive "smell map," which they can use to triangulate (with accuracy through time as well as in direction) routes back home whenever they need to get there, from wherever they may have wandered.

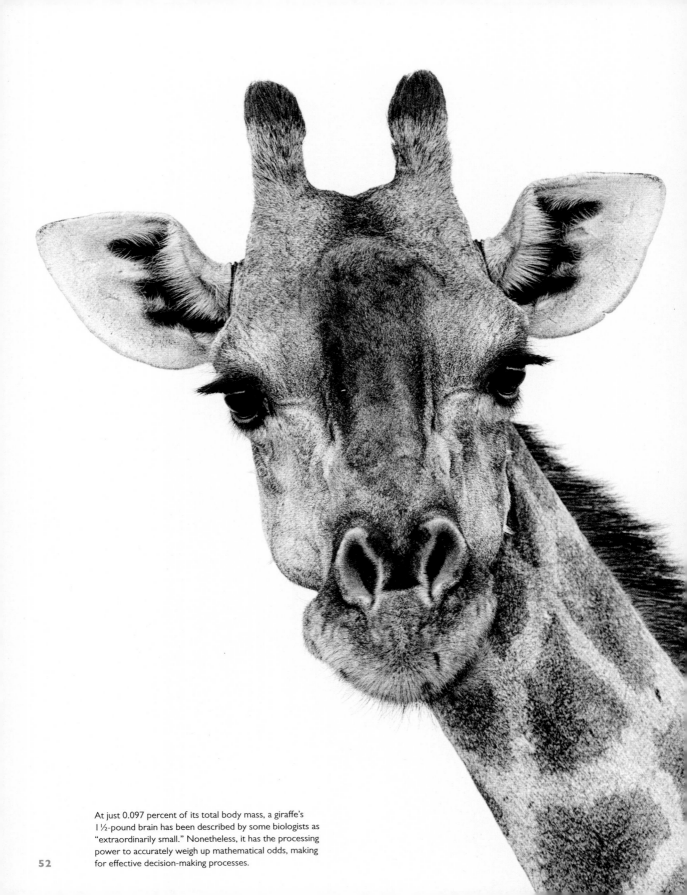

At just 0.097 percent of its total body mass, a giraffe's 1½-pound brain has been described by some biologists as "extraordinarily small." Nonetheless, it has the processing power to accurately weigh up mathematical odds, making for effective decision-making processes.

GIRAFFE GIRAFFA CAMELOPARDALIS

What are the chances?

There's no denying that the giraffe is a most improbable-looking animal. Its outlandish body proportions amazed the first Western people to see it, but the world's tallest animal has other surprises up its very long, spotted sleeve. A 2023 study revealed that it has a skill that, for many years, we believed only humans possessed—a knack for assessing mathematical probability.

This ability, statistical inference, emerges in human children when they are somewhere between one and five years old. Some primates, and also keas (a startlingly clever New Zealand parrot) have demonstrated it too, but to uncover its existence in giraffes, whose brains are proportionately rather petite, was unexpected. The study, which took place at Barcelona zoo, exploited the fact that the test subjects—two male and two female giraffes—like carrots much more than they like zucchini. The researchers began with two transparent boxes, containing carrot sticks and zucchini sticks in different proportions. A researcher took a stick from each of the two boxes, using closed fists so the giraffe could not see what had been selected, and invited the test subject to "pick a hand." In most trials, the giraffes opted for the hand which had gone into the box containing mostly carrot sticks.

This suggests that the giraffes were able to work out which box gave them a higher chance of obtaining their preferred treat. In a more difficult version, the researcher then put a barrier in both boxes, so that the giraffes could see the contents of the very top of the box only, before repeating the test. This proved more challenging, but one of the four subjects, a female called Nuru, still reliably picked the hand that had gone into the box which had more carrot sticks visible above the barrier. Control trials were used to rule out the possibility that choices were made based on other factors, such as scent, or accidental cueing by the researcher.

These results lead us to wonder why a giraffe would need to have the ability to make statistical inferences, as it goes about its natural life as a browsing herbivore. It also compels us to consider that, in our investigations into animal intelligence, we should not limit ourselves to species that we already know to be bright.

BIG BROWN BAT *EPTESICUS FUSCUS*

Navigating the sonic maze

Turn out the lights, and what do you sense? In total darkness, when we can no longer rely on our evolved primary sense, we must instead pay closer attention to the inputs reaching our brains via other senses. Every moving thing creates pressure waves through the air around it and, at a certain point, that air movement wobbles our eardrums enough to set the sensory hair cells in our inner ear in motion. Thus stimulated, they send a neuronal signal to our brain, and we interpret this data as sound. In the absolute dark, without visual data to distract us, more sound inputs make it to our conscious perception than usual, and we analyze them with more care than we might otherwise.

For a big brown bat, hearing is the dominant sense and an unlit space is its happy place. Release a few moths into the room and things get even happier for the bat. Watch under infrared light and you will see it describe a flight path of extraordinary speed and complexity as it chases down its (also extremely agile) prey, performing lightning turns, dives and backflips, skimming walls, ceilings, floor, and furniture, but never bumping into them. It finds its path and tracks its prey through sound, and it could not be clearer that, for this animal, the soundscape it perceives is every bit as richly detailed as the visual world that returns to us when we flip the light switch. However, the sounds it uses are not all just "there"—it has to actively build its sound map through making sounds of its own.

Most of the world's 1,400 or so species of bat are echolocators. This amazing ability to determine a location using reflected sound is how they plan a route, find their food, and keep themselves safe when flying about at high speed in near total darkness, often in an obstacle-filled three-dimensional space. Just as storm petrels (see page 49) are able to build and then navigate using a "scent map" of their world, so bats create a "sound map." They do this by emitting a stream of high-frequency calls, and listening to the returning echoes as the sound waves bounce back from every solid object they strike. There's much more to it even than this, though—bats must filter out irrelevant noise, adjust their map to allow for their own fast movement (compensating for the Doppler effect), and even overcome the defenses of prey that have evolved defensive tricks, making their own calls to try to jam the bats' sonar systems.

Echolocation allows bats to steer around tree trunks when necessary, but also to make a featherlight landing on them when it's time for a rest.

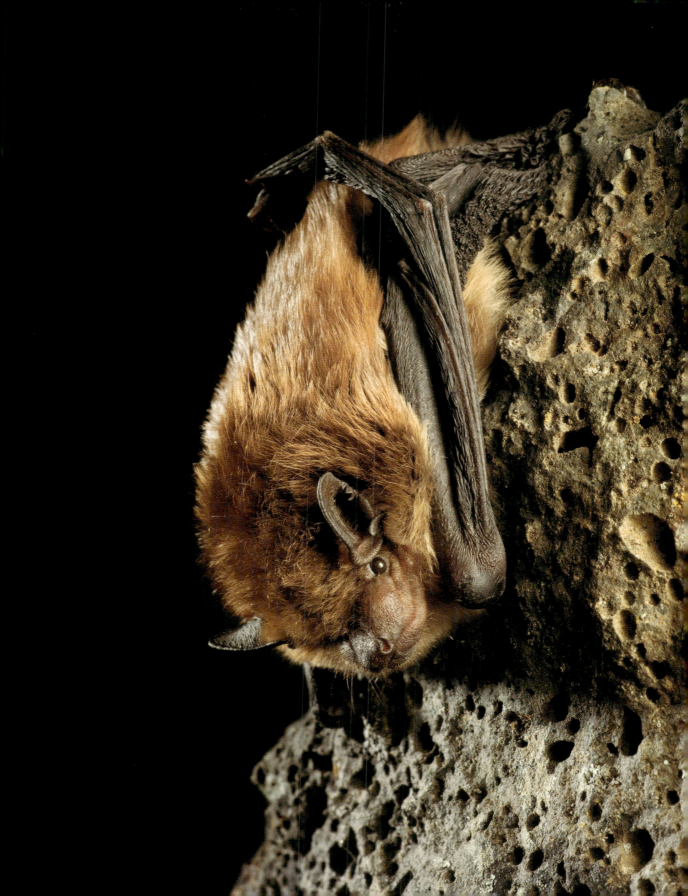

The big brown bat is a fairly standard insect-eating, echolocating bat of the large Vespertilionidae family (vesper or evening bats). It is a common species in North America. It's been the subject of much research into the minutiae of echolocation, though this is challenging—even the finest sound-gathering equipment available struggles to measure all the echoes that a single bat hears in flight, taking into account, too, the differentials between right and left ear.

We often consider most bats to be ugly, or at least quirky-looking. Their oversized ears, undersized eyes, and fleshily ornamented noses don't appeal to our sense of beauty. We might make an exception for the fruit bats, with their big eyes, modest ears and uncomplicated foxy snouts, but fruit bats are not echolocators. Their food does not fly around, so they don't need the same sensory equipment as the insectivorous bats do—sight and scent are more important to them. However, insect-hunting bats are auditory machines and their funny faces are sculpted the way they are for sound-collecting and sound-directing efficiency. Every fold of nose and ear is shaped by evolution to aim their squeaks outward to exactly where they are needed, and suck in all incoming sound with as much positional precision as possible.

Tuning in

When out and about, the big brown bat emits pulses of variable or modulated frequency (unlike some other species, which call with a constant frequency). The pauses between the pulses (interpulse intervals, or IPIs) are sometimes long and sometimes short. This flexibility comes into play when the bat is navigating its way through unfamiliar and cluttered environments, as was revealed in a study in which bats flew down corridors with widths of 40, 28, or 16 inches, with varying numbers of obstacles in the form of plastic chains hanging from the ceiling. The narrower the corridor and the more abundant the obstacles, the shorter the bats' IPIs became. This remained consistent through repeat trials, too, suggesting that the bats didn't remember (or perhaps, more accurately, didn't need to remember) the layout of the room to complete the challenge—they were able to calculate a safe flight path every time simply by using real-time analysis of the data provided by their echolocation pulses. The precision of their sound perception is extreme—they can sense a miniscule echo delay of just two millionths of a second, which corresponds to a distance of less than $\frac{1}{32}$ inch. Extraordinary—but necessary, when homing in on a fast-moving moth that may itself be just a few fractions of an inch long.

You might use a bright flashlight to make your dark surroundings visible, but you also risk dazzling yourself with it. The call of a big brown bat, exiting the animal's mouth, hits 138 decibels, which would be enough to drown out surrounding

sounds and probably be quite unpleasant for such a sensitive-eared creature. The bat deals with this by contracting its inner ear muscles as it squeaks, blocking out its own squeak for the necessary handful of milliseconds. Also akin to us using a flashlight, the bat's sound map yields the clearest detail at close range, but beyond a few yards the detail is lost. Imagine running full-tilt through a maze in darkness, navigating via the pool of light thrown by your wildly swinging torch. Also, as you run, you are trying to snatch flying baseballs out of the air. We would struggle to use our eyes with anything like the skill with which a bat uses its ears.

Big brown bats overcome the risk of a confusing stream of overlapping calls and echoes by only ever calling once they have picked up the echo from the previous call. This ability becomes truly mind-blowing when we consider how quickly a bat calls during the final phase of a chase-down. At this point, the calls come out at their fastest rate—about two hundred times per second. This is the so-called "terminal buzz" because individual sounds are now quite indistinguishable to us, and because it means probable termination for the unfortunate moth that is under attack. Every time a bat hunts a moth, its brain is carrying out a continuous stream of positional calculations and adjustments, at unfathomable speeds.

A singular voice

A bat's calls do more than allow it to navigate its world and capture its prey. With vocalization and sound perception refined to this extent, and with bats spending much of their down-time in the company of other bats, it is unsurprising that sound plays an important role in their social lives. It's been found that each big brown bat's call is unique, and that there are similarities between related individuals. Like most bats, big brown bats breed in colonies, wherein each mother has to track down her own baby. Young bats soon start to climb around so a baby may not remain exactly where its mother left it. Being familiar with each other's calls helps both mother and baby to find one another in a very busy and noisy environment. Being able to recognize the calls of other adult bats that are relatives or roost neighbors might also be of great social significance.

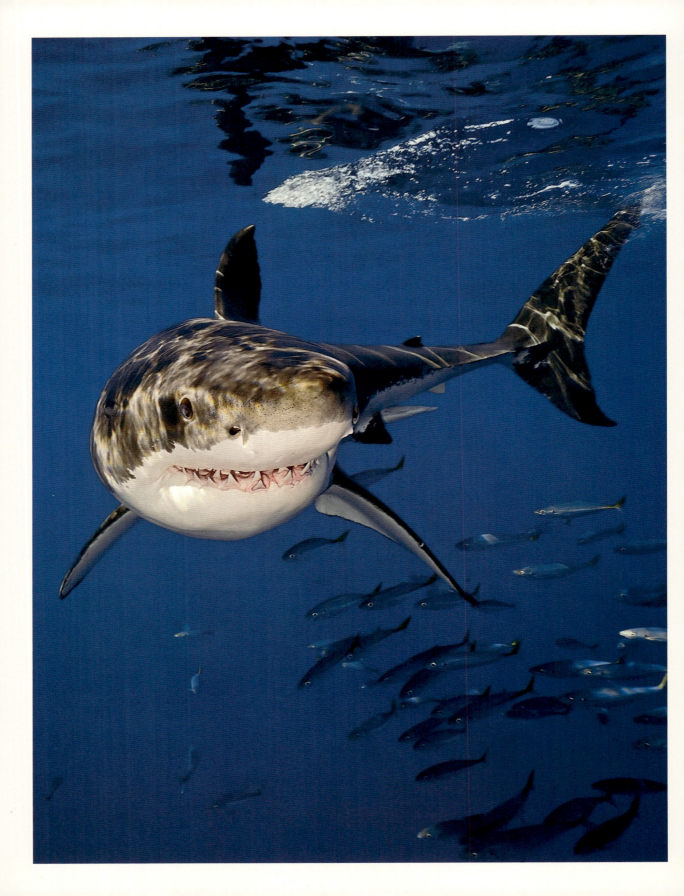

GREAT WHITE SHARK *CARCHARODON CARCHARIAS*

One drop of blood

For humans, it's one of the most feared predators on the planet, even though we're easily able to avoid ever meeting one simply by "never going into the water again," to paraphrase the tagline of the classic shark movie *Jaws*. The great white shark is one of the largest of all shark species and is the largest shark (indeed, the largest fish) that preys on big animals rather than plankton (the diet of the even bigger but much less scary whale shark and basking shark). The biggest specimens exceed 20 feet in length, and there have been more than eighty confirmed fatal attacks by great white sharks on humans. Consequently, this exceedingly impressive and intelligent animal has been much vilified. It has also long been hunted for meat and other body parts, leading to a "Vulnerable" classification from the International Union for Conservation of Nature, in 1996. Stricter conservation measures have since seen some populations start to recover and, as awareness of its plight has increased, more nuanced and sensitive representations in factual and fictional media have begun to improve its public image. Our respect and understanding for the great white is growing, and studies of its hunting behavior are revealing that it's a far cry indeed from the mindless chomper-of-everything-in-its-path featured in *Jaws*.

A shark's renowned sensitivity to the scent of blood is no myth, however—a great white can detect just one drop of blood in 22 gallons of water, though whether this will actually pique its interest depends on a host of other factors. Not surprisingly, though, smell is a key sense when hunting. These sharks are also able to pick up pulsating low-frequency sounds, are extremely sensitive to variations in water pressure (produced by moving objects), can detect miniscule electrical charges (such as those produced by the beating heart of a small fish), and have highly discerning taste buds, to determine whether or not they should swallow whatever they've just bitten. They can even sense the Earth's magnetic field, which helps them to navigate. They do, however, have poor eyesight by our standards, lacking the ability to discern colors or fine details, though their eyes are adapted to function just as well in very low light as in brighter conditions. The data sent to the shark's brain from this array of sensory gear then allows it to search efficiently for prey. In addition, great whites have evolved a variety of hunting techniques, enabling them to tackle many different prey types. These include marine mammals, and even whales, which are very intelligent in their own right.

With an arsenal of super-senses and the intelligence to pick the best hunting technique in diverse situations, the great white shark is no mindless killer.

All in the timing

The most common method of attack is a discreet approach, followed by a high-speed charge. The shark delivers an initial bite that will, ideally, incapacitate the prey, preventing it from escaping and allowing the shark time to analyze the taste in its mouth. Often, though, a shark will know exactly what it's attacking, because it will have come to a particular place at a particular time, in seach of a particular kind of prey. Although they are regarded as opportunists, and certainly take a diverse range of prey, great whites may be full-time or part-time specialists in their prey choice, and they will develop special tactics to cater for this.

One example occurs annually, from April to September, when many great whites will head for the waters of southern Africa to feed on young Cape fur seals. Six weeks after they're born, the seals enter the water for the first time, and although they make a less substantial meal, they are a much easier target than the wilier adults. The sharks swim close to the sea bed, usually well offshore, checking above as they go for pups that are alone or in small groups; larger groups are more vigilant and also perform a confusing all-directions scatter when alarmed. When it makes its attack, a shark will swim up vertically at top speed, launch itself out of the water (breaching) and land a powerful bite in what is known as a "Polaris attack." The seal is consumed rapidly, without the usual pause to taste—perhaps because the shark is certain about what it's attacking, or perhaps to prevent one of the many other sharks stealing its kill. The success rate of the most skilled individuals tops 80 percent, and they may eat a dozen or more seals in a day. Surviving seal pups become very cautious very quickly, though, modifying their behavior so that they're much less vulnerable to this kind of attack. Once their hit rate starts to drop, the sharks then move on to other hunting grounds.

A whale of a meal

Seals are smart, but whales are smarter. In recent documented encounters between great whites and whales, the whales in question have been orcas, and the sharks have not fared well. However, in 2020, scientists observed a great white shark taking on a humpback whale three times its length and considerably more than three times its weight. The lengthy encounter was filmed, and the footage revealed just how strategic and ambitious a great white can be.

This particular shark was a 13-foot adult female, known to researchers as Helen. She encountered the unfortunate whale off the coast of South Africa. The whale, swimming on the surface, was already compromised, suffering from a prior injury or illness, and it was alone. Nevertheless, Helen needed strategy and patience to tackle it. Her first move was to approach from behind and deliver

a fearsome bite to the whale's tail. This severed an artery and the whale began to bleed heavily. Helen then moved away and waited for thirty minutes, while the whale bled and became weaker. Helen then returned and began to bite her victim's head. The whale fought back with what remaining strength it had, but Helen secured a strong grip and dragged it underwater, then held it in place until it drowned.

The researcher who filmed the encounter, marine biologist Ryan Johnson, was struck by the efficiency of Helen's two-stage attack, saying, "It was as if she knew exactly how to go about it." It does indeed seem as though Helen really understood her air-breathing prey's biology, and this was all the more remarkable given the great rarity of documented great white attacks on large whales. The many secrets of this extremely charismatic and effective predator appear to include the possession of a highly strategic mind.

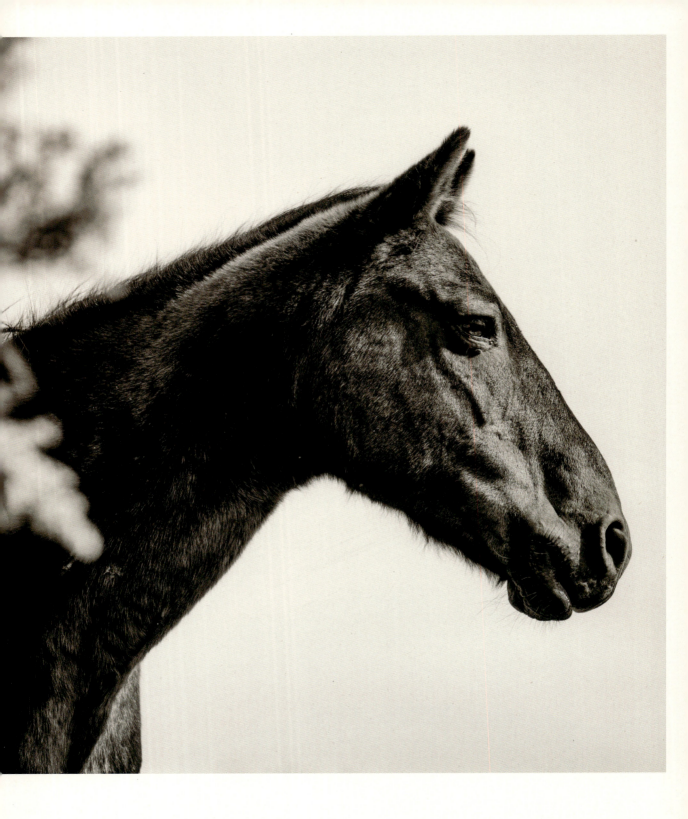

Facing the high jump: every time a show-jumping horse approaches the next obstacle, it must decide in that moment whether it can or cannot make it over the bar.

DOMESTIC HORSE *EQUUS CABALLUS*
Calculated risk

It's a beautiful synergy of human and animal. The horse, groomed to perfection, canters elegantly from one colorful obstacle to the next under the precision guidance of the rider, and performs prodigious yet effortless-looking leaps to clear the bars. But then it all goes wrong—the rider urges the horse to quicken her pace as they approach the next fence, but at the last moment the horse slams on her hoof-brakes and veers away. The rider had confidence that the horse could make the jump, but the horse herself had other ideas.

If you were fleeing from a hungry predator and suddenly encountered a fence or ditch, you might veer away just like that horse, or you might launch yourself into the best leap you can manage, and hope for the best. But let's take away the predator, and say you are just out for a leisurely run, or even a walk. Now, you will probably stop when you reach the obstacle. You'll get up close to it, maybe walk along it a bit to look for the narrowest crossing or the most solid-looking takeoff point. You'll plan your run-up—you might even measure out your steps to ensure that you'll push off from your stronger leg (even though you suspect you'd do this instinctively anyway). Or you may conclude that the jump will be too much for you, and you look for an alternative way round.

What's going on in your brain in these scenarios is a complex interplay of conscious and unconscious thought processes. You can have a guess, from the feedback you get from your body (how strong or how tired your muscles feel), at what you can and can't do. However, you will also remember how far or high you have actually managed to jump in the past. On top of this, you will be weighing up the likely consequences of trying or not trying. Failure might be painful and, if you really are being chased by a predator, failure might well be deadly … but success could mean salvation. Even in the low-risk scenario we can expect to enjoy a rush of dopamine (a neurotransmitter that's released in our brains when we experience feelings of triumph and pleasure) if we successfully execute this challenging jump.

For a show-jumping horse, every jump is a challenge, intended to push the animal close to its physical limits. The rider's task is to train the horse carefully and consistently over jumps of different sizes, giving rewards for success, over many months and years, to give it as strong a sense of certainty as possible that it can clear

every jump, and that it will be worth it. Then, on the day itself, the rider must control the horse's pace so that it approaches each jump in the optimal way, and give strong enough direction that at every fence the horse opts to jump rather than refuse. Sometimes this means that the rider will overcome the horse's better judgment and the opposite of a refusal happens—the horse jumps but doesn't make the necessary height. It hits the fence, perhaps with one foot, perhaps with all four, and incurs a fault. Of far more importance (to the horse, at least), it may also incur an injury. Usually not, as the bars or bricks at the tops of the jumps are designed to fall easily if knocked—but does the horse know this?

The horse has been domesticated for around six thousand years. Over the course of its domestication, it has developed, through selective breeding, into a range of breeds that vary in shape, size, and, crucially, temperament. For some breeds, the flighty instincts and excitability of the wild ancestor are not desirable at all and have been suppressed, but for show-jumpers and racehorses, these traits are needed (albeit in a somewhat controlled form). The horse needs to "know" that it can run fast and jump high—instincts that are the product of millions of years as a prey animal whose primary means of defense is flight.

A devoted equestrienne would no doubt take exception to the idea that her mount is only running and jumping out of fear, and she would have a point. Domestic horses and their riders generally form bonds that are obviously affectionate and trusting in nature—the horse, after all, is much more powerful than its rider. So why does the horse usually choose to obey the rider's directions and take on those risky jumps?

There are many possible reasons. The horse–rider relationship may be altered when the rider is mounted, and the horse may well respond out of fear of the person on its back. After all, some riders do strike their horses with whips, and (despite much disagreement within equestrian sports), the structure of horse skin compared to human skin suggests that a blow with the whip is not just an encouraging tickle but hurts the horse just as much as it would its rider. Or perhaps the bond between rider and horse is close enough that the horse senses the rider's urgency and responds as it would to another horse in the herd that was reacting to a threat. Horses are highly sensitive to the moods of others. If they're shown photographs of horses displaying signs associated either with a positive mood (ears pricked, nose and mouth relaxed) or with fear and defensiveness (ears pulled back, nostrils flared, jaw tense), they will approach the former but avoid the latter. They respond to human moods too. If shown photographs of angry and happy human faces, and then allowed to meet those same humans in person (but now wearing neutral expressions), they will avoid the people they previously saw looking angry.

A third possibility is that a horse, just like a human, experiences a dopamine thrill when it clears a high jump. Studies show that horses have the same link between dopamine release and a sense of excitement that we do, so perhaps they jump to attain that mental state—for joy and for fun, in other words, perhaps even outweighing any extra reward that the rider might provide. It makes sense from an evolutionary perspective that, for an animal that's routinely hunted by predators, behaviors associated with successful escape should deliver a feel-good brain response. When horses and especially foals play, this is what they practice—running hard, turning fast, and, of course, jumping. All the while that they are horsing around like this, they maintain their balance so that they stay upright, ready at all times to make a serious run for it should that predator appear. As with other mammals, the unconscious motor skills they develop are coordinated by activity in the cerebellum (a large structure that looks like a miniature cerebrum, but is part of the hindbrain). This structure is proportionately sizable in horses, and is larger than that of a human brain, even though the horse brain as a whole weighs only about 1 pound 5 ounces (less than half the weight of a human brain).

A split-second decision

We can see that, all in all, the horse approaching the jump might have a lot on her mind, in a manner of speaking. Does she share the rider's belief that she can clear the jump? Does her body feel fully fit and healthy, and does the ground underfoot feel firm enough for the strong push off she needs? Does she fear that the rider could hurt her? Does she know that she's jumped over an obstacle of comparable size before? Has she been steered into the right pace and stride length for a successful takeoff, or is there time for a last micro-second adjustment? Does she have a sense that she's being pursued or is otherwise in danger? Does she anticipate the rewards (psychological as well as material) of success, or fear the pain of hitting the obstacle?

The ultimate decision to jump or refuse is presumably the product of some, if not all, of these calculations, and the fact that it all takes place unconsciously and at lightning speed in a brain so much smaller than our own is quite mindboggling. This is the machinery of the mind in impressive action—we see it in all fast-moving animals, but the additional factors involved when the animal is a horse under (partial) control of a human rider take our wonderment to another level, and help us to understand why the bond between *Homo sapiens* and *Equus caballus* is so enduring and so profound.

AUSTRALIAN EMPEROR DRAGONFLY *HEMIANAX PAPUENSIS*
A trick of the flight

The insect world is like a microcosm of any wider animal ecosystem. Or perhaps it's really a macrocosm, given that insects outnumber and out-diversify all other animal groups. Within a natural insect community there are the herbivores, the small predators, and the top six-legged hunters which happily devour all the rest. These alpha predators include mantids, tiger beetles, and, of course, the dazzling dragonflies.

When an Australian emperor dragonfly emerges as a winged adult, it's around 2½ inches long. It has huge, wraparound eyes and two pairs of long, narrow wings. It can fly backward, hover, and hit 30 miles per hour, all while executing pinpoint-precise flips and turns. Adapted to take down prey in midair, it's highly active and curious. When it brakes mid-zoom and hovers close to you, it's difficult to escape the impression that you're being assessed.

Dragonflies have exceptional vision and are very alert to any movement. If you want to get close enough to photograph a resting dragonfly, try raising your camera while standing well back, and then shuffle closer, very slowly. In this way, you don't appear to move so much as gradually grow larger. This is called "motion camouflage," and it's a technique that the dragonflies themselves use—only much more skillfully, and under much more challenging conditions.

A study on Australian emperors carried out by Akiko Mizutani and colleagues at the Australian National University revealed that these insects use motion camouflage to get close to target insects (prey or rival dragonflies). By tracking dragonflies' flight paths, the researchers found that as the dragonflies approached, they maintained their position relative to the target such that they appeared not to be moving at all, just looming larger—even though, to our eyes, both insects would appear to be flying rapidly in quite unpredictable patterns. If we were to try to program a calculating machine to do this, the number and rate of calculations would be dizzying. Yet a dragonfly brain can do it. This brain may be tiny but it's highly specialized, and was recently found to contain "small-target motion detection" neurons that enable highly sophisticated tracking of small flying things. The experience of seeing through those eyes and perceiving with that incredible brain is very hard for us to imagine—but who would not want to experience a day as a dragonfly?

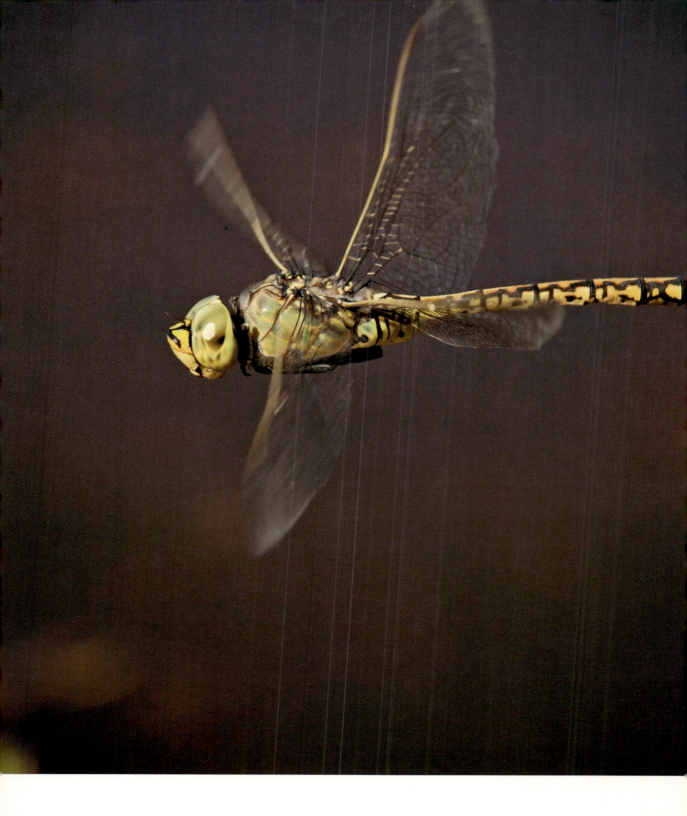

A looming presence: large dragonflies like the Australian emperor play tricks on their prey's visual perception, to get close without appearing to move.

67

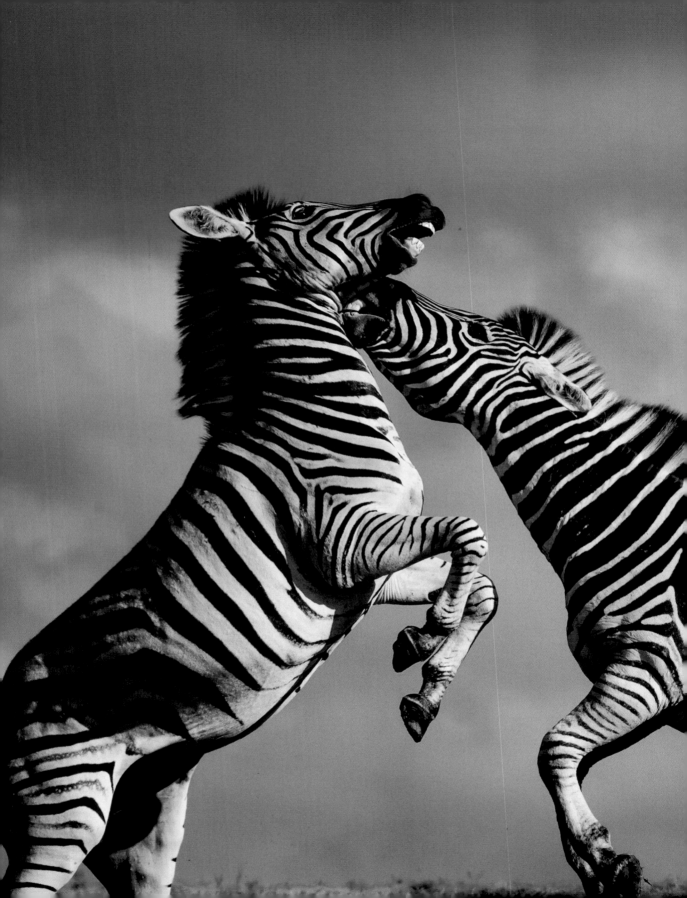

3

COMMUNICATION
Sing, Dance, Jump-Yip

COMMUNICATION SING, DANCE, JUMP-YIP

Sitting down to write can be challenging at times, especially on days when the pings and buzzes of notifications from a phone and computer demand almost constant attention. Yet switching off those notifications can be difficult too, because they feed one of our most fundamental needs—the need to communicate. Humans are highly social, like most of our primate cousins. However, our use of effective and elaborate communication is most definitely not a contender for something that "separates us from the animals."

There are many reasons why one animal may want or need to communicate with another, and many, many different ways to do it. Baby songbirds, unable to feed themselves, will beg when a parent comes to the nest with food, but the parent only carries food for one chick at a time, and often holds it in each chick's mouth in turn, only releasing it to the one that responds most desperately. Hungry baby grebes, as well as squealing incessantly, flush a brighter red on the bare patches on their heads. Mother bats arriving at the nursery colony call to their waiting babies and the babies call back. Animals wanting to mate send signals to the opposite sex using vocalization, visual display, and scent markings—and all of these communications may also serve as deterrents to others of the same sex. Male mammals may determine the receptivity of females by tasting their urine. Physical touch might be a friendly message, or a warning. Some warning signals are intended not to drive others away but to alert them to a universal threat—and such "alarm calls" are often understood by other species too.

Even the most solitary animals often have a variety of communication signals (albeit many of them carrying the same message—"Go away!"). However, it's in the highly social species that we see communication skills evolved to their most sophisticated degree. Animals that live in groups or breed in colonies need to be able to get along, and in closer social groups they need to cooperate as well, on a regular basis. Misunderstandings, disagreements, and full-on fights are best avoided,

most of the time—they use up precious energy and divert attention from more survival-focused activities. So, signals that will help resolve conflicts are important. It's also important that, if something threatens the whole group, an appropriate warning is given quickly and understood universally.

When animals are on the move together, communication is vital, so sometimes messages that can travel over distances are required. And if engaging in a team activity, such as cooperative hunting, every individual needs to know its role and be able to communicate its intentions to the others. In courtship rituals, the volume and diversity of information that the pair exchange may be considerable. A peacock shaking his tail coverts at a potentially interested peahen is exhibiting the quality of his genes and his state of health. He will chase her to prove that he is a strong runner, but also to see if she is fit too. When a male and female great crested grebe perform their complicated, beautifully synchronized courtship dance, they demonstrate fitness, health, the ability to work as a team, and more. The "weed dance" element, when both birds dive to gather underwater weeds that they then wave at one another in a rearing-up, chest-to-chest display, is a ritualized enactment of parenting behavior—catching "food" underwater and bringing it to the "chick."

In the most tightly knit community types, wherein all members are related to each other, build a shared home, and stay together for life, communication is complex, constant, and operates on multiple levels. Group members check in with each other frequently, monitor each other's biological processes, and pass on detailed messages that are elaborate enough to be compared to human languages. In the case of eusocial animals, where numerous "workers" spend their lives servicing the needs of the colony and its leader, communication reaches perhaps its highest and certainly its most supernatural-seeming expression.

BLUE WHALE *BALAENOPTERA MUSCULUS*

Deep water, deep sound

The sight of a blue whale breaking the surface, sending up its tall, steamy cloud of breath, and showing a vast length of graceful rolling back before vanishing again, stirs our senses to an enormous degree. Enormous is the word—at 70 feet it is the biggest animal that ever lived on our planet. Through overhunting, we almost managed to wipe them out entirely, but since full protection was given to them in 1966, blue whales have been slowly recovering (although they remain threatened by marine pollution, climate change, and other hazards).

These whales are not especially social, rarely being seen in groups except in exceptionally rich feeding conditions. They remember productive areas where krill is abundant, and revisit them at the right time of year.

Infrasound is a category of low-frequency sound waves, defined as being below the auditory range for a human ear (about 20 hertz), though we may be able to feel the buzzing it generates on our eardrums. Many animals, though, appear to be able to hear much lower frequencies than us. They can not only hear infrasound, but they also use it as a means of communication.

Blue whales are enthusiastic "singers," and the extremely loud sound and infrasound they generate (mainly in the 8–25-hertz range, but including phrases at higher frequencies) is optimized to be carried through water. The songs are very long and elaborate, and show structural variation between different subpopulations. The function of these songs is not known for certain, but both sexes produce them while feeding, as do males when competing for the attention of females. Average frequencies have been falling since the cessation of hunting, too, suggesting improved survival among the biggest (and deepest-voiced) whales.

It is possible for a blue whale to hear the song of another from 1,000 miles away or more. This could point to meaningful communication on a global scale. A sound wave takes half a minute to travel 25 miles underwater, meaning that echolocation for these great whales is a very different experience to that of a hunting bat. The paths taken by migrating (and constantly singing) mature blue whales show great efficiency in three dimensions as they steer the quickest course between towering undersea mountains—echolocation is used to draw the maps, but it is apparent that experience and memory refines them, over a life span of 90 years or more.

The hugest of animals, the blue whale also has the hugest of voices, its song sending unmistakable pressure waves through one thousand or more miles of deep ocean.

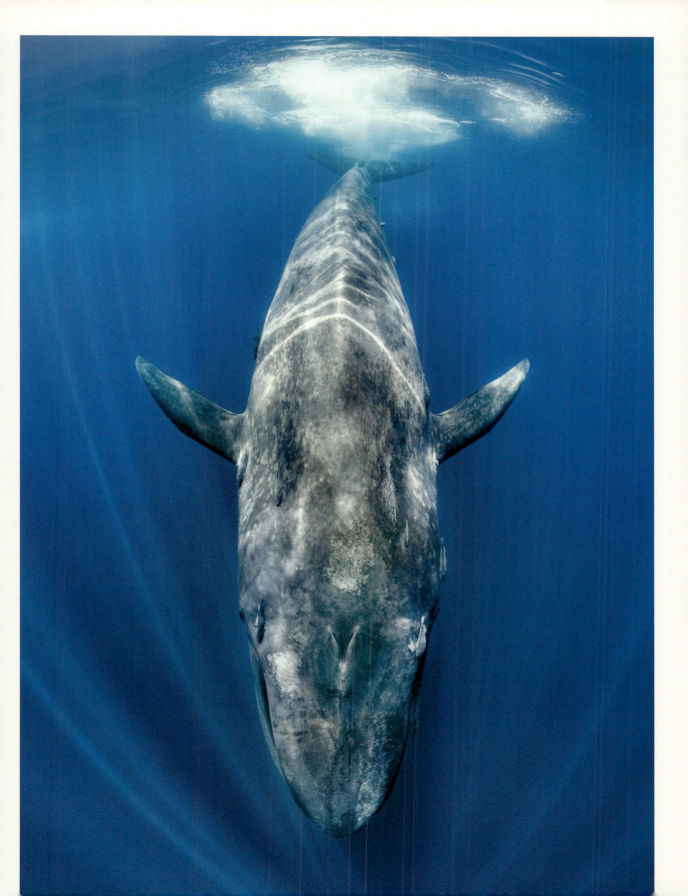

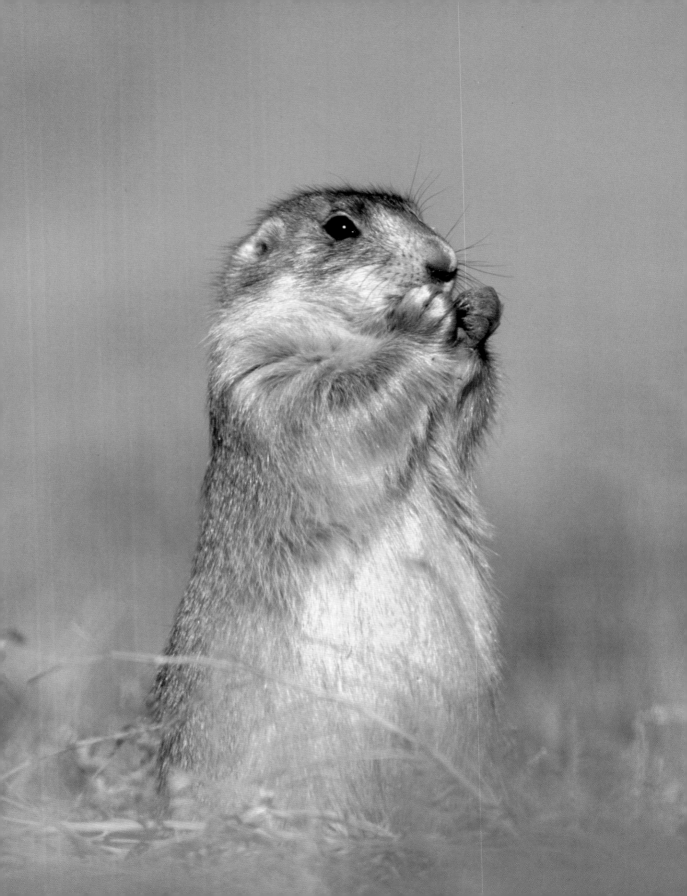

BLACK-TAILED PRAIRIE DOG *CYNOMIS LEUCURUS*

Know thine enemy

First things first—prairie dogs are not dogs. Why they have been named such is because of their slightly yappy calls, but really these are squeaks rather than barks. In fact they are squirrels, of the ground-dwelling rather than tree-climbing ilk. Ground squirrels tend to be bigger, chunkier, shorter of tail and smaller of ear than tree squirrels, they usually live in burrows that they dig themselves, and they are also generally quite sociable.

All prairie dog species are native to North America. The best-known is the widespread black-tailed prairie dog, found across a broad swathe of the central US states and just reaching into southern Canada and northern Mexico, but there are another four species found on the continent. An adult prairie dog weighs about 2 pounds, males being a little heftier than females, and is about 16 inches long. Like other squirrels it often stands up on its hind legs to have a good look around because it has a very large number of different predators and at any moment may need to take some kind of evasive action to avoid being grabbed by a fox, hawk, snake, or something else.

Prairie dogs create large "towns" of tunnels in their grassland habitats. The biggest can hold thousands of individuals, but this is not a free-for-all—within the towns, there are distinct subgroups. Within these there is further subdivision, with the basic social unit being a male and up to three adult females, along with a few youngsters that are not yet of breeding age. This group or "coterie" fiercely defends its own set of burrows against encroachment from neighboring coteries. However, the entire town reacts when any one individual has something to say that might affect them all.

The alarm call is a great example of a communication type that is regularly shared between different bird species. Any birder knows that when she is out in the woods and hears a racket of loud, chattering alarm calls from several different songbird species all at once, it's worth tracking them down because the chances are good that they have found an owl at its roost. That first agitated chack-chack-chack call attracts the attention of other nearby songbirds and they rush to the scene, adding their own voices. The various species' calls are all surprisingly similar (even though other sounds they make, such as song and contact calls, are very different), reflecting the universal nature of this

Town crier: if an enemy should appear, this vigilant prairie dog will be ready to issue a detailed description of it to all others within earshot.

emergency. The owl is not actually very dangerous right now, but will be later on when it wakes up, just as the songbirds go to roost, so if they can gang up on it now, shout at it, and force it to fly away, they will all be a bit safer when night falls. They might do the same if they discover a cat or other mammalian ambush hunter, which they know they can avoid (as long as they keep their eyes on it) simply because they can fly and it cannot.

Just as many songbirds have a similar-sounding angry alarm call for this kind of hazard, they have another for dangers that are much more immediate—say, if they spot a hawk drifting overhead, which could at any moment launch an attack. To call loudly now would be to risk one's life, so they give a soft, high-pitched, thin call—a seeee or peeeep perhaps, that's difficult to pin down to a location. But again, these types of calls are similar across different species, and are universally understood. The response though, is different—find cover if you are not in it already, and stay still, wait for the danger to pass.

Varying the alarm call depending on the nature of the threat is a very smart move. For a prairie dog, the best thing to do on hearing a signal that means "hawk overhead" is to dash to the burrows without a backward glance. But if the warning is "I've spotted a snake," diving into a burrow could be deadly—better to stand up, look around and figure out where the snake is before running away from it overground. So it is not really surprising that when we analyze the alarmed squeaks and yelps of prairie dogs, which all sound similar to us, we find that they produce subtly but consistently different sounds, which carry different meanings and provoke different reactions. What is surprising to us is just how much variety and detail the calls seem to capture. This brings the prairie dog's array of sounds and movements into the realms of what might be regarded as a language.

Adjective, noun, verb

The biologist Con Slobodchikoff, working in Arizona, has studied the vocalizations of wild prairie dogs for several decades. With his ears well tuned into the distinctions between the calls when they detected danger of various kinds, he realized that the prairie dogs differentiated between different dangerous animals, even to the point of having different calls for "dog" and "coyote"—the latter triggering a much more hasty and fearful response than the former. But that was just the start—he also realized that the calls also differed consistently between different individuals of the same species. This led him to wonder whether the calls actually carried more detailed descriptive information.

Things were now getting beyond the discriminatory abilities of the human ear, so Con and his team of researchers got some computer software onto the task, to

minutely examine the sonic properties of the calls. They also got to work designing a study wherein they showed their prairie dog colony a series of humans and domestic dogs, one at a time. The dogs were of varied appearance (a husky, a golden retriever, a spaniel, and a dalmatian), and the humans were all dressed in different colors. The results blew the researchers away. The distinctiveness of the calls given in response to the test "stimuli" seemed to demonstrate that the prairie dogs were capturing an elaborate description of each one, including information about its size, shape, and color, all in a squeaked note less than a tenth of a second long. There was even information held in the rate of the squeaks, with a rapid volley of squeaks given for a fast-moving person, and a reduced delivery rate for one who was strolling slowly.

Why would it matter to the prairie dogs what size an approaching dog is, or what color shirt a passing human happens to be wearing? A possible answer to this comes when we look at the hunting tactics of coyotes. They don't all do the same thing when they enter a prairie-dog town with a view to hunting. Some might dash after the first prairie dog they see, while others might lie down quietly near an outlying burrow and wait. Given that different individuals of at least some predator types might be dangerous in different ways, it seems that learning to recognise and describe particular individuals could be a good idea for the prairie dogs. On hearing the squeak that means "large ginger-toned coyote running fast," a prairie dog that has previously had a near-miss with a coyote that matches that description might modify its response and run to its burrow a bit faster than it would have done otherwise.

All for one and one for all

Delightfully, black-tailed prairie dogs also share a distinctive signal that is very much communal but not associated with a particular alarm situation. This is a squeal that is accompanied by standing up suddenly, throwing back the head and extending the front legs forward. Called the "jump-yip," it is as contagious as a stadium wave, and appears to be a sort of spot-check of group vigilance. If one of your fellow prairie dogs jump-yips in your vicinity, you should immediately do the same, to show that you are ever-alert to the behavior of your companions.

Plenty of biologists and linguists say that the prairie-dog system of communication falls a long way short of true language, but really this just highlights the fact that we don't have a cast-iron definition of what language actually is. Con Slobodchikoff's view is that elaborate and highly language-like communication in the animal world is in fact much more common than we realize, and we will uncover more and more examples if we just listen more, and get more creative in our methods of decoding their various signals.

COMMON ZEBRA *EQUUS QUAGGA*
Sensory perception

All too often presented simply as pleasingly patterned lion-food, zebras are part of the furniture in wildlife documentaries set in the sub-Saharan savanna. However, there's much more to zebra life than their victim status and smart outfits.

Zebras live in mixed-sex groups. Once a month, a mare enters estrus (when they can become pregnant). This lasts five to ten days, but she only wants to mate on two or three of those days. In the case of the plains zebra, the main social unit is a highly stable group comprising one stallion and several mares (plus those females' young offspring, most likely fathered by the incumbent stallion). Mares are usually loyal to their stallions long-term, and stallions defend their mares from other males as best they can. "Spare" males—mostly younger individuals—form bachelor herds and keep busy practicing their fighting skills against each other while waiting to begin their own harem, usually by enticing a young mare away from her natal herd. Both group types move around seasonally as food availability dictates, sometimes coalescing into very large herds.

Grevy's zebra has a different setup. In this species, there are no harems or stable groups. Mature stallions defend a territory, and mares wander around as they wish, visiting different males' territories. To make his territory more appealing, a stallion will even dig out his own waterholes. Hopefully, his home patch will attract enough mares, and keep them around long enough, that there'll be plenty of mating opportunities.

In both species, one of a stallion's most important tasks is figuring out when any given female is ready to mate. This means being constantly aware of the estrus status of multiple mares, and prioritizing his efforts toward those that are about to become receptive to him. A female shows her willingness through behavioral signals, but he can also smell when estrus begins. Now he stays close to her, and may make repeated (and repeatedly rebuffed) mating attempts, but he must also collate the information his nose gives him about the other mares in his orbit and redirect his attention accordingly—all while remaining ready to fight off other stallions. The most successful plains zebra stallion can retain a maximum of about eight females long-term. Grevy's mares, though, wander between territories and mate with multiple males no matter what the stallions do, so a Grevy's stallion must deploy quick and accurate nose-math to win maximum mating opportunities.

Throughout his life, a zebra stallion needs to keep an eye, and a nose, on all the mares in his vicinity, and decide where to direct his energy.

SUPERB LYREBIRD *MENURA NOVAEHOLLANDIAE*

An impressive collection

Is it a bird? Is it a chain saw? Or could it perhaps be a cell phone, a screaming infant, or an impatient driver sounding their horn? You were right the first time—it is a bird, but no ordinary bird. The Australian superb lyrebird is so named because of the male's very fancy, long tail feathers, which he fans out and shakes about in his dancing courtship display. However, for all his visual beauty, his voice, and in particular his skills of mimicry, are even more superb.

A male lyrebird seeks to attract multiple females into his territory, and builds a sort of arena comprising a series of earth mounds, from which he sings to passing females while performing his tail-fanning display. The dance steps he uses are coordinated with the song he produces, of which about 20 to 25 percent is "lyrebird sounds" and the rest is mimicry—of other birds' songs as well as assorted other noises. Females are solo parents, but also use song (including mimicry) to defend their nests and feeding areas from intruders. The imitations are incredibly skilled to our ears, and even the mimicked bird species sometimes respond as they would to the real thing. This is especially impressive given that young lyrebirds learn most of their repertoire from other lyrebirds, rather than original sources.

The phenomenon whereby evolution is guided by one of the sexes' preferences for certain traits when choosing its mates (traits that often don't seem to provide any direct survival benefit) is known as sexual selection. It's responsible for a range of marvelous oddities in nature, such as the male peafowl's colorful (if inconvenient) train of feathers, and the comical semaphore dances of some jumping spiders—and the superb lyrebird's song.

The female lyrebird is not holding out for the male to make the one particular sound in his performance that is her favorite—it's the quality and quantity of every element that matters, not what the elements actually are. The song needs to be an "honest signal" of the male's quality, and it can only be honest if he incurs a cost in amassing and performing his repertoire. To learn as many different sounds as possible, and replicate them as well as possible, takes up time and energy that the lyrebird could be spending on self-care. So if he can perfectly perform an epic collection of sounds while still looking impressive, he is telling the female truthfully that he has terrific genes, and that his offspring (carrying his genes in combination with hers) would be equally successful, strong, and superb.

The song of a male superb lyrebird is a culture-clashing tour de force, including carefully curated samples of every kind of sound he has encountered.

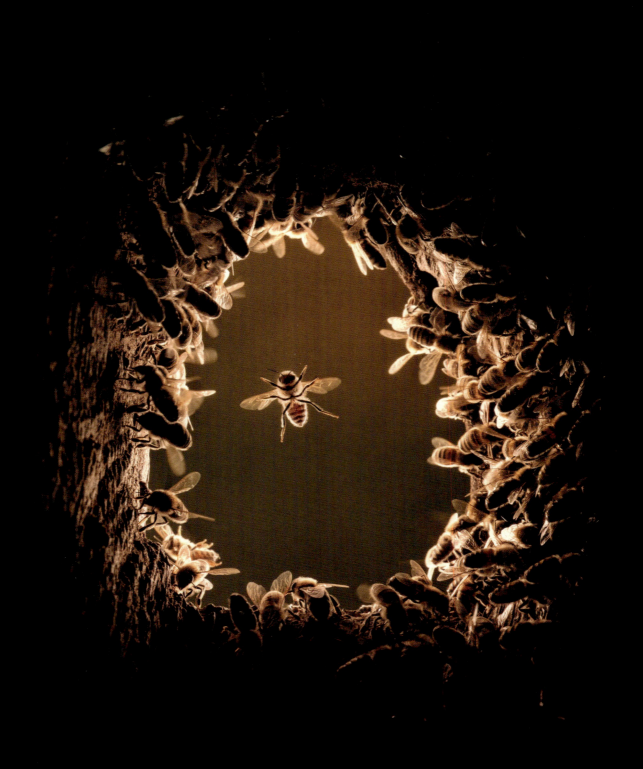

WESTERN HONEYBEE *APIS MELLIFERA*

The dance of deliciousness

In the late Mesozoic era, when the world was still home to dinosaurs, pterosaurs, and various other iconic prehistoric creatures, the first angiosperms, or flowering plants, evolved. The pollen they produced—which, when carried on the wind from one flower to another, enabled fertilization—was packed with protein and proved a valuable food for various insects, including other members of the lineage that include ants, wasps, and bees. Moving between flowers, these insects transferred some pollen from one to another on their bodies, and so began one of the most vital and colorful coevolutionary adventures our planet has ever seen.

Honeybees have evolved a eusocial way of life, whereby one individual (the queen) remains in a large nest and lays eggs, while numerous nonbreeding female workers go out and about collecting pollen and nectar—their bodies are adapted to carry both in large quantities. They eat a little as they go, and whatever they bring back to the nest is used to feed the at-home contingent. This comprises the queen, all of the larvae until they pupate, any young drones or male bees, and the young worker bees, who don't go out to forage straightaway but stay in the nest for several days first, taking care of the eggs, larvae, and pupae.

A honeybee hive functions much like a single, large organism. It's therefore no surprise that the individual bees are great communicators, engaging in nonstop signaling to one another through chemical, auditory, and visual cues. Watch for a while and you'll see that the workers are in constant contact with each other. They touch antennae, groom one another, and coordinate various activities. Soon, with luck, you'll also see the most famous form of honeybee communication.

When a worker finds a new feeding area, she returns to the hive to tell her sisters the news, and she does so through interpretive dance. The steps of her "waggle dance" follow a figure-eight pattern—its orientation and length tell them exactly how far away the spot is and in which direction, while the vigor of her wiggling abdomen indicates how excited she is about what she's found. The dance may also be used to convey information about water sources or possible new nest sites. As she dances, she releases attention-grabbing pheromones, along with the scent of the nectar she's found, which is thought to help other workers find it by following its scent trail in the air. She may feed some of the nectar to her nearby sisters to prove its quality. The other bees can even sense the electrical field she generates, which

A worker honeybee heading home to her sisters, perhaps with a delicious story to tell and an all-new dance to perform.

83

could provide additional information about her find. It is known that pollen sticks to bees because it carries a negative electrical charge, while bees' bodies carry a positive charge, and bees can sense variations in flowers' electrical fields, which may carry information such as when the flower's nectaries were last drained by a visiting bee.

Any number of workers may be waggle-dancing across the honeycombs at the same time, so the other bees must decide whose dance is the most compelling. They will also be looking out for bees performing a simpler variant, the circle dance, which is used for nectar sources closer to the hive. A less well-known set of moves is the tremble dance. Here, the newly returned worker makes short, direct runs, and in between stands still and jiggles her body from side to side. Its purpose is to tell the other workers that help is needed to unload nectar from her and other returning workers, so they may need to drop their current task. Workers also perform a grooming dance when they need some cleanup help from their sisters.

A mighty monarchy?

Humans first began to keep honeybees in Africa and Eurasia more than seven thousand years ago, though they were no doubt harvesting wild honey for many thousands of years before that. These bees like to nest inside crevices (especially cavities in tree trunks), so it was easy enough to build a well-ventilated facsimile that would do as well. Over time, these evolved into modern hives that are structured to help the bees to build their wax combs more efficiently. Perhaps those first beekeepers simply built their hives and hoped bees would colonize them, but at some point in the history of beekeeping, humans realized that managing a bee colony is much simpler once you identify and isolate the queen.

In natural conditions, in a good summer the workers in a hive will feed a batch of around twenty larvae on royal jelly, meaning they develop as fertile queens rather than sterile workers. While these queens-to-be are pupating, the original queen and half of her workers leave the hive and seek a new nest site, in a process known as swarming. Back at the old nest, the new queens emerge and engage in a battle royal. The sole survivor (usually the first-born, as she can sting the others to death while they are still struggling out of their pupal cases) flies out to mate with drones from another hive, taking on a store of sperm that she will use to fertilize her eggs for the rest of her life. She then returns to the nest to begin her reproductive career, while the workers continue theirs—at first as cleaners and larva-carers, and in the second half of their six-week active life span as foragers.

Loyalty by chemistry

The whole setup may remind us of our own working lives—giving our time and energy to the big boss, in exchange for food and lodgings (just without the intermediary step of exchange of money). Worker honeybees, though, never demand a nectar-rise, or leave to become freelancers to the highest bidder. In fact, we are looking at things somewhat askew. Far from being the leader of the hive, the queen is at the mercy of her workers. They absolutely need a queen, to lay eggs and so keep the hive "alive," but it is their choice whether that particular queen lives or dies. It is the workers who make the royal jelly that has the power to turn any young larva from worker to princess. If their queen is underperforming (perhaps she is injured, getting too old, or just not laying eggs fast enough), the workers will dispatch her and create a new queen.

A healthy and productive queen doesn't need to worry about being bumped off by her workers. As long as she keeps up her end of the bargain, they will take excellent care of her. However, things would be very different without a certain something called "queen substance." This chemical compound, otherwise known as oxodecenoic acid, is produced in a healthy queen's mandibular glands. For us it has no smell, but for honeybees it is a powerful pheromone. When the new queen flies out to mate, it attracts drones to her, and back in the hive it has an effect on the developing workers—suppressing the development of their own female reproductive organs, and preventing them from rearing other larvae as queens. The nonstop mutual grooming and food-sharing between the bees ensures that the royal pheromone is always being spread through the colony. If its production ceases, the news spreads just as quickly, and the workers unite to depose their ruler.

As long as the queen keeps releasing enough queen substance, she keeps her place, and new worker bees are constantly produced to replace those that die. Drones (which develop from unfertilized eggs) are produced when the time is right, and fly out to find new virgin queens from other hives, and when the hive gets too busy, the bees swarm and a second colony is formed. The queen's natural life span is about four years, over which time she could lay one million eggs. Without voices, and only one million brain cells (compared to our one hundred billion), honeybees nevertheless "talk" to one another in detail, and their ability to do so enables them to live in a vast social system of impressive complexity and efficiency.

SPERM WHALE *PHYSETER MACROCEPHALUS*

What are you saying?

The biggest-brained animal on Earth, the sperm whale is a creature of superlatives. It's also a true wanderer—there are certain oceanic zones where you're more likely to meet it, but it knows no geographical limits.

Its most striking feature—that double-decker bus of a head—contains the equipment that makes it such an extraordinary vocalizer. The clicking sounds it makes for echolocation are sent backward into its head, to be amplified via huge fat-filled cavities before emerging at a deafening 236 decibels, and with a much narrower focus than the "wide-beam" sonar clicks of some of its smaller relatives. This extremely specialized and far-reaching sonar system may help it avoid colliding with the sea bed when diving fast and deep in pursuit of its favorite prey—giant and colossal squid.

Female sperm whales and their babies live in close-knit pods, containing between six and (more unusually up to) twenty individuals. They hunt cooperatively at times, herding prey to improve the success of their attacks. Their spare time, however, is primarily dedicated to social activity. This involves swimming in close contact, and conversing with long sequences of clicking calls known as codas.

Matriarchal sperm whale groups don't mingle, and it's very rare for any individual to leave her group. This implies a strong group identity, which is borne out through sonic analysis of their codas. Different groups effectively speak in different dialects. Interestingly, the distinctiveness is most marked between groups that live closest together and are most likely to encounter one another.

Although group ties are close, when the group members are all actively foraging and diving deep (routinely to 6,500 feet, and sometimes almost to 10,000) they put a fair bit of distance between themselves. When they're away from their group, it's much more likely that they'll hear other whales before they see them, so calling and listening to calls is the best way to quickly reunite (important when dangers, including those posed by orcas, are around). They are not hostile toward whales speaking the "wrong" dialect—they simply ignore them, just as we might tune out a language we don't understand. The coda dialects are passed down from mother to daughter and are likely to stay in a family for centuries (given that sperm whales can live into their seventies).

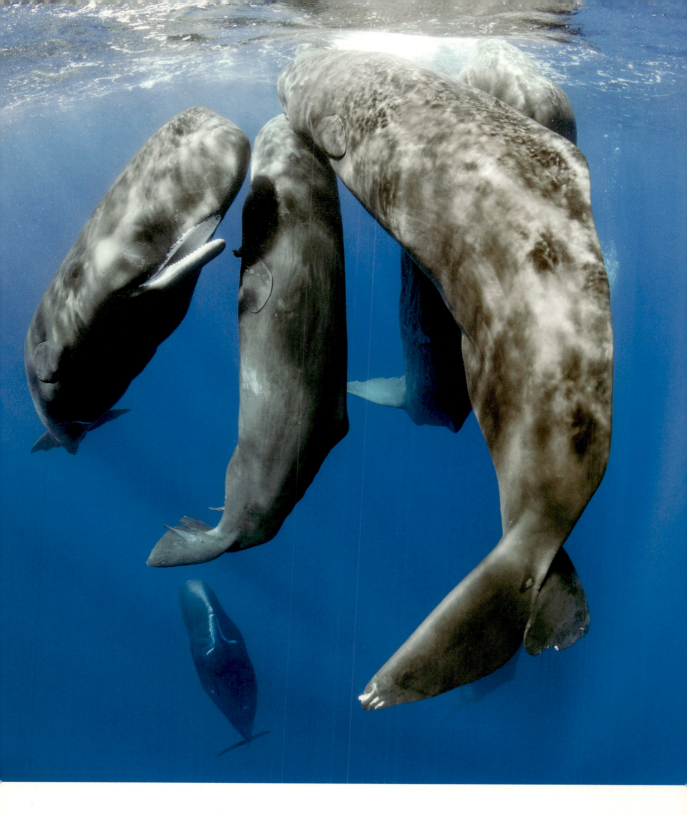

A sperm whale sisterhood maintains its close ties through exchanging codas—phrases of sound that carry special meaning for them, but which no other family would understand.

87

DOMESTIC DOG CANIS FAMILIARIS

A two-way conversation

Your canine best friend might have a curly coat, a flat snout, or droopy, dribbly jowls. He could be a slender athlete who's one of the fastest things on four legs, or he may have the physique of an ambulatory sausage. He might be the size of a rabbit or a pony—you get the picture, domestic dogs come in a dizzying array of different forms, thanks to selective breeding for a range of preferred traits, over many generations. But keep tracing those generations backward and every dog's family tree gets to the same point eventually—great great (and many more greats) grandparents who were wolves.

Wolves are apex predators and keystone species within their ecosystem, through their ability to regulate the fitness of large grazing mammal populations, and the distribution of smaller "mesopredators" too. The natural presence of wolves in a habitat promotes the well-being of everything from plants to the biggest plant-eaters and other carnivores, and their removal can cause serious ecological harm. They are also highly social and highly cooperative, making them a perfect species for humans to domesticate—harnessing all that power and intelligence in a loyal and biddable form has made many aspects of human life easier and better over the centuries.

People first domesticated wolves about twenty-three thousand years ago. Fast-forward to the present time and there are about nine hundred million domestic dogs on Earth, between them representing more than 330 distinct breeds (plus any number of crossbred combinations). Some breeds have been developed to guard and some to fight, some are sight-hunters and others are scent-trackers. Some round up sheep and some catch rats, and some are bred simply for beauty or a sweet and loving natures. They are all less brainy than their wild-living ancestors—a common consequence of the domestication process. A dog with the same body size as a wild wolf has a brain about 10 percent smaller. Nevertheless, that brain remains an impressive piece of equipment, perhaps most of all in terms of its capacity to enable all dogs to form deep and complex bonds of understanding with a human, or humans, in their life.

Every dog owner knows that their pet can learn to distinguish spoken words, and associate behaviors with those words. Sit, stay, lie down, high-five—all simple voice commands easily taught to an attentive dog, with the help of a motivational snack

Millennia of bonding with humans has influenced the evolution of dogs' facial musculature. Raise an eyebrow at a dog, and it is now able to raise one back at you.

89

to reward the correct action. That same dog also quickly picks up what certain other words mean without any special training. "Let's go to the park," sends him hurrying to the front door, but he knows that "Back soon" means his human is going out and he's not invited, so those words send him grumping off to the sofa for a snooze. Working dogs develop these skills to a high degree of precision—through words and other sound commands alone a shepherd can guide his border collie to steer a flock of sheep through a veritable obstacle course to an end goal.

But can dogs learn to use human language themselves? Christina Hunger, who works with children with speech delays in Chicago, makes use of a machine that plays recordings of pre-recorded words. The children press the buttons to choose which words the device should say, in order to express their thoughts and wishes. Realizing that this handy gadget could give her an insight into the workings of a nonhuman mind too, she decided to try to train her young mixed-breed dog, Stella, to use the machine too.

Stella picked up the idea quickly, and was soon using the machine in ways Christina had not anticipated. Saying "eat" followed by "no" meant that she had not yet had her supper, but on another occasion she was watching Christina watering the houseplants and used the machine to say "water," apparently simply as an observation because her water dish was full. Most amazing of all was the day when she repeatedly used the machine to ask to play outside ("Want," "Play," "Outside"), but when Christina did not comply (because she was on the phone), an increasingly upset Stella instead made the machine say "Love you" and "No." This study provided a glimpse inside the canine mind that illuminated not only the communicative ability of the animal but also her emotional range (including, but not limited to, the experience of petulance!)

Other dog (and cat) owners are now involved in this field of research. Dogs trained to use similar devices learn the names of their favorite canine playmates, and ask their owners if they may go to a particular park to play with a particular friend. If someone in the household is away for a while, the dog asks after them. If one household pet is under the weather, another will express their worries to the owner about it. These findings recall what was beautifully shown in the movie *Up*, in which the human characters meet a golden retriever named Dug, who is fitted with a device that allows him to speak his mind in pre-recorded English words. The male human voice Dug uses is mature and refined in tone, but the things he says are extremely doggy in nature—"I have just met you, and I love you," "Oh boy, a ball," and "SQUIRREL!"

Face-reading

For most dogs, smell is a major sense and eyesight of less importance. However, domestic dogs are assiduous watchers of human faces, and are very skilled at making sense of the expressions they see. Smile at your dog and he will probably respond with a wagging tail and perhaps some other signs of enjoyment, while directing a frown his way triggers a worried response, such as lip-licking. Dogs are not alone among domestic animals in understanding certain human expressions (we saw in the previous chapter how horses do it too), but they certainly do it the best, and this is down to the effort they put in rather than any innate predisposition. They do not have the same "face-sensitive" brain hardware that humans do, and their brain activity is the same when shown an image of the back of a human head as when they see a face—human brains are much more sparked by faces. Dogs are also keen observers of human body language, which is very helpful for us when it comes to training them in how to conduct themselves in social settings.

They are also no slouches themselves when it comes to face-pulling, and many of the expressions they use when looking at us are not ones that you will ever see on a wild wolf—these are communication tools that dogs have developed just for dog–human interaction. It goes even deeper than that—the actual facial anatomy of dogs includes changes to musculature and the appearance of two new muscles that enable a strong eyebrow raise that a wolf could not achieve. The resultant expression resembles a human face looking sad, and appears to be used by dogs to gaze at their owners when they want some care or attention. They will use a gaze like this if, for example, they are given a puzzle to solve and don't manage to figure it out on their own and need to appeal to a human for help.

Eye contact between dog and owner also builds the depth of their bond, because when they gaze at one another, both of the species involved experience a surge in the hormone oxytocin. This hormone, generated in a brain structure called the hypothalamus and let loose in the bloodstream via the pituitary gland, does a range of useful things to various body tissues, including causing uterine contractions when a female mammal is giving birth. It is also released when we cuddle people we love (though also when we feel betrayed or jealous). It is strongly associated with feelings of closeness and trust and it plays a key role in building emotional bonds.

Dogs may not be hardwired to especially like or seek out human faces, but the twenty-three thousand years of coevolution between humans and domestic dogs have created a very special, complex system of communication between the two, and it is the dog who has put in the most work in adapting and learning how to talk to and how to understand these strange bipedal apes who have diverted his evolutionary history so completely. A very good friend, indeed.

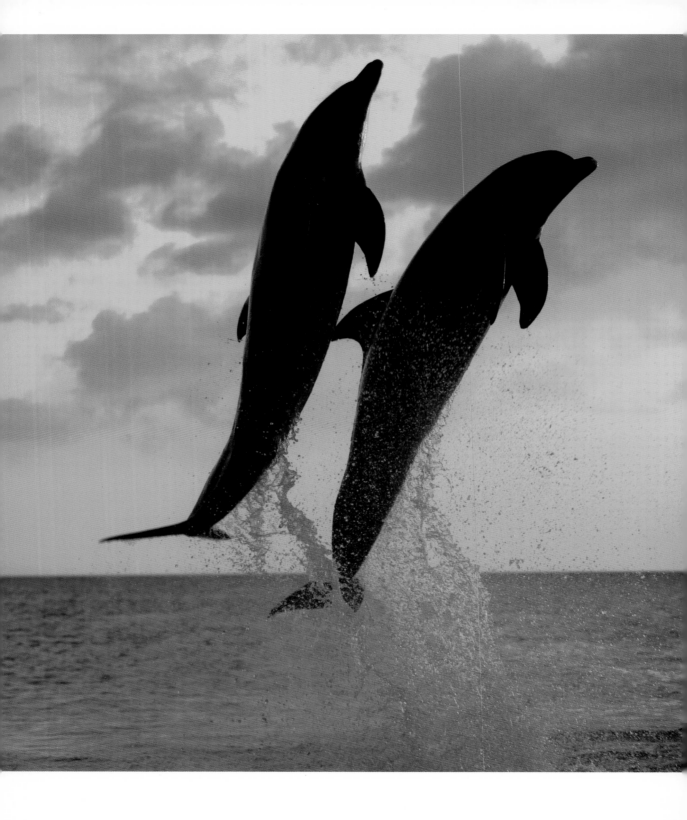

Bottlenose dolphins seem to be able to swap ideas in instant and invisible ways, to conjure up an improvised, synchronized performance at the drop of a hat (or fish).

COMMON BOTTLENOSE DOLPHIN *TURSIOPS TRUNCATUS*

Tantamount to telepathy?

Who doesn't love those musical-theater moments when two characters, who've only just met, break into spontaneous song (or dance, or both) in flawless harmony? We know that months of rehearsals lie behind the performance, but the illusion is compelling. Could we ever find such instant, cooperative rapport with a random dance partner in real life? Maybe we could. After all, bottlenose dolphins can.

Two captive male bottlenose dolphins were trained to perform a wide range of actions in response to specific cues from their trainer. They were then trained individually to perform a sequence of behaviors in response to the command "different." This meant that the dolphins could choose actions from their repertoires without a cue, but that each action, whether it was a particular jump, somersault, or fin wave, could not be repeated. As a pair, the dolphins were also taught the command "tandem," whereby an action cued by the trainer needed to be performed by both dolphins simultaneously to earn a fishy reward.

Next, the researchers combined the two commands, asking the dolphins to perform "tandem different" actions. Now, not only did the pair have to think of a string of different things to do, but they had to perform each of them at the same time. They rose to the challenge with ease. The trainers then threw in another level of complexity, teaching them a further command—"create." For this, each dolphin was taught that to earn the reward, it needed to come up with a new action of its own. Once they had learned "create," the dolphins were teamed up again, and asked to "tandem create." After apparently "conferring" for a moment, the two dove underwater, then surged up and jumped together, while simultaneously spitting out a mouthful of water—not a natural action for a dolphin!

We have yet to understand how they communicated and agreed what to do so quickly, and perhaps we never shall—this ability may simply be beyond the capabilities of the human brain. You can well imagine that the marine mammal's bigger, bulkier, more furrowed and fissured bit of thinking kit could give its owner advanced thought-powers that we lack. For centuries we've tried and failed to find compelling evidence that telepathy could exist, but maybe we've just been looking at the wrong species.

AFRICAN GRAY PARROT *PSITTACUS ERITHACUS*

More than words

Talking parrots have long been celebrated in real life and in fiction. Yet they were also traditionally regarded as being incapable of understanding what they were saying—the very term "parroting" means to mindlessly repeat things without knowing their meaning. Parrots, though, are clearly clever birds, with problem-solving skills, so why not language skills too?

Irene Pepperberg, an American animal psychologist and latterly conservationist, was interested in animal language-learning, especially in birds. Alex, purchased as a youngster from a pet store in 1976, became her primary test subject at various universities, and was soon overturning expectations left, right, and center.

Alex was taught some 150 words—their meaning as well as their sound. He observed two trainers interacting conversationally, one of them serving as instructor and delivering prompts and questions, such as "What color?" when showing an object to the other trainer. The second trainer demonstrated the desired responses, motivating Alex to follow the modeled behavior to gain attention from the instructor. Once Alex's learning had progressed, he was able to spot and correct deliberate mistakes made by the model.

Pepperberg reported that Alex demonstrated an understanding of colors, quantities, and comparative concepts ("same," "different," "bigger," "smaller," and so on). He also combined words to describe objects new to him—he dubbed his first apple a "banerry," which Pepperberg considered to be the result of it being as big as a banana, but with the color of a cherry. Alex comprehended that four notes played on a piano was the same quantity as four physical objects. He also learned to express his wishes, for example saying "Want to go" when he wanted to be moved, and "Want to go back" when he wanted to relax in his cage.

Sadly, Alex died at thirty-one—according to Pepperberg, some way short of his full cognitive potential. His spiritual successor, the African gray N'kisi, who belongs to American artist and researcher Aimee Morgana, can use nearly one thousand words, and on meeting the primatologist Jane Goodall, asked, "Got a chimp?"—perhaps the first known joke ever told by a bird.

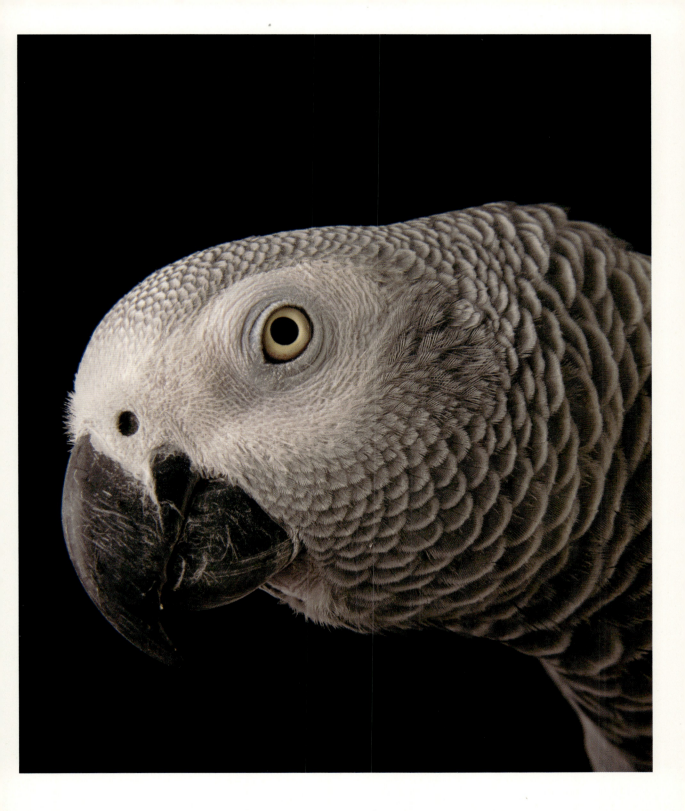

African gray parrots are known as talkers, but in the case of Alex it was quite clear that he was also a listener, and a thinker.

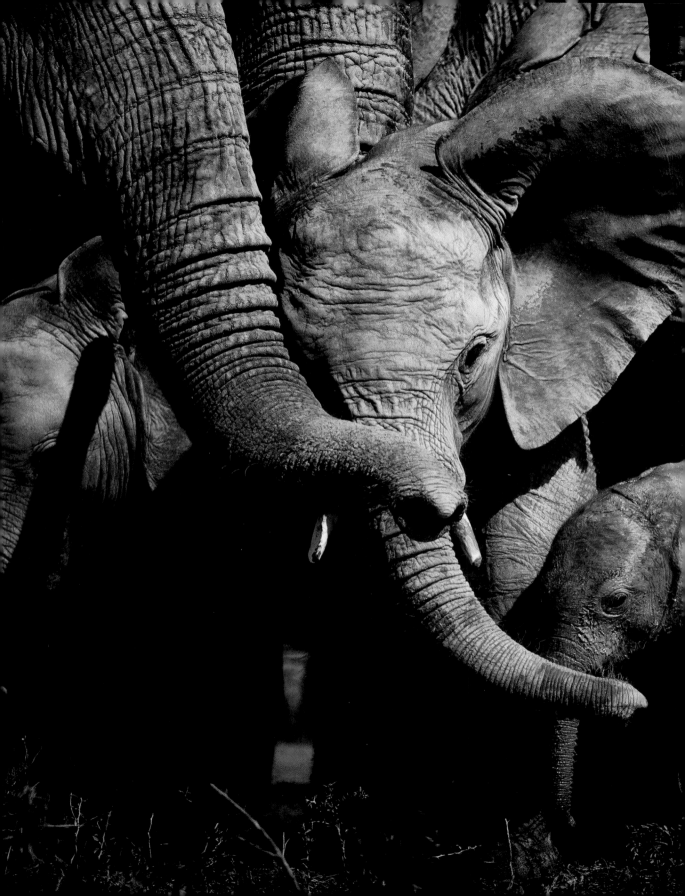

4

BONDING
Better Together

BONDING BETTER TOGETHER

However much we value independence and self-reliance, most of us would agree that healthy family and social bonds make our lives easier and more joyful. We can readily observe animals forming meaningful connections with others of their species too, and these associations can be incredibly valuable and enduring. Bonding with others, however, does sometimes require us, and our fellow animals, to put aside our own immediate wants and needs, and invest time in getting to know all the ways in which they are different from us.

Baby mammals of all species feed on their mothers' milk—an intimate process that requires long-term cooperation and coordination between mother and infant. Siblings are competitors for food and attention, but can also be playmates, helping each other to develop physical and social skills. For some species, such as lions and cheetahs, playing together as littermates evolves into hunting and battling rivals together in adulthood. In the case of same-sex siblings, this closeness and cooperation can not only last a lifetime, but also enable them to thrive far more than singletons. A male cheetah who is lucky enough to grow up with two or more brothers has much better odds of living a long life, being well fed, and fathering plenty of cubs than another who only has sisters.

Nearly all birds incubate their eggs with their own body heat, and must then feed and protect their chicks for weeks or months. In the majority of species, these tasks fall on both mother and father. In some cases, though, others are involved, too. Southern ground hornbills only produce one chick every two years, but a young adult hornbill cannot successfully raise its own chick until it has at least six years of prior experience as a "helper" at the nest of another, older pair. In all, some eight percent of bird species will form cooperative groups when they breed. Not all of them have to breed cooperatively, but they generally have more success when they do. These bonds may be maintained after

breeding, members of the group continuing to support each other through everyday foraging, roosting and predator-avoiding behavior.

Some mammals have similarly cooperative lifestyles, for example, some species of mongoose, including the much-loved meerkat. Everyone in the group plays its part, not only in childcare but in finding food and defending against predators. Some meerkat "helpers" will never have the opportunity to reproduce, and in some other species, helpers may not even be related to the babies that they help to raise. Apparent harmony may also mask power struggles and bullying; much more so in some species than others. However, the depth of the bonds between at least some of the individuals in these social groups is beyond question.

Many species are at their most social when not breeding. Living and moving around as a group has lots of obvious benefits for a range of birds, mammals, and others—more eyes to spot danger and opportunity, more chances to meet potential breeding partners, and of course, reduced odds of being the unlucky one who falls victim to a predator. But if we track the individuals in a group, we find that there's much more to it than safety in numbers. Even in species where constant fission–fusion group dynamics hold sway—where the size and composition of the group will fluctuate, separating (fission) or merging (fusion) in response to its environment or activities—small subgroups will often stick together no matter what, despite moving freely between larger gatherings. These individuals seek each other out, choose to spend time together, and may also demonstrate caregiving behavior toward one another. These associations may last for years, and are often not based on breeding or familial associations, or any other obvious relationship. No matter how clinical, objective, and non-anthropomorphic a lens we view them through, it's difficult not to characterize these connections as friendships.

ARMY ANT ECITON BURCHELLII
An effective collective

If you go into the Central American rainforests today, make sure you don't get in the way of armies on maneuvers. *Eciton burchellii* is probably the best known of all army ants, and it is the scourge of the other insects that share its habitat. When out on a hunting raid, its thousands of workers do not stay in a narrow column like most army ants, but spread out, fanlike, to cover a 50-foot wide area of forest floor, leaving scent trails for others to follow. If one individual encounters prey, its fellow workers quickly come to the scene to help execute the kill and butcher the prey. Its elaborately structured and organized society, founded around four distinct worker body-types, makes it a predator of frightening efficiency.

The queens mate with multiple males, and it is the father's genes (as well as environmental factors such as diet) that determine which worker caste an ant will be. The four types, differentiated by size and ferocity, are minimas (or minors), medias, soldiers, and porters. Soldiers are defenders and porters are carriers of larvae, pupae, and prey (or chunks of prey), while minimas and medias are generalists. One of their tasks is to choose the sites for the colony's overnight nests—these ants spend much time on the move and can camp out at any suitable location. The temporary nests they make ("bivouacs") are formed by the ants' living bodies, linked together by the claws on their legs to form a sort of sturdy mesh. Inside this, the queen shelters, along with all ants that are still in the immature stages. At dawn, the bivouac disassembles and the ants set off for their day of hunting.

It's precisely because they are such incredibly efficient hunters that the ants must remain mobile. They can strip an area of practically all other insects (that are not able to escape through flight) in short order, forcing them to move on to find more food. They also attract their own retinue—flying predatory insects and antbirds that try to snag prey disturbed by the ants, and butterflies that feed on the droppings of the antbirds. Under rigid genetic and chemical control, these army ants may not have much freedom, but they enjoy safety and plentiful food through their membership of an exceptionally effective society.

Ants of the genus *Eciton* live in an extraordinarily advanced society, to the point of creating homes and transport networks from their own bodies.

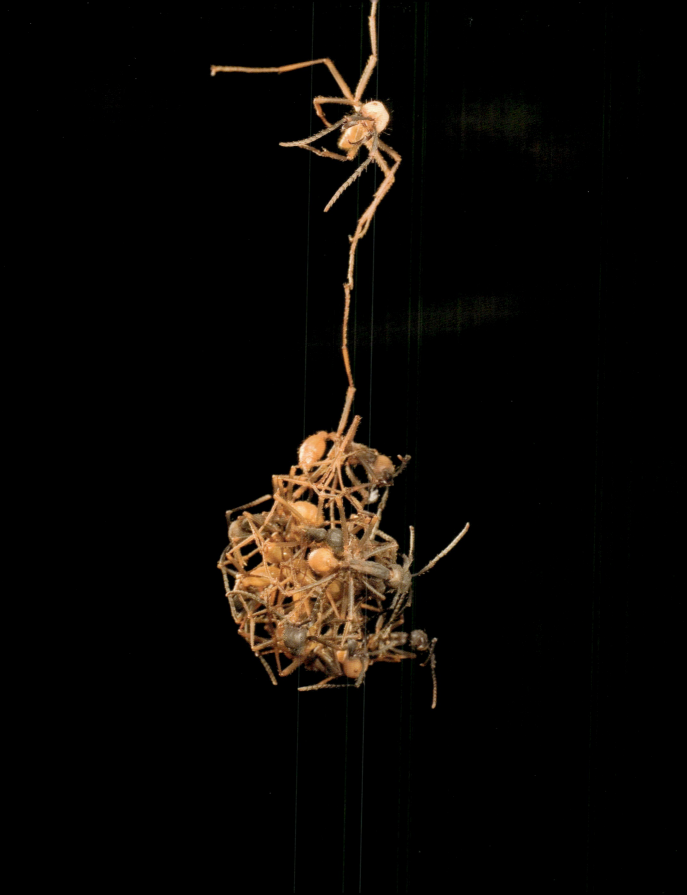

When it comes to winning the hunt, African wild dogs are on top of their game and streets ahead of the competition.

AFRICAN WILD DOG *LYCAON PICTUS*

Paragons of efficiency

From the miniscule meerkat to the mighty lion, via cheetahs, spotted hyenas, and bat-eared foxes, several disparate species of predatory mammals in southern and eastern Africa's savanna have found that life and hunting are better done as a team. Wolves, the dog world's answer to lions, do not occur in sub-Saharan Africa, and the "true dogs" as a group are not very well represented in this part of the world, but one species is perhaps the most successful group-living and group-hunting predator on the continent.

African wild dogs are incredibly striking animals, and you can admire their elegant silhouettes, Mickey Mouse ears, fluffy white-tipped tails, and tortoiseshell coats on many a nature documentary (sadly, encounters with the real thing are hard to come by, given their great rarity today). When the footage switches from family life to a hunting sequence, though, the sensitive should look away. Lacking the throat-crushing bite of a lion, a hunting pack of about ten adults (sometimes many more) often begin to tear up and consume their victim while it's still alive. We shouldn't denounce this behavior—it's simply the natural product of evolutionary process; for the dogs, the prey animal is food.

An African wild dog looks like a big animal but it has a much lighter build than a wolf, weighing only 44 to 55 pounds on average, compared to 88 pounds for a typical wolf. Despite this lightweight frame, these dogs can hunt zebras that weigh more than 440 pounds, though their preferred prey are mid-range antelopes, such as Thompson's gazelles, kudus, and impalas. Wild dogs will also take on much smaller prey, including African hares, various rodents, lizards, and birds such as guineafowl, but they are less likely than other large carnivores to feed on carrion.

As is typical for the true dogs, they possess exceptional endurance and can sustain a chase over many miles. A decent-sized and well-practiced pack will make a kill up to 80 percent of the time—a far higher hit rate than other savanna predators such as lions (about 30 percent) or cheetahs (around 26 percent). A wild dog on its own, though, will only bring down its prey some 15 percent of the time. Not surprisingly, lone dogs are almost never seen, while a fair few lions and many cheetahs live and hunt alone for sustained periods.

The energetics involved in these hunts also make for impressive reading. The dogs switch places in the chase when they tire, allowing rested members to lead the way. They don't go all out in a single chase but pursue for a short way, sometimes just for a few seconds, to assess the potential prey's fitness, before deciding whether it's worth continuing. Compare this to a cheetah, which sprints itself to near total exhaustion for no reward in 74 percent of its hunts. It also takes on a much higher risk of serious injury at this speed. When it does make a kill, it gets back an average of twenty-two times the energy that went into the chase, but a wild dog in its pack regains more than seventy times its invested energy per kill. Even when prey is scarce and the risk of losing a kill to marauding spotted hyenas is high, a pack will typically bring in a sizable surfeit of meat—six dogs consistently catch enough to feed as many as sixteen. (When African wild dogs were much more widespread than they are today, many populations lived in more wooded habitats, so were more likely to take a cheetah-like approach, with short, fast chases predominating over long-distance endurance pursuits. They also suffered much less harassment from other large carnivores, such as lions and spotted hyenas.)

Is sociality the key to success?

African wild dogs have an unusually egalitarian society. The pack does have a dominant pair, who stay together for life and are usually the only animals to breed, but other pack members do as much parenting as the breeding pair. All members of the pack will guard the pups, play with them, and feed them (by regurgitating meat) after a successful hunt. The dominant pair are typically not related to each other but their pack comprises their siblings and cousins, and their grown-up offspring.

The closeness of the pack is evident in their behavior toward each other. When reunited they show complex greeting rituals, and when traveling or hunting they maintain contact through a large repertoire of vocalizations. These include a huffing "sneeze" call that's usually initiated by the dominant animals and spreads, like a stadium wave, through the pack. It serves as a rallying call, signaling that it's time to move on. Other members then join in, and once enough of them have produced the call, the pack will head off to hunt or rest elsewhere; if too few animals respond, the call will not result in movement.

Complex cooperation is also evident during the hunt. If the pack corners a single but powerful individual, such as a kudu bull, with his large spiraled horns, they will attack simultaneously from several directions. If they want to separate an individual from a herd, most of the pack concentrates on heading off the herd, leaving just one or two dogs to pursue the target. When tracking prey through a habitat with dense foliage, the dogs will split up, each one finding a different

line, increasing the odds of one of them finding a shortcut. They are also ready to change tactics if conditions dictate, and will separate to kill more than one prey animal in a single chase if the opportunity presents itself. Cooperation continues once the kill is made, as the dogs work together to defend their kill from scavengers, though this often fails.

The level of social intelligence shown by these dogs is evident in every interaction, and their lives seem much more stable and closely entwined even than other wild dogs, such as wolves. It's therefore natural to compare them to their cat counterparts, the lions, as both are savanna-dwellers that appear to have developed their highly social ways in response to the particular challenges of hunting in this environment. However, some biologists argue that sociality in lions is not primarily down to the way they hunt, but rather their habitat, which imposes the need to defend their territory against other lions. Hunting success for lions doesn't vary greatly between groups and solo hunters.

Wild dogs, on the other hand, are increasingly thought of not as savanna specialists, but, in fact, better adapted to thrive in more mixed habitats, where their adaptable, cooperative hunting skills really shine. For them, high sociality really is key to hunting success, as well as everything else that they do. Sadly, this species has suffered centuries of extreme, deliberate persecution, with most animals today living in well-protected national parks in savanna landscapes, but if granted a bit more tolerance, it might thrive again in more marginal habitats, unbothered by lions, hyenas, or humans.

AUSTRALIAN MAGPIE *GYMNORHINA TIBICEN*
Rescue mission

If you're not a native of Australia, you may not be aware of the terrible (as in terrifying) reputation of this smart (in every sense) bird. Aussie magpies look a little like the magpies of Europe and North America, but they are not corvids. They are noisy, curious, sometimes destructive, and often charming. However, during the breeding season they fiercely dive-bomb humans near their nests, attacking with pointy bills and sharp claws.

These magpies are frequent garden visitors, entertaining householders by playing imaginatively with washing lines, garden ornaments, and each other. This playtime, often involving lots of rolling around upside-down and grappling, gets pretty rough. However, a recent study in suburban Queensland suggested that these birds really do have each other's backs when it counts.

The researchers who carried out the study were interested in the daily movements of the birds, so fitted five individuals with GPS trackers. These are incorporated into a backpack-style harness that fits snugly to the body, with the tracker on the bird's back so the sun can charge its solar battery. The $\frac{1}{25}$-ounce device is designed not to impede normal movement and behavior, though of course it's still an unnatural encumbrance and many birds initially try to remove it. However, the design makes this impossible. Eventually its strings degrade and it falls off, to be (hopefully) recovered and used again.

The participants in this study, though, were never successfully tracked, because they took the harnesses off each other (the non-harnessed birds in the group joined in too). Like friends unzipping each other's party dresses because they can't reach their own, they used their claws and bills to free one another from the devices. As sometimes happens in scientific research, the team had uncovered something quite different—and arguably more interesting—than what they'd set out to study.

Perhaps the birds were driven by curiosity and playfulness rather than an urge to help. However, a very convincing "rescue behavior" in birds has been documented before. Seychelles Warblers sometimes get the sticky seeds of Pisonia trees stuck on their feathers while foraging. This can impede their flight, but these gregarious birds will pluck the (inedible, to them) seeds off each other, despite the risk to themselves.

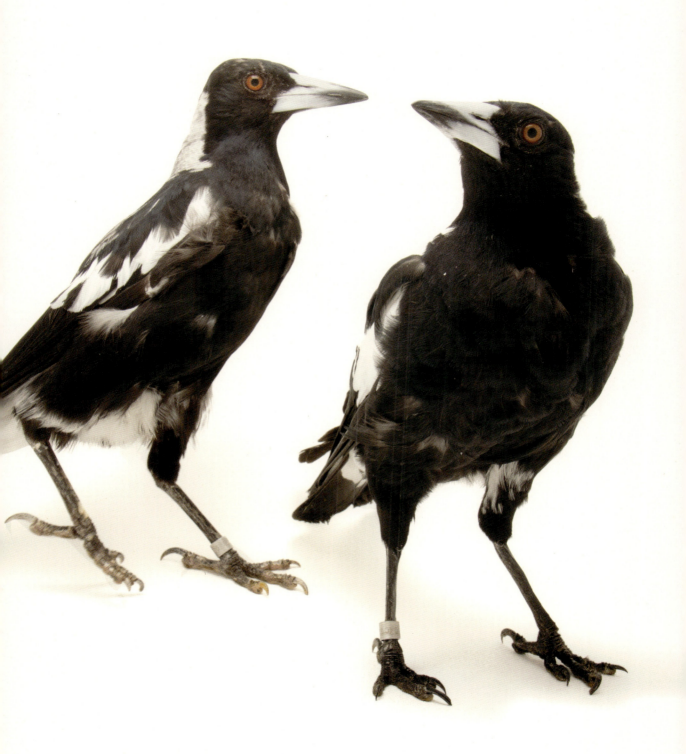

They are regarded as menaces by some Australian people, but Australian magpies may show true loyalty toward their partners in crime.

107

LION *PANTHERA LEO*
Sibling strength

We may commonly refer to the lion as the "king of the jungle," but a better epithet might be "queen of the savanna." These animals prefer open country, and are most commonly associated with expansive, tree-dotted grasslands where antelopes, Cape buffaloes, and zebras graze. It's also the females who do the lion's share of the hunting. The mighty males shirk the work, but stroll in after the event to claim the best bits of the kill (though perhaps that's exactly the behavior we might expect of a king, at least one from earlier, less enlightened times).

The lion, native to Africa and a small part of India, is one of some forty species of cats found across the world (together comprising the family Felidae), and one of just five true "big cats"—members of the genus *Panthera*. Unlike its fellow big cats (the tiger, leopard, jaguar, and snow leopard), the lion is a highly social species, and the only one in which the sexes are very obviously different in appearance (sexual dimorphism). Males are markedly bigger (averaging 440 pounds, compared to 330 pounds for females) and grow thick manes, which help protect their heads and necks during fights with other males. Strong sexual dimorphism in a group-living species tends to point toward very different social roles and life histories for males and females, and in the lion this difference goes deep beneath the skin.

A pride of lions may hold thirty or more individuals, though the average is just thirteen. About half of these are fully grown females and most of the rest are their dependent cubs. Female cubs are likely to stay with their mother's pride for life, as long as the hunting remains good. When food is scarce, prides tend to be smaller and young females may be booted out, as it's better for a struggling pride to hold on to its more mature, proven hunters. Young males, however, invariably have to leave, and they suffer a high mortality rate—hunting alone as best they can, and competing with other males for the chance to join another pride. One or more adult males associate with a pride, but they face regular challenges from other males and their reign will often last only a couple of years before they are deposed.

If a male lion cub's littermates include a brother, he'll have a great advantage in life. When they leave their natal pride, the boys will stick together, so they'll not only hunt more successfully than lone males, they'll also be capable of deposing a resident singleton male and capturing his pride. If this happens, they will have a genetic investment in all of the cubs that the lionesses produce after their

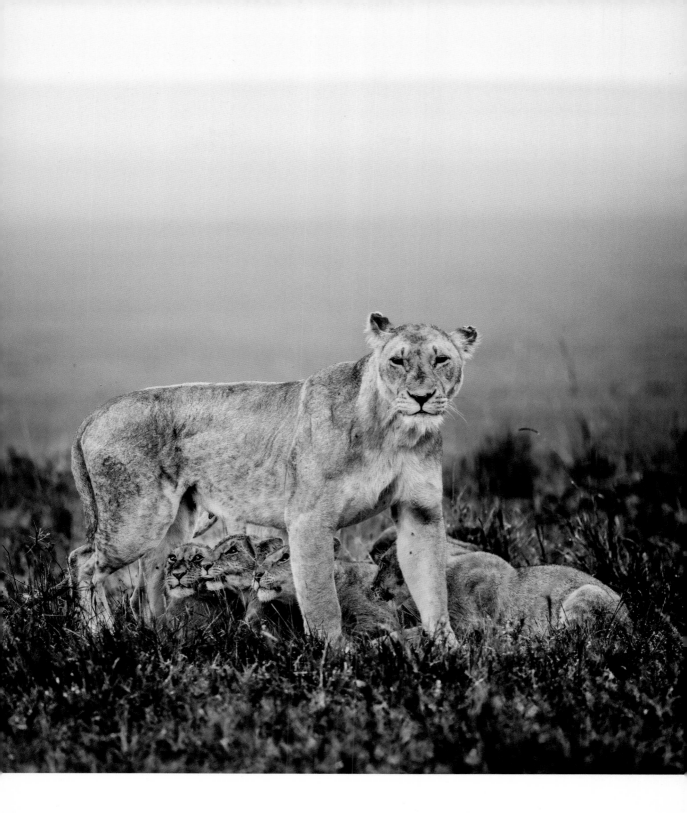

The cleverest cat: there is strong evidence to suggest that lionesses can out-think all other felines, including their male counterparts.

BONDING

Disney might have taught you otherwise, but lion brothers typically maintain a close, strong, and highly survival-enhancing bond for life.

LION *PANTHERA LEO*

takeover, because they will all be their sons, daughters, nieces, or nephews. A coalition of three or four brothers will likely fare even better. Young lone males may team up together, but the lack of a familial relationship will make this connection weaker and less stable. Of course, age and/or circumstance catch up with all lions eventually, and males that are ousted from their pride but not killed in the battle will spend the last phase of their lives as rather tragic, solitary figures, often battle-scared, profoundly weakened, and barely able to sustain themselves. A wild male lion will live, on average, just eight to ten years.

A lioness, though, can bank on six to eight more years than this, and she's likely to live out her life as a member of the pride into which she was born. As with males, female cubs are greatly advantaged in life if they have sisters and/or female cousins that are close in age, and the lifelong bond between female siblings provides the stable core of lion family life. Sisterless and cousinless females may be accepted into a pride as useful extra muscle, but their link with the group remains more tenuous, and they will be ousted if the pride starts to struggle to bring in enough food.

Most of the females within a pride are related to each other, and living together means that all things are shared. It's well known that the females in a pride, along with nearly full-grown cubs, hunt together as a cooperative team, coordinating their positions and timings in order to safely catch prey far larger than any lone lion could manage. Less well known is the fact that the females in a pride take care of all of the cubs together. If one sister has a litter of six cubs and another produces just one, the sisters produce the same amount of milk and suckle all seven cubs between them indiscriminately.

The sisterhood also defends the pride's cubs as a group. Male lions that take over a pride and drive away the previous males will attempt to kill all the small cubs. This will bring the females back into estrus quickly, enabling the new males to father a batch of cubs of their own, but the females won't passively accept this outcome and will fight to protect their cubs. Males are larger and more powerful than females and will usually prevail in a one-to-one battle, but the more females there are in a pride, and the more closely bonded they are and more determinedly they fight, the better their chances of saving the lives of at least some of their cubs.

A matriarchal mind

The frontal cortex of a mammal's brain is in charge of a wide range of behaviors, including purposeful control of the muscles, as well as memory, attention, reasoning, and social interactions. There's not much difference in overall brain size between the five *Panthera* species, but there is a difference in the size of the

frontal cortex, with the largest of all belonging to the lioness. Her body may be smaller than her male counterpart's, but the thinking part of her brain is markedly bigger.

Why does a lioness need this extra brainpower? As we've seen, the two sexes lead very different lives—much more so than some other social mammals. For a male, being associated with a pride is highly desirable; otherwise he must hunt alone or with just one or two other males, with all the risks that entails, and his chances of fathering cubs are much reduced. The privileges he stands to gain are worth the risk and stress of fighting.

The social connections between the females of the pride, however, allow them to form a unit that's capable of far more than the sum of its parts. In some parts of Africa, large lion prides regularly hunt African bush elephants—the largest land mammal on Earth, and an extremely clever animal in its own right. The results of lionesses' shared parenting are no less impressive. The sisterhood is the pride; males are only required to provide sperm, and to fend off other males that are a threat to the cubs. The extremely high level of cooperation that this way of life demands has driven the evolution of an exceptional brain in the lioness, which manifests as an exceptionally social mind. However, the sisterhood of lions is also remarkably free of the tension that's often observed between group members in many other social animals. If you ever have the good fortune to observe lions in the wild, you'll see that the females treat each other equally, with no individual dominating, and no cub favored over another. Every pride member knows that she belongs, and when she greets a sister after a period of separation, she does so with friendly confidence. Females who are "hangers on," permitted to live within the pride's territory and perhaps join in with hunts when conditions are right, don't engage in these greetings, and their membership of the group is never quite secure, but if they manage to raise cubs within the group, the females in their litters are likely to enjoy full membership of the pride.

VULTURINE GUINEAFOWL *ACRYLLIUM VULTURINUM*
Equality and stability

The savannas of southern and eastern Africa are replete with diverse birdlife. Most tourists are there for the impressive large mammals, but many find their attention caught by the birds too, and the vulturine guineafowl is certainly attention-grabbing. Boldly patterned and plump, with fine white spots on its body plumage, it wears a ruff of elongated black breast feathers with white-streaked centers, resembling a cloak of swords. The "vulturine" part of its name relates to its tiny bare, bluish head, jazzed up with a fuzzy red "headband." When you meet a party of these half-gaudy, half-comical birds, they don't fly away but instead start running, taking flight only when absolutely desperate. In short, they won't strike you as being overburdened with brainpower, in terms of anatomy or behavior.

But take another look at these birds, and reflect on this—all of the individuals in a group know each other extremely well. They are the opposite of a random assemblage. When they roost at night (which they do in one of the large trees scattered across the savanna, overcoming their aversion to flight to reach the safety of the high branches), up to eight different groups join together, so one tree may contain a few hundred birds. However, come the dawn and the descent to the ground to start a new day of on-foot foraging, the gathering breaks up into smaller parties of around twenty-five to thirty-five (though it can be as few as thirteen, or as many as sixty-five), and these parties always hold the same individuals—week after week, month after month. They walk together, often traversing large tracts of land over time as need demands, although they don't defend any territories and don't necessarily revisit the same places each time when they settle to breed (which they also do within their established groups).

The long-term consistency of group membership seen in the vulturine guineafowl is unusual in the avian world. Many birds form flocks—sometimes with other species as well as their own—and enjoy the benefits this brings, but groups tend to be unstable, prone to fracturing and reforming in different configurations. The extent of this fission–fusion aspect of group dynamics varies greatly between species, indicating that sticking with the same group long-term may be advantageous or disadvantageous, depending on circumstances.

A beautiful but far from big-headed bird, the vulturine guineafowl nevertheless has a brain that's able to remember dozens of friends and acquaintances.

The little flock of guineafowl that run together day after day may or may not be related, and the sex ratio in the group is about equal. Through their daily wanderings, they meet up with other groups at times and may mingle with them for a while, but they'll always separate again into their established groups, and meeting and parting occurs without ceremony and (unusually) without aggression.

Group membership is clearly nothing to do with chance, and the researchers who identified this consistent group loyalty also discovered that meetings between different groups are also far from random. The team, from the Max Planck Institute of Animal Behavior in Germany, worked in partnership with students and researchers at the Mpala Research Centre in central Kenya, studying a population of four hundred wild vulturine guineafowl over the course of a year. Having marked all the birds individually, to record the consistency of group membership over time, their next step was to fit one to five members of each group with GPS trackers. The movements of the groups as a whole could then be followed, including how often they encountered other groups, and how much time they spent in each other's company when they did.

The birds displayed different preferences at group level, with the same groups tending to meet up more often, and spending longer together than would be expected by chance. It would seem, therefore, that vulturine guineafowl have their fellow group members, from whom they are never parted, but then their group as a whole has cordial acquaintanceships with other groups. The lack of hostility between groups is as remarkable as the loyalty within groups, and to find both of these dynamics in operation at the same time is highly unusual in itself. Most group-living animals that have long-lasting and tight-knit bonds are fiercely aggressive toward other groups, but then most animals that live this way do so because their numbers are needed to maintain a territory. Vulturine guineafowl wander through a large home range and have no ties to a particular spot or set of resources within it—only to each other. However, most animals with similarly nomadic inclinations seem just as free and easy about the company they keep as they are about the places they travel through.

Optimum numbers

Enduring friendships of this nature in social animals are generally not at all unusual, though. If we look at other birds that forage and travel in flocks, we see, on a superficial level, a lot of forming and fracturing going on within their groupings. Take the Bohemian waxwing, a bird that breeds in Arctic climes but is often forced to travel a long way south in winter to find enough of the berry bushes that it feeds on. In years when the berry crop in their homelands fails

catastrophically, huge numbers travel together, arriving first in the UK from Scandinavia in flocks that are hundreds or even thousands strong. They descend on a good feeding area, strip all bushes of their fruit, then move on. As winter progresses, the groups fluctuate in size, generally breaking up into smaller parties as they are forced to travel farther and search harder for food. However, these fluctuations disguise the fact that small groups (fewer than ten birds) often stay together all winter long, moving between larger groups together. This has been observed in color-ringing studies, which involve marking birds with brightly colored leg rings in unique combinations so that individuals can be recognized from a distance. This behavior is common in birds that forage in this way and it shows that keeping familiar company around is advantageous.

For vulturine guineafowl, staying together in non-varying groups long-term appears to be a good tactic because they both travel and breed together, while most birds that flock in the nonbreeding season separate into territory-holding pairs when they nest. However, even for the loyal and level-headed vulturine guineafowl, group membership does occasionally present challenges. A female may lay as many as eight eggs in a clutch, and her young mature quickly, so if a few females have successful nests, the size of the group can more than double in a short space of time. Conversely, these birds have many predators and a run of bad luck can see numbers drop just as dramatically. At the optimal group size (about thirty-five), breeding productivity peaks—more eggs hatch and more young make it to adulthood. Some birds (most likely the youngest) will opt to abandon a group that's much bigger than this, and join a smaller group, bringing it closer to optimal size. The occasional need for some group members to make such a move could explain the vulturine guineafowl's unusual two-tier friendship setup. With lasting group loyalty being so important, these birds' brains are capable of recognizing the individuals in their group over long tracts of time. However, they also appear to recognize dozens, or even hundreds, more individuals belonging to groups that they only see now and then—an ability that allows them to maintain equally long-lasting, warm relationships with other groups, in case they do have to move over to a new group someday.

JAGUAR *PANTHERA ONCA*

Seeking a sidekick

You need a bit of luck to see a jaguar. It is a close cousin of the lion—the two shared a common ancestor that lived in the Old World, with ancestral jaguars thought to have migrated to the Americas via land bridges some two million years ago. However, their ways of life could scarcely be more different. Lions live and hunt in groups on open savanna, while jaguars slink through dense forest, all alone, jealously guarding their territory from their own kind. In the Pantanal in Brazil, though, jaguars are developing a somewhat different way of life.

This is a densely vegetated wetland area, which becomes much more of a wetland during the rainy season. Access is easier by boat, and researchers exploring this biologically rich area in small boats have discovered that it holds an unusually dense population of jaguars. That is "dense" in the sense of high numbers, not that the cats are lacking in intelligence—they certainly are not. Here, living in close proximity to so many others of their kind, jaguars are becoming more social. They don't just tolerate each other, but have been observed hunting together, feeding together, and even playing together, without the usual territorial hostilities.

Even more remarkable is the recently observed phenomenon of jaguar "bromances." Several male–male pairs of jaguars have been tracked by researchers, and one of these pairs has remained together in their shared territory for at least five years. Both of them have had multiple liaisons with different female jaguars but this doesn't seem to have stoked any competitive fire between them. The researchers believe that the alliances were born out of cooperative hunting. Pantanal jaguars hunt a lot of fish, but males in particular also kill black caimans—members of the crocodile family. A large caiman is a formidable and dangerous prey, but it provides a very large meal. It's possible (though not yet observed) that these male pairs are joining forces to take down big caimans more easily, and sharing the spoils, as well as working together to keep other males away from "their" shared females. The Pantanal may be the cradle for a new era of jaguar history, where these most solitary of cats learn and embrace the joys of friendship.

Jaguars in the Pantanal, in Brazil, are learning that being a bit friendlier to their fellows can open up some exciting new ways to hunt and to live.

AFRICAN BUSH ELEPHANT *LOXODONTA AFRICANA*

Long years of love

In 1999, a much-loved elderly female Asian elephant died at a zoo in Lucknow, India. Damini was seventy-two years old, so certainly well into her twilight years, but the circumstances of her death were particularly tragic. Some four weeks earlier, her companion (a much younger female, Champakali) had died while giving birth to a stillborn calf. Immediately after Champakali's death, Damini stood over her friend's body, stroking it with her trunk, while tears streamed from her eyes. Eventually she stopped eating and drinking, and finally collapsed. All veterinary efforts to save her life failed.

Those of us who spend perhaps too much time looking at animal-related social-media stories will have come across plenty of examples of apparent animal grief, in a wide variety of species. We feel the loss of people close to us so intensely that the lure of anthropomorphism is particularly powerful here, and a more clinical and experienced human eye might discern, for example, that a swallow in a photograph, fluttering around the dead body of another that has been killed on the road, is actually continuing the territorial fight that led to the accident, rather than expressing sorrow. However, the story of Damini and Champakali is more difficult to ascribe to anything else. This story of apparent devastating grief involved captive Asian elephants, but among wild African bush elephants, native to the southern and eastern African savanna, the response to loss of a group member is particularly well documented.

When an African bush elephant is born, after twenty-two months of gestation, she can look forward to up to seventy-five years of life. Potentially more than sixty of those years will be spent in the company of her mother, if she happens to be her first-born calf. Her birth will also have been attended by female relatives—aunts, cousins, grandmothers—and, among those, the group leader, or matriarch. She is likely to be the oldest female in the group, bringing her extensive experience to bear as she guides the others to the best places to find food and water, and rallies them when they need to defend a newborn calf and the other babies in the group from danger.

The newborn calf will receive one-to-one care from all of the adult females in the group, including the adolescent females, who spend much time "babysitting" young calves and acquiring parenting skills. In an impressive demonstration of

Attachments this deep carry a cost when lives end. African bush elephants appear to be affected by a bereavement in a way that we find all too familiar.

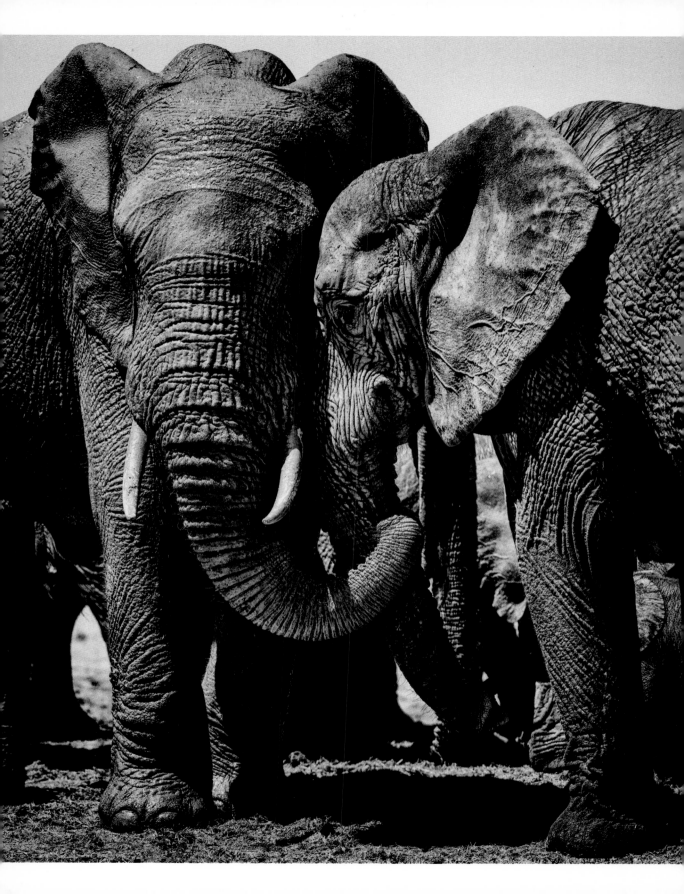

Members of a group will attend the body of one of their own for days after the death, and the apparent effect on their mood is all too clear.

AFRICAN BUSH ELEPHANT *LOXODONTA AFRICANA*

efficient knowledge transmission, these babysitters, or "allomothers," are most likely to care for the calves of experienced older females, while first-time mothers receive proportionately more help from their elders.

The group as a whole is typically a family, with an average of ten members, although multiple families sometimes associate loosely together. They are nomadic by nature, covering great distances in search of the resources they need, and they walk together, often sticking very close. The family group includes mature females and calves, plus adolescents of both sexes, although males leave the group when they become sexually mature, to live either alone or (especially when younger) in groups with other bulls. Mature males are interested in mating with females (and in fighting with and driving away other males) for only about three months a year, when they are in a heightened hormonal state known as musth. When not in musth, males can coexist peacefully, and at these times the older bulls help to moderate the aggressive urges of the youngsters, using their experience to provide a similar guiding role as do the matriarchs in female groups. The older elephants within groups are vital not only as guides but also teachers, demonstrating feeding techniques and even tool-making (modifying a branch into a useful flyswatter) for youngsters to copy.

When a social group becomes very large, it may split into two, or more. This benefits all, as the groups can forage in different areas and it takes them longer to consume all available resources. However, those family ties are not forgotten. Although these extended families may be separated by miles, they continue to walk in the same direction and at the same pace, keeping in touch all the time through their infrasound calls and often rejoining each other later.

The importance of long-standing family ties, and the associated passing-down of survival skills and environmental knowledge, seems to our minds to be an intuitive setup for the formation of deep, complex bonds between group members. We say that an elephant never forgets, and there's plenty of evidence from captive elephants that this is indeed the case, with individuals showing familiarity even after separations of more than twenty years. Perhaps our elephant calf will remember experiences with different group members, with these recollections shaping the depth of her bonds with them? This may be an anthropomorphic step too far—or perhaps not. We are, after all, dealing with a highly intelligent animal, bearer of the biggest brain of any land mammal, and we're talking about 24/7 relationships that persist for decades and through countless challenges.

Crying at funerals

Elephants can cry. That's to say, they produce tears, which flow when they're in an excited or stressed state, and this apparent weeping has been observed in African

bush elephants that are gathered around a fallen group member. It's also been reported that they produce distinctive sounds on these occasions. Elephants are extremely vocal, using a range of different calls (including infrasound, which we cannot hear and need gadgets to detect) in different settings. These include the soft growl of a matriarch signaling that it's time to move on, and the so-called "mating pandemonium"—a chorus of excited (celebratory?) calls made by a matriarch-led group when one of its members has just mated with a bull. In grief, they may sometimes produce sounds that are almost like screams.

Their behavior around a dead group member can also be unusual. The researcher Marc Bekoff reported observing a group of elephants wandering to and fro, apparently aimlessly, and standing listlessly, with heads and tails drooping, for some time after the death of their matriarch. Many others have noted elephants standing guard over the bodies of the dead, driving away scavengers, and mother elephants will even carry dead calves in their trunks. When attending the dead, elephants will gently stroke the body with their trunks. They have also been seen to do the same thing with elephant bones, which may or may not have belonged to long-dead group members. And they will sometimes even appear to bury their dead, laying grass and branches across the body.

The role of grief

Humans enjoy rich emotional lives, but sometimes "enjoy" is entirely the wrong word, and never more so than when yearning for the company of a beloved person who has died. We feel this pain even though we know that death is unavoidable, and even if the death in question was a peaceful departure at the end of a long and happy life. Yet we rarely question why we feel this pain. When we see apparent grief in animals, though, "Why?" comes to mind much more readily. Animals are adapted to function efficiently in their environment and to respond in the most healthy ways to natural stresses—the better to survive and reproduce. Surely prolonged grief harms an animal's chances of survival, reducing its energy for these important activities? This line of thought carries us away from biology and toward philosophy. We cannot know (and almost certainly never will) how it feels to be an elephant, and whether its experience of grief is in any way like our own. Perhaps if we could, we'd find it so different that the word "grief" would seem utterly inappropriate. Nor can we know whether this experience carries benefits for elephants, just as it's very difficult to conceive of any positives when we are grieving. Perhaps grief is just a toxic by-product of being a social animal, which evolution may eventually discard—for us and elephants alike. Or perhaps both humans and elephants have a biological need for the capacity to feel loss. Maybe it is our intense response to loss that enables us to build such enduring and enriching bonds with others—the bonds that provide the well-being needed to power a long, happy, and productive life.

5
CONSCIOUSNESS
Knowing Me, Knowing You

CONSCIOUSNESS KNOWING ME, KNOWING YOU

All matter that exists in our universe is, or was formed from, stardust. And here on Earth (and who knows where else) the natural and inevitable process of life's evolution has brought about a situation where some of these assemblages of dust can look at themselves and contemplate their own "dust-hood." This is the marvelous quality of consciousness—having a brain smart enough to know that it is a living thing, and that it is actively thinking.

This is a slippery idea to pin down, but at the same time, a great many humans through history have felt very confident in asserting that their species is the only one of the millions on Earth that possesses true consciousness. All other animal behavior, however complex, was attributed to mindless instinct—like a muscle reflex. Science, though, never stops asking questions, or trying to devise practical ways to answer those questions objectively. Simply assuming we are the only animal species ever to have evolved true consciousness seems arrogant and—worse—unscientific.

Biologists need the help of psychologists and philosophers here, though, to nail down the definition of consciousness. The eighteenth-century French philosopher René Descartes supplied us with the phrase *Je pense, donc je suis* (aka *Cogito, ergo sum*; "I think, therefore I am"). By his reckoning, experiencing our thoughts and being aware that these thoughts are self-generated is the nature of consciousness. For any thinking human, consciousness and self-knowledge are self-evident, from a very young age. As we mature, become effective communicators and attain Theory of Mind, we understand that other humans have their own thoughts, too. But how can we find out whether animals think, and, if so, what they think about their own thoughts? And are our own minds up to the task of conjuring the conscious experience of a being whose body, senses, and way of life are so different to our own? In his classic philosophical essay "What is it

like to be a bat?" Thomas Nagel says that imagining himself placed inside a bat's body is not the correct approach to this challenge—he says: "I want to know what it is like for a bat to be a bat. Yet if I try to imagine this, I am restricted to the resources of my own mind, and those resources are inadequate to the task."

Other definitions of consciousness are broader, or simply quite different. You might argue that simple awareness of an external stimulus constitutes consciousness, even though this might bypass any thought process completely. We can see that animals (especially those that are evolutionarily closer to ourselves) have waking and sleeping states, and that levels of awareness vary during the waking state. By this definition, virtually all animals have as much consciousness as we do. However, most of us prefer a more Descartian view of the term, with reflective thought, self-awarenes and awareness of what may be going on in other minds at its core.

Investigating this in animals presents obvious difficulties, but biologists have devised some clever techniques. Their findings suggest that many animals do indeed show signs of Descartian consciousness, and that not all of these are creatures that we regard as clever or "advanced." More fascinating still, though, are those cases where animals have taken the initiative and gone beyond the parameters of the research to show us something of the nature of their thoughts. Through close one-to-one relationships between researcher and individual animal, a variety of animal subjects have revealed much more about their thoughts, memories, and insights than we ever expected. We might still yearn (a little whimsically, perhaps) to talk to the animals. But maybe the animals' desire to talk to us, and have us know their thoughts, is just as real, and not so much whimsical as pressingly important. Their ways of doing so might be strange to us, but we owe it to them to listen—patiently, and with open minds.

ANT *MYRMICA SPP.*

Facing facts

You're getting ready for a big night out. You have primped and preened to your satisfaction, got your best outfit on, and are preparing to head out of the door when you catch sight of yourself in the mirror and—what's that? You must have touched something grubby and then touched your face because there's a dirty mark on your cheek. You hurry to the bathroom, where you wipe it away, checking in a (second) mirror that it's all gone. Then you head out, thankful that you spotted the problem before you appeared in public. Accomplishing this task is not exactly a big deal, but then we have learned to recognize our own reflections from an early age. Even those of us who shun mirror ownership will sometimes see our own faces looking back at us from other reflective surfaces, and know that we are looking at ourselves. It's all part of our awareness that we exist. It is also, conveniently, an aspect of consciousness that we can test in other animals, via a variant of the dirty-mark-on-face experience.

The mirror test involves attaching something visible to an animal—something that is clearly out of keeping with their appearance. The addition needs to be something that the animal cannot or can only barely feel, so that it's not compelled to clean itself simply because of tactile discomfort—say, a blob of paint that's allowed to dry. The subject will already have been familiarized with a mirror. How it reacts when it sees its reflection with the added element gives us an idea of whether it realizes it's looking at its reflected self. Several species have passed the mirror test, though many others have failed. One of the more surprising members of the former group is the ant.

The study in question used three different ant species, all belonging to the genus *Myrmica*. The researchers, based at the Faculté des Sciences at the Université Libre de Bruxelles, collected entire five-hundred-strong colonies of each species from the wild—complete with queens, workers, and nest chambers full of immature life stages—and set them up in comfy new lodgings in the lab. Once the ants were settled in, mirrors were introduced to their quarters.

When confronted with a mirror, the ants invariably slowed down from their usual businesslike pace and spent time exploring it, touching its surface with their antennae and mouthparts. They also spent time cleaning their legs and antennae in front of the mirror, which the researchers interpreted as a possible displacement

Worker red ants look at hundreds or thousands of other ants all day long, but it would seem that they could still pick themselves out of a ant line-up.

activity (a behavior performed to self-distract or self-comfort when in a stressful or intense situation). They showed no such response to pieces of plain glass that had been set up identically to the mirrors.

Next, the researchers marked the ants with a dot of paint on their faces. In some subjects, this was blue, so visibly contrasting with the ant's coloring. Others received a dot of paint that matched the color of their faces. A third control group was touched on the face with the paint-marking tool but no paint was actually placed. None of the ants reacted to the presence of the paint until they were in front of a mirror, but then those marked with a blue dot began to try to clean the spot from their faces. None of them made any attempt to clean up the reflected face they saw, only their own. The ants with no dots or same-colored dots did not do this—they simply continued with the mirror-related behaviors seen in all of the ants before the addition of the paint.

The ants therefore emphatically passed the mirror test, suggesting that they knew they were looking at their own reflection. This caused something of a stir in the animal-psychology world, challenging old biases with the suggestion that a mere insect, possessing a paltry 250,000 neurons in its brain, could demonstrate what we regard as a highly advanced aspect of consciousness. What use, we might wonder, is self-recognition (and, by inference, self-awareness) in an ant? It is, after all, not just an insect but surely the most mindless of all insects, with no initiative of its own—acting identically to all of its nestmates, and only ever in service of its queen. Nor is a queen herself a clever or thoughtful monarch; rather, she is an egg-laying machine, unconsciously controlling all of her workers' behaviors through the release of pheromones. Yet the evidence was there—the worker ant caught sight of her own reflection, and responded by attempting to clean her dirty face.

The hazards of a wobbly identity

An interesting, though rather disturbing, addendum to this study is what happened to the test subjects when they returned to the nest, having failed to rid themselves of their new face paint. While the unpainted and brown-painted ants were treated exactly as before by their nonsubject nestmates, blue-spotted ants across all three species received less than a warm welcome, and some were grabbed, bitten, and stung. Ants can release pheromones to calm aggressive nestmates, and the test subjects appeared to do this, but it wasn't always enough. Of the eighteen blue-marked ants, five were eventually killed.

Ants are ferociously protective of their nests. No wonder, given that some species are "slave-makers," specializing in invading the nests of more peaceable

species (see page 155). So, going into attack mode is a typical and appropriate response to an ant of another species. Ants recognize their own species by olfactory (scent-based) and visual cues, and the blue-spotted faces of the test subjects didn't match the appearance of their species. Recognizing other ants of one's own species is self-evidently an important skill, but it's not wholly innate—it develops over time. Very young ants, newly emerged from their pupae, can't do it, and interestingly, they didn't display self-recognition behaviors with the mirrors either. But ants in the wild don't encounter mirrors, as a rule, so we can assume no prior experience or learning had occurred in the adult test subjects. We must therefore consider the possibility that the mature ants had developed a concept of selfhood, so on meeting a mirror, they—fully and rapidly—figured out that they were looking at themselves. It seems an incredibly sophisticated behavior, but as the researchers pointed out, ants do have other surprising cognitive skills, being able to "learn to do specific tasks at specific times, memorize several visual and olfactory elements," and more. And let's not forget that our planet is home to some 20 quadrillion ants. It would be unwise indeed to underestimate them.

GIANT MANTA RAY *MOBULA BIROSTRIS*

Limitations of the mirror test

The giant manta ray lives up to its name—it is the largest non-shark fish in the world, and spans up to 23 feet from wingtip to wingtip, and 30 feet from head to tail-tip. It is noted for its graceful flight-like swimming action, and the two cephalic fins either side of its head, which funnel water into its mouth when feeding.

Manta rays travel long distances through open water, sometimes in groups, and while they feed mainly on plankton, they also catch smaller fish, and at times swim deep underwater to hunt. They can also accelerate to 15 miles per hour. They appear to demonstrate quite complex social interactions, and inside that strange, flat head is a big brain, befitting a socially intelligent animal.

If you were going to look for a fish that demonstrated signs of consciousness, the giant manta ray would be an obvious starting point. In a study published in 2016, researchers at the University of South Florida investigated how two captive rays responded to a mirror placed in their tank, and the results were intriguing. It was impossible to complete the mark test (see page 132) on these fish because of their watery environment, so the data was only collected while exposing them to the mirror. The researchers interpreted the subjects' behavior as best as they could, comparing it to similar studies on other animal species.

The rays showed great interest in the mirror but did not react as if the reflection was another individual. Instead, they frequently hovered and circled in front of the mirror, opening and closing their cephalic fins while observing their reflected image. They were also observed releasing bubbles—not part of their normal behavioral repertoire. These frequent, distinctive and unusual responses led to the strong supposition that the rays might recognize themselves. If they succeed at the mark test as well, manta rays might join the still very short list of species to "pass" the mirror test (see page 132).

The researchers point out that the mirror test, in general, builds on the assumption that vision is the dominant sense for the studied animal, which might not be the case for many species, including manta rays. If we're clever enough to work out ways to test self-recognition through, say, smell or magnetoception, we may well find this aspect of consciousness exists in a much wider variety of species.

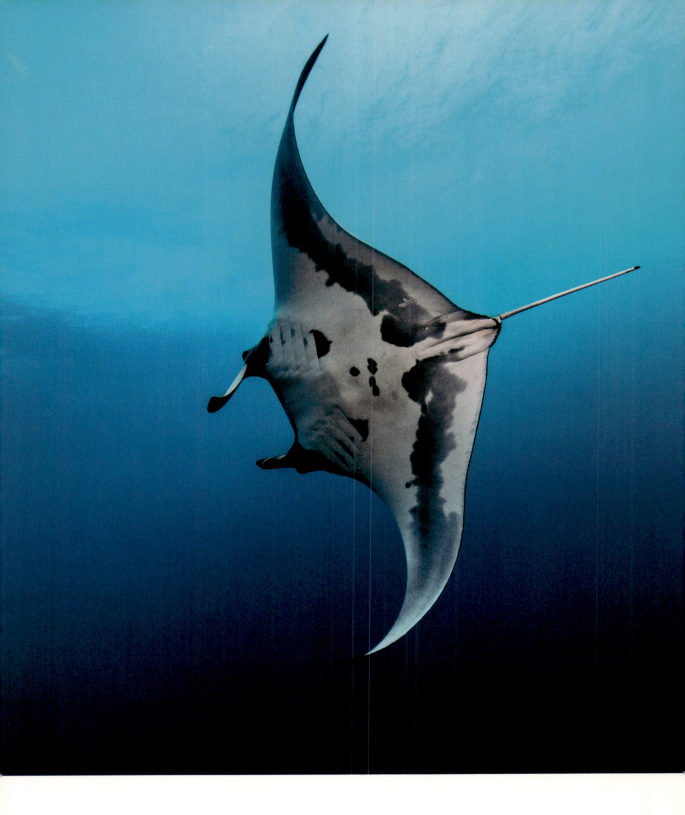

With a life so far outside our own experience, the manta ray presents us with significant challenges as we try to learn more about how it uses its infeasibly large brain.

WESTERN LOWLAND GORILLA *GORILLA GORILLA*
Reading the signs

One of the most iconic and moving TV moments of all time was first broadcast in 1978, as part of the BBC's *Life on Earth* series. Sir David Attenborough had traveled to Rwanda to meet a family of mountain gorillas, and was filmed sitting among them, speaking softly to camera as the animals lay beside and half on top of him, playing gently with his hair and boots. The common chimpanzee and bonobo may be our closer evolutionary relatives, but this exceptional piece of film has stirred up perhaps more universal fellow-feeling for another species than any other. That a human can sit down in the company of wild gorillas (albeit carefully habituated to human company) and be completely accepted into their group tells us a lot about this greatest of apes and its willingness to be social with our own species. Could deeper connections and shared understanding be forged between humans and gorillas—enough for us to gain insights into how they really think?

On July 4, 1971, seven years before the screening of that *Life on Earth* episode, a western lowland gorilla was born in San Francisco Zoo. In reference to her birth date she was named Hanabi-ko ("fireworks child" in Japanese), though she became known as Koko. Koko developed a lifelong friendship with researcher Francine Patterson, who cared for her and also taught her a form of sign language, in the hope that the two of them could communicate.

Apes don't have the same vocal anatomy as us, so cannot produce our complex range of sounds—early attempts to teach captive chimps to speak encountered this problem very quickly. Several apes, though, have been taught from infancy to use sign language, as well as to understand (if not replicate) spoken language, and it's usually agreed that they attain a level of language proficiency comparable to an average three-year-old human.

Koko learned to make more than one thousand different signs, and understood about two thousand spoken words. She didn't, however, show any understanding of syntax, so her words and sentences were not always easy to interpret. Indeed, some critics considered that she made signs at random much of the time, and that any meaning ascribed to them was an anthropomorphic stretch. While a good dose of healthy cynicism isn't a bad thing when evaluating research (particularly involving a much-loved individual animal), it does seem clear from the many hours of documented interactions that Koko knew what she was saying when she

Through sign language, gorillas have been able to talk to us, and some of the things they have to say would seem to relate to their innermost thoughts and most powerful memories.

"spoke," and the way she expressed her thoughts on emotional events provided profound insights into her thought processes.

One of Koko's most famous episodes came in 1985 when she asked for a pet cat. The cautious researchers tried to fob her off with a stuffed toy, but she rejected it, and was later offered her pick from a litter of real kittens. She selected a male—a tailless Manx—and named him All Ball. Fears that she might harm the animal proved unfounded; she treated him with gentleness and affection. When All Ball was killed in an accident at a young age, Koko was told the news and seemed to understand, responding with a sequence of signs: "Bad. Sad. Bad. Frown. Cry-frown. Sad." Later, when alone, she was heard making uncharacteristic sob-like sounds.

Koko made frequent use of emotionally loaded words, and could refer back to previous experiences, including the death of All Ball, which she referenced for months after the event. However, she could also be cheeky and playful, as when she took against an interviewer, unkindly describing her as a "toilet." In terms of overall intelligence, Koko scored between 70 and 90 on an IQ test designed for human children. Invention, one of the hallmarks of intelligence, was evident in her ability to create portmanteau words to describe objects she'd not seen before—a ring was a "finger-bracelet," a mask an "eye-hat," and a cigarette lighter a "bottle-match."

Recounting the past

When she was six years old, Koko was joined by a three-and-a-half year-old gorilla, Michael, found in Africa as an orphan. Koko's keepers hoped he might be a breeding partner for her in due course. The romance didn't work out but the two gorillas bonded closely as friends, and Michael, despite being a later starter than Koko, also learned to use sign language proficiently, learning from Koko as well as Francine Patterson.

Michael mastered fewer signs than Koko, but he showed great enthusiasm for other pursuits, such as painting and listening to classical music. The six hundred or so signs that he did learn were sufficient for him to tell a tale that was interpreted as a description of his mother's death at the hands of hunters. The words he used, in response to a question about his mother, didn't seem to be attributable to anything in his current life: "Squash-meat. Gorilla. Mouth-tooth. Cry. Sharp-noise. Loud. Bad. Think-trouble. Look-face. Cut/neck lip hole" ("lip" being the word used by Koko and Michael for "girl").

Many gorillas and other primates are killed for bushmeat in Africa, and this is how many orphaned young gorillas fell into human hands in the nineteenth and twentieth centuries—they were worth more alive than the meat on their small bodies would fetch. That Michael appeared to remember what had happened, and seemed able to describe it, makes us wonder whether, in moments alone, he relived that traumatic event and ruminated upon it.

Uncertain reflection

Communicating with animals that have learned to use a language we understand is a powerful tool, bringing us tantalizingly close to understanding what and how they think—about themselves as well as the world at large. However, all "talking animals" have faced intense scrutiny from skeptical parties, right back to Clever Hans, a performing horse in early-twentieth-century Germany that could move his hoof a certain number of times to give the (invariably correct) answer to a math problem provided by his trainer. He was feted as a mathematical genius, but careful investigation later showed that the number of times he moved his hoof was determined by tiny involuntary cues from the trainer. Out of this came the term "Clever Hans effect," which has been used by some critics with reference to Koko, Michael, and other sign language–using apes. Perhaps the convincing use of signs is simply due to the undeniably close and empathic bond between ape and trainer?

Gorillas as a species don't consistently pass the mirror test (see page 132; although Koko was reported to have done so), generally performing worse than chimps and orangutans. By this measure of consciousness, they underperform an ant! But maybe, for a clever ape, self-awareness comes naturally in a way that the concept of a mirror never will. Gorillas, chimps, and orangutans, though close cousins to each other, all have their own evolutionary history, shaping them and their minds to their particular way of surviving in a specific environment. They are as different from each other as they are from us, in the ways they've evolved to think, feel, react, and behave.

Through their ability to learn and use a human language, Koko and Michael have taught us a huge amount about their thought processes, their self-knowledge, and how they understand their own inner worlds. There's an enormous amount still to learn about all of the great apes, and as the ones carrying out the research, we humans must hang on tight to our objectivity, even when working with these highly relatable, almost-family creatures.

EURASIAN MAGPIE *PICA PICA*
Here's looking at me

Dapper, bold, and strutting, the Eurasian magpie is a familiar garden bird in Europe, as is its near-identical counterpart the black-billed magpie in America. They are small members of the corvid family (unlike the Australian magpies we have met already). British folklore insists that Eurasian magpies love and regularly steal shiny objects, although this is not backed up with much hard evidence. However, science has demonstrated a special connection between this bird and the most reflective object of all—a mirror.

The mirror test, whereby an animal is marked in some way and then shown its mirrored reflection to see if it realizes the marking is on its own fur, feathers or cuticle, tests self-recognition. Very few animals have passed it, to date. Most show aggression or other behavior toward their reflection (though not the ant, see page 132) and don't move beyond this stage.

The five test-subject magpies were first familiarized with the mirror, before having small stickers (either brightly colored or black) placed on their black throat feathers, which they ignored until they were shown the mirror. Then, three of those with colorful stickers tried to scratch or preen them off. The results were repeated when the control and test groups were swapped over, across four trials per bird in all. An easy pass—for at least some of the group, and even mirror-test aces such as common chimpanzees do not show a 100 percent pass rate.

This finding, in 2008, was one of the early indications that the big-brained corvids are on a par with the great apes in their mental ability. The same five magpies had already previously demonstrated as good an understanding of conservation of volume (the awareness that transferring water between different-shaped vessels does not alter its quantity) as chimps, and superior to that of monkeys. Five is, admittedly, a small test sample, but there is no reason to think that these particular five were exceptional geniuses. In fact, magpies have evolved within an ecological niche that strongly favors quick wits. They are social but competitive, they store food to hide it from other magpies, and they are omnivores, so have a keen curiosity (because anything might be edible if you can work out how). No wonder they are as bright as they are beautiful.

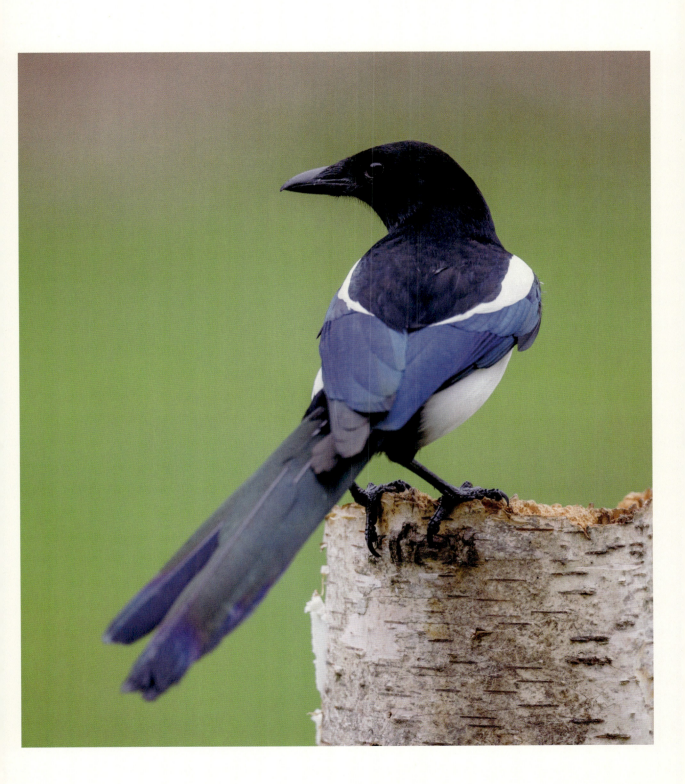

With eyes as sharp as its bill, the ever-alert Eurasian magpie is a keen, thoughtful and self-aware observer of its world.

FANCY RAT *RATTUS NORVEGICUS DOMESTICA*

The joy of laughter

We owe a lot to the brown or Norway rat (*Rattus norvegicus*). Domesticated "lab rats" have provided us with a wealth of insights into matters biomedical, genetic, psychological, and more. Not all domesticated rats live in labs, either. Pet "fancy rats" are said by their many fans to be much more clever and affectionate than any hamster or gerbil. The traits that make wild rats problematic—their curiosity, adaptability, and gregarious nature, for example—translate into charming attributes in a pet.

One of the most delightful traits of tame rats is that they laugh when tickled. Laughter—and a sense of humor in general—is yet another quality that we struggle to see as anything but human. We laugh at animals all the time, but we don't expect them to laugh at us. This behavior in rats was well studied by Jaak Panksepp, an Estonian–American psychobiologist who worked at a variety of US and UK universities. Rats, especially juveniles, emit a series of chirping calls, quite unlike other vocalizations, when tickled on the back of the neck by a human. Their pleasure at the sensation is evidenced by the fact that they choose to approach the same human hands that have tickled them before. They also nibble each other's napes when they play together, and this also elicits laughter. Some individuals are more ticklish, more playful, and more inclined to chuckle than others, and other rats choose to spend more time with these individuals. However, all rats stop laughing when a concerning stimulus is introduced, such as a whiff of cat urine, suggesting that laughter only occurs when they're relaxed. We can surely relate to this—excessive laughter leaves us physically helpless, so we're most likely to give way to it in safe situations, or when we desperately need to ease a tense atmosphere.

Although rats appear to laugh in response to a particular sensation, can we really attribute this to the level of consciousness needed to experience amusement? The funniest jokes are those that surprise us, and surprise is also needed for tickling to have an effect (which is why we can't tickle ourselves). It's the moment of being wrong-footed that makes us laugh, and we also laugh with relief when we escape a scary situation. Laughter, therefore, seems to be tied to an awareness of vulnerability. In the case of rats, the back of the neck is targeted in interactions that are loaded with tension, such as fighting and mating, as well as during playtime. Maybe rat and human laughter alike is nervous by nature—but they (and we) seem to greatly enjoy dissolving into giggles, nonetheless.

What's so funny? Pet rats love to laugh, and the rats who seem to have the most fun are also the ones that have the most friends.

COMMON BOTTLENOSE DOLPHIN *TURSIOPS TRUNCATUS*

The uncertainty principle

Getting to know oneself, truly and deeply, is a lifelong project for many humans, though denounced as a navel-gazing waste of time by many who take a more seize-the-day approach. Yet we mostly make better choices in life when armed with at least some depth of self-knowledge. Through self-examination and self-knowledge we can accept our flaws while nurturing and celebrating our strengths. Many animals show great knowledge of their own physical limitations, but whether they recognize the limits of their mental abilities is another matter. Time to revisit the big-brained common bottlenose dolphin, and take a look at how this thoughtful creature thinks about its own thinking.

Lots of the things we do for fun can involve a progression in difficulty. We like to push ourselves and explore what we're really capable of, but if we get stuck, it's also comforting to know that we can retreat to an earlier and easier stage. We can also use resources to gather more information, which may help us to succeed eventually.

How we react to our own uncertainty has been tested empirically, and the two responses described above are exactly what we do in the lab as well as in real life—we either retreat from the problem, or we seek out extra information. A 1995 study tested both humans and common bottlenose dolphins on the same "uncertainty" task. The participants were asked to discriminate between two different sounds, which became progressively more similar over subsequent trials. They were also allowed a third response: giving no response and retreating to an easier trial. When the subjects neared the threshold of discrimination, humans and dolphins alike went for the "don't know" option—indeed, the results for the two species were close to identical.

This task's setup enabled the subjects to demonstrate that they "knew that they don't know," rather than just reaching a point of failure. This seems a rather unambiguous demonstration of consciousness. Thinking about thinking, or metacognition, is (as we've already discussed) very much a higher function of brains and minds, but given all that we already know about the mental abilities of dolphins, it's not really any surprise that they match us so perfectly on this task. Later studies, though, revealed similar results for rhesus monkeys and even pigeons. Exploring the "uncertain response" has perhaps only increased our uncertainty about how widespread animal consciousness really is.

Having to deal with one's own sense of doubt is one of the drawbacks of being reasonably intelligent, and bottlenose dolphins seem to handle it much as we do.

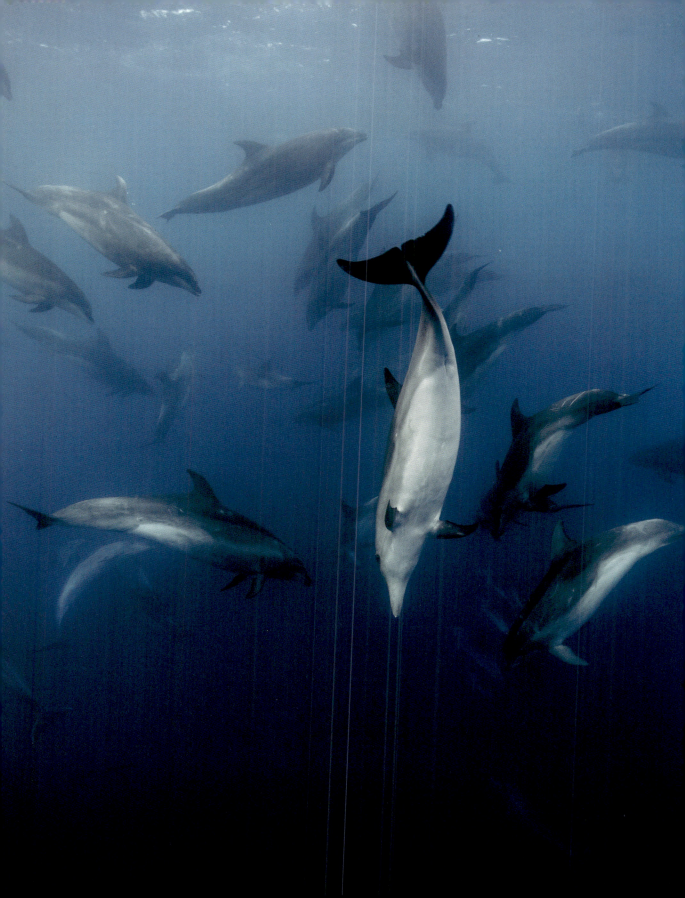

6
WINNING
Strategy and Tactics

WINNING STRATEGY AND TACTICS

It can be a hard thing to witness, but many animals hunt, kill, and eat other animals, and they live this way from the day they're born until the day they die. Catching other freely moving life-forms, which did not "want" to be caught, was the original way of life for some of the earliest marine-dwelling animals, and predatory tendencies have persisted and even re-evolved in numerous modern animal groups. To be a successful carnivore, an animal has to overpower but often also outwit its various prey species, time and time again, so we see high intelligence in many predators. Non-predatory species may also be highly intelligent animals in their own right as well, of course, because evolutionary pressure favors those that find ways to escape. In every natural encounter of this kind, one must win and the other will lose.

Hunting, catching, and killing are not the only ways in which one species may need to defeat another. Parasites do not kill their host, but exploit it, and often harm it to a greater or lesser extent, so many animals have parasite-avoiding behaviors, which the parasite has to evade. There are also other forms of parasitism besides the kind that comes immediately to mind, whereby the parasite lives on or in the host and consumes its body tissues. How about kleptoparasitism, where one animal steals food from another? Great skuas force northern gannets to regurgitate the fish they've caught simply by chasing and attacking them until they've had enough. European kestrels loiter around tailing barn owls, and when the owl catches a vole, the kestrel dashes in to try to snatch the prey from the owl's talons.

Then there is brood parasitism—a tactic that has arisen independently in several unrelated bird families, with varying degrees of sophistication. The parasite lays her egg in a nest that's not her own, in the hope that the host parents will not notice, and will incubate it and raise the resultant chick, saving the parasite a lot of time and energy. Some species do this routinely to others of their own species, dropping off spare eggs in

several nests, even though they keep a nest of their own too. It might be seen as taking the phrase "Don't put all of your eggs in one basket" to its literal extreme. In the case of some obligate brood parasites (which lay eggs in the nests of other species and never make a nest of their own), the complexity of the deception has become extreme, with the host species counterevolving adaptations to avoid being duped. It's like an arms race, with the contestants locked in an escalating battle that spans endless generations and the balance of wins and losses tilting one way and then the other through time.

Even in apparently cooperative associations, close study will often reveal that there is a winner and a loser. Oxpeckers search the skin of large grazing mammals for ticks and other skin parasites that they remove and eat, but they're also quite happy to pick at a healing scab and drink the blood. It's therefore not always advantageous for a buffalo, giraffe, or antelope to allow these little birds to do their parasite-removing work. Bee-eaters are cooperatively breeding birds, with the offspring of an established pair gaining valuable experience by helping their parents raise the next brood before heading off to breed on their own. However, the parents sometimes ensure that they get help for longer by sabotaging their youngsters' first nesting attempts.

Any situation where one animal needs to act against the interests of another to further its own creates a very strong selective pressure on both parties. The result is the evolution of natural wonders and horrors, whether it's the extraordinary acceleration a hare can achieve from a standing start, the fearless ferocity of the honey badger, or the suicidal altruism of termites that protect their nest against predators with their own ruptured, toxin-leaking corpses. The need to conquer increasingly unconquerable opponents is a powerful shaper of the animal mind.

COMMON CUCKOO *CUCULUS CANORUS*
Multilevel deception

For European humans, the mellow double-note of the male common cuckoo is a much-anticipated and welcome sign of spring's arrival. For the small songbirds that share the cuckoo's habitat, though, it is far from something to celebrate, because this bird is a highly specialized obligate brood parasite.

When a female cuckoo lays an egg in an unwitting host's nest, she is dooming the host's entire reproductive effort that season. Her chick is a miniature powerhouse from the day it hatches. Its first task is to throw out its foster siblings, whether they are hatchling chicks or still in the egg, by hoisting them onto its back and tipping them over the brim in a sort of press-up maneuver. Alone in the nest, the endlessly hungry cuckoo baby rapidly grows much larger than its exhausted foster parents. It fledges and migrates long after its feckless biological parents have completed their return journey to the wintering grounds in Africa.

Investing in the next generation is the biggest of deals for animals, and, for the cuckoo, success hangs entirely upon conning another species into doing all the work, for no genetic reward at all. Therefore, the cuckoo's anatomy, biology, and, above all, behavior are all strongly guided by this need for trickery.

For a start, common cuckoos look similar to Eurasian sparrowhawks—a dangerous predator of small songbirds. Females spend their time discreetly scoping out territories and nests of potential hosts, but males often sit on a prominent perch. This alarms the local songbirds, and they try to drive it away from the area. This creates the opportunity for a nearby female cuckoo to visit the songbirds' unattended nests.

The egg itself is in disguise too—much smaller than would be typical for a cuckoo-sized bird, and its patterning usually matches that of the host's eggs. Each female cuckoo will stick to one host species; her eggs will match that host's only. Each population of cuckoos that uses the same host is called a "gen" (plural "gentes"), and the preference is passed on genetically. She will also remove one of the host's eggs, leaving the total number of eggs unchanged. Occasionally, a host will reject the cuckoo egg, and some host species are better at spotting the deception than others. The highly adapted cuckoo is therefore continually under evolutionary pressure to refine its trickery—its future survival absolutely depends on it.

When a fledgling cuckoo reaches adulthood she will seek out the same species that raised her, and play the same trick on them that her mother did.

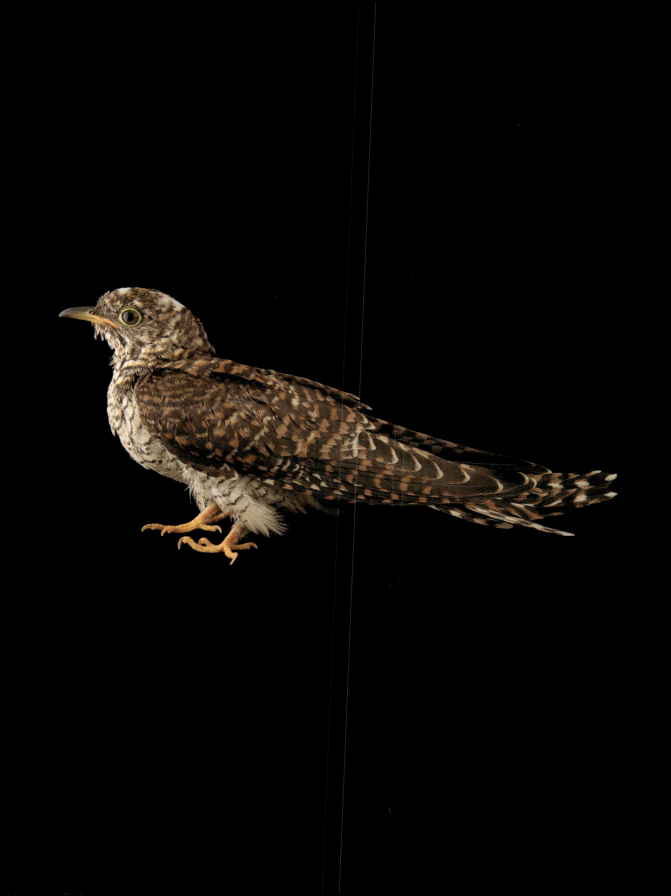

SPOTTED HYENA *CROCUTA CROCUTA*
Might of the matriarch

Spotted hyenas are often cast as the underdogs in the savanna hierarchy of predators. This is unfair on several levels. For a start, they belong to the cat rather than the dog branch of mammalian carnivores, so "undercats" would be more appropriate. And secondly, they have a more advanced and elaborate social system than many a bigger and badder carnivore—more akin to a troop of primates. Their brains also resemble those of advanced primates in size and structure. With their great intelligence and organizational skills, they are a force to be reckoned with and have enjoyed impressive success as a species (they are more numerous than any other large African carnivore). However, theirs is far from a caring and supportive culture.

Hyena society is female-led, and the alpha female is the biggest and most dominant animal in the clan. All female spotted hyenas' daughters automatically take the rank directly below hers (displacing any of her older sisters), so when the clan leader dies, her youngest adult daughter takes over. She has already been equipped for dominance by androgens (masculinizing hormones) while in utero, which are responsible for female hyenas' larger size as well as their male-like genitals (including a pseudo-penis, through which females must not only copulate but also, with considerable difficulty, give birth). Lower-ranking female cubs receive a much lower androgen dose, so are much less masculinized, in both anatomy and propensity for aggression.

The strict rules of sociality within a hyena clan are enforced through ritualized aggressive and submissive behaviors that begin from birth—cubs are born with open eyes, sharp teeth, and a fighting spirit; cubs killing their siblings within days of birth is not uncommon. Relationships are somewhat modified by relatedness, with high-ranking females tending not to bully their own fathers as much as they do other males, and unlike in some other social mammals, other females besides the alpha are allowed to breed. However, their cubs' fate is sealed from conception, and low-ranking males in particular can have a very miserable time. It is curious that, in this species, females achieve power and rank through extreme masculinization, while actual males are diminished and downtrodden.

Hyena culture is complex but at the same time rigidly structured, and the prospect of rising through the ranks is out of reach to all but a few.

Many ant species are perpetrators or victims—or both—of slave-making or other forms of social parasitism. For example, in *Myrmica rubra*, shown here, miniaturized queens ("microgynes") do not establish their own nests but instead invade those occupied by older normal-sized queens, co-opting the workers to raise their own young.

SLAVE-MAKING ANT *ROSSOMYRMEX SPP.* AND OTHERS

Child-snatching

Brood parasitism in birds such as the common cuckoo is a well-known phenomenon. It also occurs in social insects, but the tactics are rather different and, in the case of slave-making ants, governed more by force than cunning. Slave-making behavior in ants has evolved independently in several unrelated groups, and in some cases is just a sideline, while for others—such as the four species in the genus *Rossomyrmex*—it is a permanent and all-encompassing way of life.

The term "slave-making" may seem extreme, not to mention controversial, but it remains in use at present to describe the way these ants obtain their workforce. The first act of a young *Rossomyrmex* queen is to seek out a nest belonging to her host species (an ant of the closely related *Proformica* genus). She enters the nest and is not attacked by the workers within, thanks to powerful pheromone secretions from her Dufour's gland (part of her reproductive anatomy), which suppress their natural defensive behavior. She kills the *Proformica* queen or queens, then takes over, producing her own eggs, which the mind-controlled hosts tend and raise.

When the parasitized nest needs more workers, some of the new *Rossomyrmex* workers seek out another *Proformica* nest nearby. When one of them locates a nest, it returns home, leaving a pheromone trail that guides its sister workers to the location. An army of *Rossomyrmex* workers now invade the nest, and steal away numerous larvae and pupae. When these become adults, they fall under the influence of the *Rossomyrmex* queen and serve the colony just like those in the original captured nest, contributing all their energy to the continuation of *Rossomyrmex*, and achieving nothing for the future of *Proformica* whatsoever.

Whether we think it right to call these abducted ants "slaves" or not, the interesting truth is that they are not forced to work through any obvious physical means. Mind control is the term that fits, although using that term presupposes that these tiny insects do indeed have a mind of their own (until they don't). The efficient functioning of an ant colony owes much to the pheromones used by both queen and workers to influence the behavior of others. Some even confuse invading enemy ants, compelling them to attack each other. That some species have so effectively coopted pheromones to exploit others betrays the weakness in an otherwise extremely impressive social system.

GRAY WOLF *CANIS LUPUS*
Team tactics

There can be few wild animals whose influence on humanity has been as profound as that of the gray wolf. We have shared territory with it ever since our own species migrated north from our African homeland and into the northern forests and tundra of Eurasia and North America. Our folk tales record our fear and respect for wolves, and even today, city dwellers who will never meet a wolf in the wild will still shiver when they hear its distant howl in a movie. Every pet dog that relaxes on the sofa of a human home is a direct descendent of wolves. When we began to domesticate wolves around twenty-three thousand years ago (the very first animal and still the only large carnivore ever to be domesticated), we set in motion the development of an extraordinarily complex and rewarding interspecies relationship. Yet wolves living in their natural state still enchant us, through the powerful essence of wildness that they retain.

The preferred prey of wolves over much of their range is deer. A big bull elk or moose will mean they need not hunt again for a few days. In some areas, packs also hunt bison, which carry more meat but are even more challenging. The wolf's biology is adapted to a feast-or-famine way of living—it can stuff down 20 pounds of meat at a sitting (a wolf itself only weighs about 90 pounds), but it can survive and even carry out strenuous hunting for several food-less days if it has to. The ability to endure hunger is matched by its ability to endure hard work, with hunts lasting hours or even days in some cases. Enduring constant disappointment is another wolfish skill, because their success rate can be around 10 percent or lower. They do, of course, have the option to tackle less difficult prey, but in the Arctic winter, small animals tend to go to ground or leave altogether (many Arctic-breeding birds, for example, migrate south in fall), so while they establish a territory in the breeding season, in winter their best bet is to follow the herds of large, hardy grazing mammals carrying out their own on-foot migrations through the long, cold months.

A group of wolves that lives and hunts together is known as a pack, with the very term "wolf pack" evoking cooperation, close bonds, and a whiff of danger. The notion of the "alpha wolf," however, is misleading. A wolf pack is a family, comprising a breeding pair, who are also leaders of the hunt and the first in the pack to eat, and a number of subordinate younger wolves. These are their

Although we think of wolves as the ultimate pack hunters, they actually often fare better when working alone and targeting smaller prey.

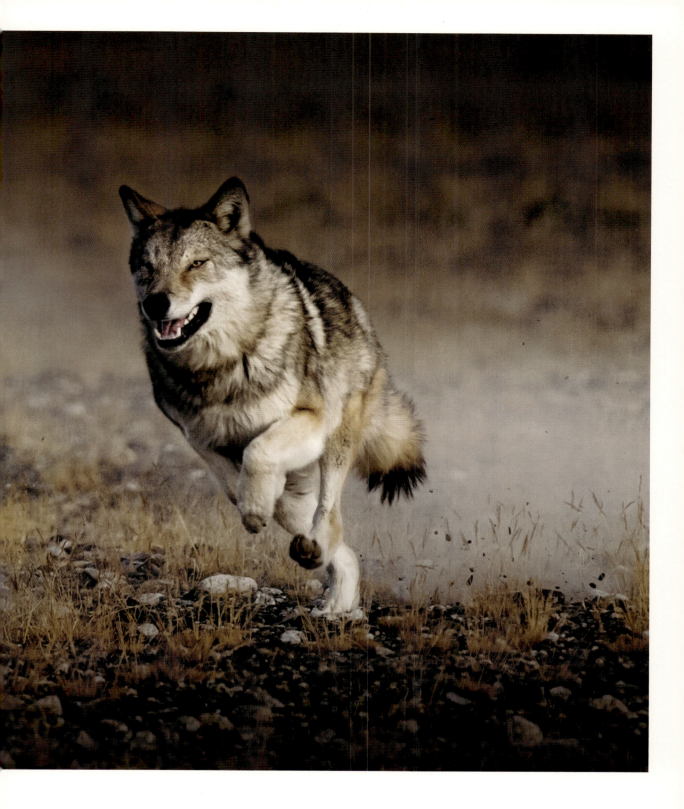

Lone wolf: Teamwork allows a pack to take on bigger prey, but wolves that hunt alone enjoy a higher hit rate overall.

GRAY WOLF *CANIS LUPUS*

offspring from the previous two or three years, and they have their own hierarchy, with the lowest-ranked individual being the most frequent target of bullying and also the most frequent initiator of play. There are usually five to eight active adult and young-adult pack members in total. Young wolves usually leave the pack around the age of three, but this can sometimes happen before they are even a year old, depending on factors such as competition for food within the pack. They temporarily become lone wolves until they meet another lone wolf of the opposite sex. Then, if they get along, they pair up, find a territory, and begin their own family.

The illusion of efficiency

A typical winter hunt begins at dusk, and may continue all night. Wolves lope 5½ miles per hour when following prey, but can sprint at 30 miles per hour for at least twenty minutes. The pack speeds up when they are close to prey and (if they're hunting a herd) have chosen an individual to try and isolate, which they do by encircling it. Those closest to the prey will then attempt to jump and bite at its hindquarters. Once the prey is sufficiently weakened, one or more try to wrestle it down by grabbing its head, although they may wait and guard it for some time, to recover their own strength before making the kill.

The way wolves isolate and circle their prey, preventing it from escaping, appears to show evidence of complex communication between pack members. However, computer modeling has shown that a "virtual wolf-pack" can replicate this behavior if you program the members to follow just two simple rules. Rule 1: approach to a close but safe distance (dictated by the particular prey's defensive capabilities). Rule 2: move away from other wolves that have also moved into position. Real wolves also prefer to hang back and allow others in the pack to undertake the risky initial attack phase, which affects the ability of the group as a whole to complete a hunt.

It is therefore not necessarily surprising to learn that pairs and lone wolves often hunt more successfully than large packs; even for wolves that are in packs, much summertime hunting is done solo. Their skill and success rate as lone hunters, tackling less formidable prey, enables and perhaps also encourages young wolves to go it alone for many months while waiting for their own opportunity to breed. Young wolves' presence in the pack benefits their parents for as long as it lasts, because the breeding pair get to eat their fill no matter what, but as the young wolves gain strength and skill, the benefits of pack membership are steadily outweighed by the costs of being subordinate.

While we think of wolves as running hunters, they have also been observed to use ambush methods, specifically to catch beavers. Since beavers can smell wolves but are shortsighted, wolves choose a spot downwind of a beaver lodge (sometimes in full view) and sit absolutely still for as long as twelve hours, waiting for one of the rodents to leave the lodge and wander or swim into pouncing range. Their patience is all the more impressive given that around 75 percent of documented hunts of this type are unsuccessful.

Cherry-picking from a genome

Every one of the diversity of domestic dog traits derives from wild gray wolves—winkled out of the same basic genome through selective breeding (plus the odd genetic mutation). However, domestic dogs have lost something along the way: a wolf-sized dog has a distinctly smaller brain than its wild ancestor. This is a well-known and widespread phenomenon among domestic animals of all kinds, but doesn't necessarily mean they are less intelligent overall; rather, that specific brain regions are smaller, such as those that govern aggression and fear responses. The comforts of domestication make these attributes less critical for survival, and certainly less desirable from an owner's point of view. Through selective breeding, we have tweaked the wolfish character to suit our wishes, but nevertheless, many of our dogs' most admirable traits are still very much in evidence in wild wolf packs today.

BLUESTREAK CLEANER WRASSE *LABROIDES DIMIDIATUS*

A slippery scam

Car looking a bit grimy? Try a roadside car-wash. For a modest fee, you leave with a spotless vehicle, and other potential customers can see what's on offer. It's a win for everyone. But what if a cleaner also broke off and pocketed your side-view mirrors or windscreen wipers? Not such a good deal any more.

Coral reef-dwelling cleaner fish, such as the delightful little bluestreak cleaner wrasse, hang out in groups at "cleaning stations." Other fish visit and allow the cleaners to pick parasitic crustaceans from their bodies. The parasites are food for the cleaners, and the clients are glad to be rid of them. But the clients have something else that's much more appealing to a female bluestreak cleaner wrasse—body mucus, full of the nutrients she needs when she's forming a batch of eggs. With her body producing up to one thousand eggs per batch, she has quite the appetite for mucus.

If the client realizes its cleaner is stealing mucus, it will leave. The cleaners, therefore, make careful decisions about who they swindle. The preferred victims are larger fish, which have more mucus to be stolen, and the cleaners entice them in by demonstrating an honest service for smaller visitors. Also, scamming is more frequent at isolated cleaning stations, with a more captive market. Only the very largest and fiercest fish—capable of delivering swift and deadly punishment—are never cheated.

If enough fish are scammed and enough are witness to it, they may avoid that station altogether, which is bad for all the cleaners but especially the males, who rarely, if ever, try to cheat the system. So if a male bluestreak cleaner wrasse spots a female colleague taking more than she should, he chases her aggressively, discouraging her from cheating again in the near future. This could be interpreted as a moral code in action—wrongdoing is punished and reoffending is lessened. Of course, the male does this out of self-interest, to safeguard his own food supply, rather than out of outrage on behalf of wronged clients, but are our moral codes any different, at heart?

As well as having a devious streak, this fish has also passed the mirror test (see page 132). Test subjects with marked faces tried to clean themselves when they saw their reflection.

7

RESILIENCE
Mental Fortitude

RESILIENCE MENTAL FORTITUDE

In 2014, a short piece of home-surveillance footage from Bakersfield, California, went viral. It shows a four-year-old boy playing on his bike, just outside his home. A neighbor's dog runs into the frame, grabs the child, and drags him to the ground. Then a cat—who turns out to be the boy's family pet, Tara—races into view and launches herself at the dog, hitting it hard in the neck with all four feet. The dog releases the boy and flees, with the cat in hot pursuit, then moments later the cat returns to the boy.

The incident was over in just a few seconds. The boy required stitches but his family acknowledged that, without Tara's intervention, things could have been so much worse. We might marvel at this cat's devotion to her family members, and feel bad for ever having questioned feline loyalty, but what's most immediately striking is her sheer courage, attacking a predator much larger than herself with absolute commitment, despite the risk to her own life. We can't help but find this hugely admirable, and the animal world is replete with examples of similar acts of mental fortitude.

For many animals, just staying alive moment to moment means dicing with death. Every predator has to attack and kill in order to eat, and every prey species has to forage for its own food under the eyes of predators that may strike at any moment. There is no way of avoiding these dangers. However, there are ways to balance the level of risk. Every day, animals of many different species make numerous decisions on whether to take a risky option—and be well rewarded if it pays off—or to play it safe, but miss out on the reward.

Fear and stress takes its toll on both mind and body. Subjecting oneself to moments of extreme risk, again and again, requires physical fitness but also a certain tough-mindedness. The same goes for dangers that

are less intense but much more long-lasting—feats of endurance, if you will. Perhaps this is a long and exhausting journey, or making it through a period of starvation. Some species have a way of life that repeatedly calls upon them to push their limits in this way, and only the toughest will survive.

Studies on various species show that there's considerable individual variation in how much risk an animal is willing to take, and how much stress it can tolerate. For example, one study in the UK showed that when female great tits are approached at their nests during incubation, some individuals will sit on their clutches of eggs more tenaciously than others. And if a sparrowhawk scares great tits away from a bird feeder, after the disturbance, some will consistently return sooner than others. We only need to look at our own species to see huge disparities in risk-taking behaviors and the general ability to handle stress. Risk-takers may harm their odds of survival, but they are also more likely than the comfort-seekers to win big. In the case of intelligent, social species that learn from one another, like us, a big win for one individual can result in a step forward for the whole community. Conversely, a big fail can serve as a lesson to us all that it's best to hang back: "No risk, no glory" versus "Pride comes before a fall."

Another study on captive great tits showed that variations in a single gene can account for significant differences in how willing the birds are to explore new objects placed in their environment. A dangerous environment would see the more cautious faring better, while fewer dangers and more positive opportunities of different kinds would benefit the health and reproductive success of those less risk-averse. Expand this again to an entire ecosystem, in which animals can live in all kinds of ways, and we can see how evolution shapes the resilience of each species in differently.

HONEY BADGER *MELLIVORA CAPENSIS*
Ultimate fighter

What is the most feared and fearsome animal in the whole of Africa? Some would say the lion, some the hippo, and some smart alecks would point a finger at the malaria-carrying mosquito. One or two, though, might respectfully whisper "honey badger" and, if asked to expand on that, would describe an animal so utterly tough, fearless, and powerful that we humans should thank our lucky stars that it's only 3 feet long and rarely exceeds 33 pounds in weight.

Honey badgers, or ratels, live over much of Africa and also parts of southern Asia. They belong to the weasel family, but unlike the slim and slinky least weasel we will meet later (see page 179), a honey badger is built like a small tank, with a no-nonsense monochrome paint job. It isn't the fastest runner, and is much smaller than many other predators in its habitat, but it makes up for this by being nearly indestructible. Its skin is both thick and loose-fitting, meaning that it's very difficult for another animal to grab, hold, or hurt it with claws, teeth, or spines. Its own weaponry includes massively powerful claws, and short, deep jaws that power a bite force stronger than a lion's. It's actually not that predatory, with dug-up insects, carrion, and plant matter making up a fair proportion of its diet, but it can also kill a wide range of vertebrate prey, and good luck to any animal that tries to start a fight with it. Even Africa's most dangerous venomous snake, the black mamba, will come off worse in an encounter between the two.

Video footage from Zambia, in 2020, recorded the memorable spectacle of a pride of lions trying, and failing, to take on two honey badgers. Perhaps the seven lions thought that their superior numbers would prevail. One of the lionesses manages to get her jaws around one of the honey badgers, but almost immediately, the badger bites back. The lioness drops it and rapidly backs away as the badger rushes at her, tail erect and teeth bared—being mauled by a lion having inspired fury rather than terror. There are similar videos online of honey badgers intimidating leopards and spotted hyenas too. This is an animal that knows exactly how tough it is, and can back up that strength by taking the fight to anyone and anything, any time.

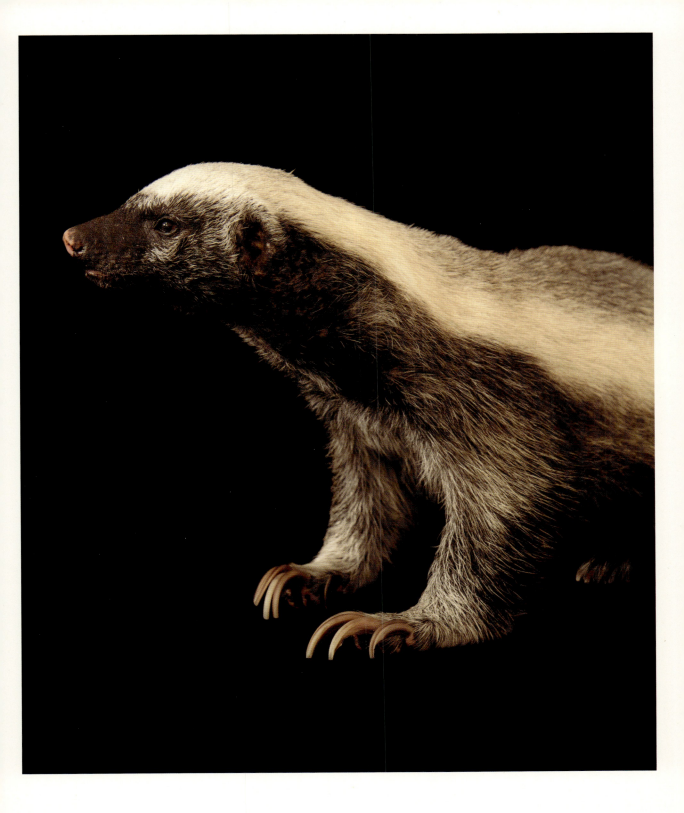

Severance claws: the honey badger is well armed with physical weaponry, backed up by a truly spectacular level of self-belief.

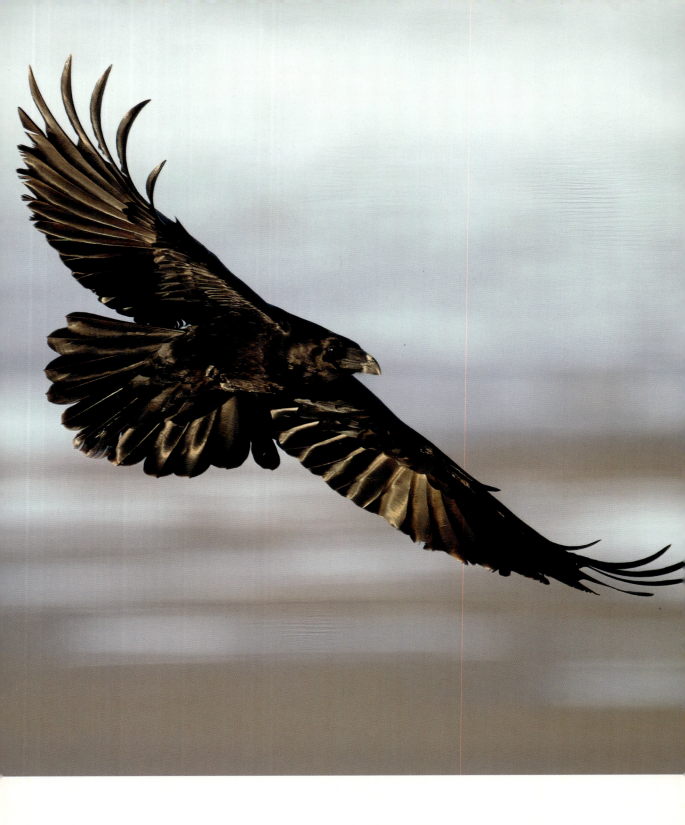

Many First Nations stories are told about ravens that make mention of their great wisdom but also acknowledge their wilder, daredevil side.

COMMON RAVEN *CORVUS CORAX*

Dancing with death

Bird brains don't come any better or brighter than that of the common raven. We have already explored this bird's impressive cognitive capabilities (see page 31) and, given that it's a species of great adaptability, it's no surprise that it's also highly curious and (when appropriate) highly courageous, too. But being brave isn't always about the headlong, thoughtless leap into action—sometimes making a risky choice requires a lot of thought. If you know that your way of life will bring you face to face with these kinds of choices, you might also benefit from practicing and testing yourself in somewhat risky scenarios. One of the ways that ravens do this is through play.

Playfulness is a way of practicing survival skills in a safer setting; it doesn't carry the same chances of reward as serious endeavor, but nor does it carry the same risk. A cat only plays with its prey when it's dead (or seriously incapacitated)—the reward has already been secured, so the cat can put in a bit of time playfully practicing its hunting and killing skills without the risk of losing its meal. Lambs leap and frolic when they feel safe—if there was danger around they would be more still and vigilant, if not racing for their lives. Play could be described as playing at risk-taking, but sometimes play does become genuinely quite risky.

As we noted in Chapter 1, ravens sometimes engage in aerial chases with peregrine falcons. The link between these two species soon becomes apparent to any birder who spends time in their habitat, which usually means wild and craggy landscapes, especially coastal, across much of northern Eurasia and North America (though both species are also increasingly found in urban areas). When they meet in the air, the raven typically seeks to engage the falcon in play, and behaves much as it does when playing with a fellow raven. It will chase the falcon, then fly above it before tumbling down to fly below it, roll over to show its belly, and wave its feet at the other bird; it may even snap at the peregrine's wingtips or tail. You might see ravens carrying on in a similar manner with other bird species, such as carrion crows, but a carrion crow poses no danger to a raven, while a peregrine falcon very much does.

The behavior is distinct from mobbing, whereby several individuals of prey species try to chase a predator away. Mobbing is risky, but birds only tend to mob a predatory bird when they have reason to believe that it's not in hunting mode—

for example, an owl discovered sleeping in its daytime roost, or a hawk that already has prey (or is sporting a bulging crop, a pouch on the front of its neck, indicating that it's just eaten). They also usually mob in groups—going in mob-handed, as it were—so each individual's risk is reduced. The raven playfully challenges the peregrine in flight, and peregrines make almost all of their kills on the wing, by stooping headlong at high speed onto prey, hitting it at top speed with an impact so forceful that the prey is often killed instantly. So powerful is this attack that peregrines regularly kill birds larger and heavier than themselves—larger and heavier than ravens, too. By flying below the peregrine, the raven almost seems to be provoking the falcon into making its trademark attack. Yet these encounters rarely end in bloodshed. If the peregrine does prepare to stoop, the raven can take evasive action—it is watching its adversary every moment, after all. So stoops may happen but rarely with full commitment. The peregrine has a much higher chance of success if it targets prey that is less wily and aware. Whether peregrines find the attention of ravens an irritant or not is difficult to know—certainly a raven's presence close to their nest is not at all welcome (ravens, like all members of the crow family, are highly omnivorous and will take eggs and chicks from an unattended nest), and this is when the falcon may respond more fiercely. However, peregrines do also appear to prefer nesting in areas where ravens also nest, probably benefiting from the ravens' alarm responses if another predator appears in the vicinity.

What does the raven get out of scrapping with the peregrine? The answer may be a question of "know thine enemy." Ravens have few predators, but a peregrine could certainly kill an unwary raven and would also grab its yet-to-fledge chicks from the nest, given the chance. Knowing exactly what the local peregrine looks like from every angle, how it behaves in different circumstances, the signs that it's about to stoop, and how much time this allows for an easy escape—all of this is potentially life-saving information for the raven's memory store. We've already seen how clever ravens are (see page 31), and studies show that it can remember the key points of a dangerous encounter for years.

Forget-me-not

An ingenious study by Christian Blum and colleagues at the University of Vienna in 2020 introduced captive ravens to a "dangerous" human and a "neutral" one. In fact, it was the same human both times, an experimenter who wore the same clothes, but one of two plastic face masks. When the experimenter wore the dangerous mask (which had black hair, a mustache, and teeth exposed in a grin), he was carrying a dead raven. When he was in the neutral mask (with dark red hair, no mustache, and no grin) he carried nothing. The masks were otherwise very similar—Caucasian male faces with comparable dimensions, hair length, eyebrow shape, and so on.

However, most of the ravens learned the difference instantly, and thereafter would alarm-call on sight of the dangerous mask, even if the experimenter was empty-handed. Most impressively, they retained this knowledge and continued to show this response four years after the initial test, even though the dangerous mask was never again associated with dangerous behavior.

For ravens, the potential advantages of genuinely risky play with peregrines are apparent, as a way to learn as much as possible about the dangerous playmate and be better prepared for all future encounters. Is it possible that ravens derive an intense psychological thrill that's similar to that sometimes experienced by humans when their play becomes highly risky? Behaviors that help us survive often bring neurochemical rewards, whether this is a sense of comfort when bonding with a mate, or a sense of satisfaction after a wholesome and filling meal. Taking adventurous risks can also help us survive, by honing our skills and opening up new opportunities, and our brains reward us with a sense of profound excitement and pride. For us, it may be triggered when climbing a cliff with no safety ropes, diving deep underwater with no scuba gear, or standing up to speak in front of an audience of thousands—perhaps, for a raven, tweaking the tail of a deadly killer brings the same heady thrill.

SNOW LEOPARD *PANTHERA UNCIA*
Into the void

The two animals are little more than specks in the camera frame, moving rapidly across a harshly beautiful Himalayan landscape of snow-covered rocky ridges. Zoomed in, we see the one in front, a bharal or blue sheep, running full tilt toward a cliff edge. Unable to stop or swerve in time, it falls, just as the one behind, a female snow leopard, leaps into the abyss and seizes the sheep in midair. The two are now locked together in freefall. They hit the slope hard, jolting apart, and (miraculously, it seems) both get to their feet. The sheep is running again but only for a moment—the cat leaps onto its back, knocks it off its feet, and once again they are tumbling fast, hundreds of feet in mere seconds, down a precipitously steep rock-strewn slope.

It seems that this can only end one way—with smashed bones and broken necks for both. But the snow leopard still doesn't let go. And when we watch back in slow motion, we can see how she twists and turns in the air, controlling her position so that the poor bharal takes the impact of every bump and bounce through the long fall. By the time they reach more level ground and their fall slows and stops, the bharal is critically injured. The snow leopard is injured and exhausted too, but still strong enough to kill her prey and drag it to a safe, sheltered spot. Now she can eat, rest, and recover. This unusually intense hunt was caught on film in the Himalayas, and was the first ever footage of a wild snow leopard tracking and killing prey.

Hunting can be hugely risky for many predators, although the danger usually comes courtesy of a particularly strong and well-armored prey, rather than the physical environment itself. But it's hard to imagine a more extreme hunting experience than this—the snow leopard chooses to throw herself off the edge of a mountain rather than wave goodbye to a potential meal, and is in the middle of a huge and quite possibly fatal fall when she actually catches it. She is the alpha predator of this wildest of landscapes, but prey is sparse and no opportunity can be wasted so, clearly, when on the hunt there is no room for hesitation.

Its beautifully dense coat allows the snow leopard to endure severe cold weather, and its fearless determination as a hunter means it can survive in a realm inhabited by scarce, agile, and wily prey.

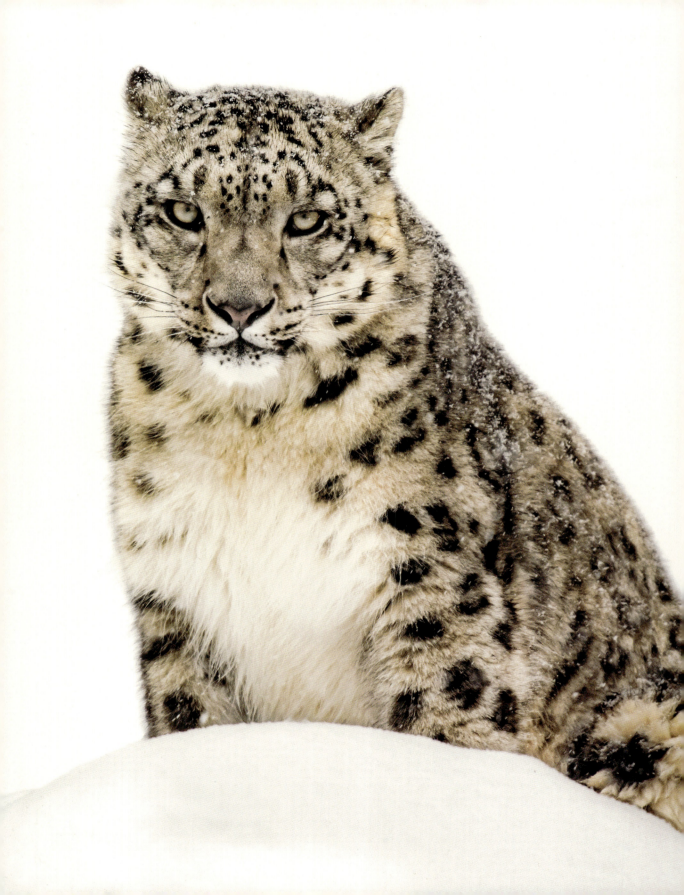

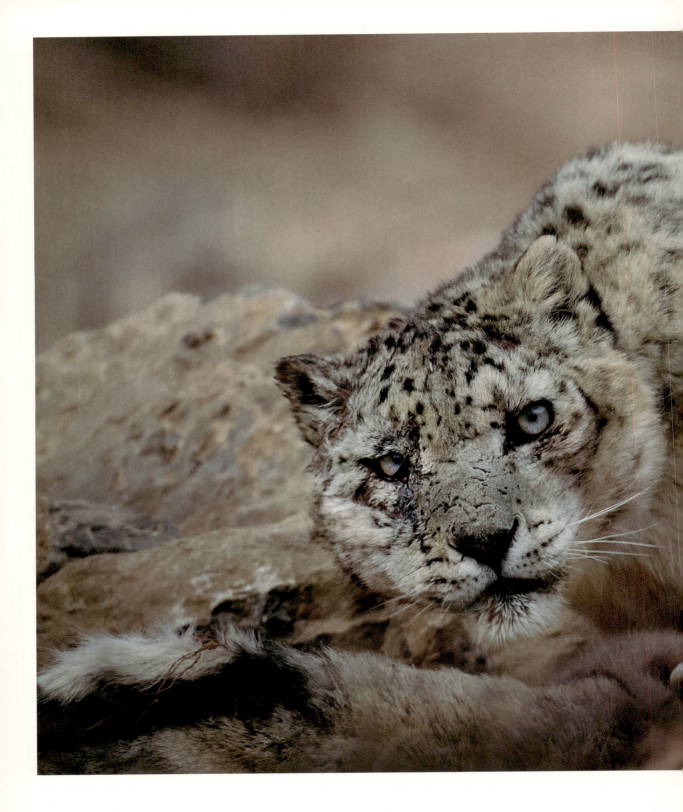

Not many meals are this hard-won. A snow leopard may risk its own life every time it hunts a bharal.

SNOW LEOPARD *PANTHERA UNCIA*

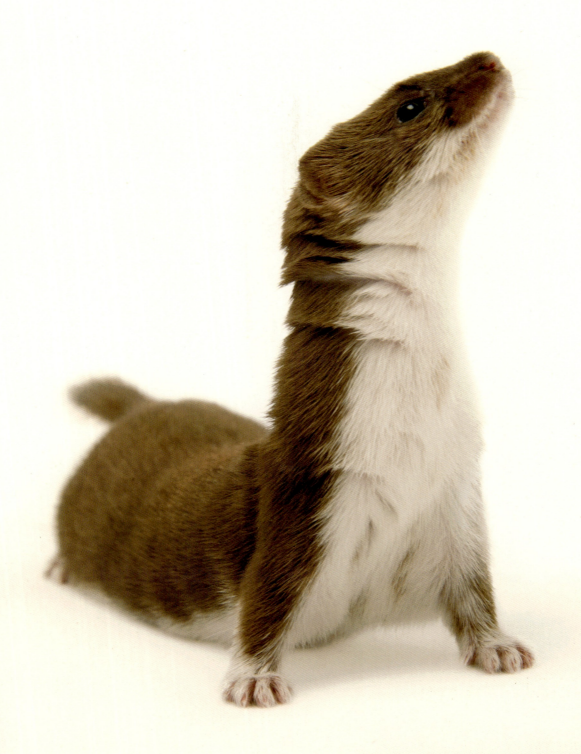

The living embodiment of "small but mighty," the least weasel is one of the planet's most successful carnivores, with ambitions that far outstrip its physical size.

LEAST WEASEL *MUSTELA NIVALIS*
David and Goliath

When we think of brave animal species, our natural biases lead us toward the hunters, such as lions, leopards, wolves, and bears. To our minds, they are brave because they take the initiative, launch the attack. All four are members of the mammal order Carnivora, and all are big and powerful enough that we know we should fear them, and that (unless we happen to have a weapon) they don't need to fear us. However, they often do fear us anyway. If we want to find true fearlessness among the carnivores, we should start not with the biggest, but with the smallest of them all: the least weasel.

The least weasel is found across a very broad swathe of the northern hemisphere, and it varies quite dramatically in size across this range, but the most hefty males of the biggest subspecies still only weigh around 7 ounces, and an adult female of the smallest subspecies may barely tip the scales at 1 ounce. Least weasels belong to the Mustelidae family—which also includes otters and badgers, martens and skunks, and the mighty wolverine, and, as a whole, is made up of mammals that are noted for being bold to the point of recklessness. This trait seems to be distilled down into a startlingly concentrated form in the least weasel, which fears no man or woman, and probably no lion, leopard, wolf, or bear either.

If you imagine a mouse or vole that has been stretched out for a while on a medieval rack, you have a fair idea of the least weasel's body shape. It has short legs but a long, sinuous body, and its small cross-section and flexible form allow it to pursue its favorite prey (the aforementioned mice and voles) into their tunnels and through any tiny gap that they may try to squeeze through. When it catches up with its victim it goes straight in with a bite to the neck, and its short but sturdy jaws deliver a force that's proportionately much greater than that of most larger carnivores.

Even though evolution has shaped it into the perfect mouse muncher, the least weasel's predatory ambitions go much further than this. This is a species of many different habitats, including very northerly places that become snow-covered in winter (the weasel's fur becomes white to match). Small rodents can become harder to find in these conditions, hibernating deep under layers of snow and earth, so least weasels need to be able to tackle a diverse range of prey, and they embrace this challenge with their characteristic no-holds-barred attitude. The

very long list of recorded prey species for least weasels includes European hares and capercaillies; the former may weigh as much as 11 pounds, while the latter is the largest member of the grouse family, with males averaging 9 pounds. Any other predator might at least hesitate for a moment before tackling something twenty-five times heavier than itself, but "hesitate" is not in the least weasel's vocabulary.

A wild ride

Weasels are, nonetheless, hunted themselves at times by larger predators, though they are far from easy prey. Gray herons often hunt in fields as well as water, standing very still before making a fast strike at anything that they spot moving through the grass. No problem if the moving object is a frog or a vole, but when a heron catches a least weasel the outcome is far less certain. Observers of this particular battle have noted how the weasel wraps itself around the heron's long bill and bites furiously at the bird's face, not even allowing itself to be dropped. The heron often ends up shaking off the tiny terror in desperation and leaving.

The most Internet-famous weasel-versus-bird moment came in 2015, when photographer Martin Le-May was out looking for wildlife in Essex, in the UK, and spotted a very agitated male green woodpecker flying by with a small, furry passenger on its back. The clearest of the shots revealed that the bird was being ridden by a least weasel. Seven years later, keyboard warriors continue to assert that the photos were faked, but interviews with Le-May and a look at the other images in the sequence show that they are genuine. For those of us familiar with least weasels, the only surprising thing about this story is that the woodpecker was able to take off and fly with the weight of a weasel not much smaller than itself on its back. But choosing to attack a woodpecker, and refusing to let go even after becoming airborne, is wholly in keeping with the least weasel's extraordinary personality. The outcome of this incident, by the way, was that the woodpecker landed on the ground again, and the weasel (perhaps distracted by Le-May's presence) lost its grip for long enough for the bird to escape.

Danger and opportunity

What makes the least weasel so brazen? People who have hand-reared baby weasels describe an animal that's full to the brim with curiosity and adventurousness. Every crack and crevice in an environment will be investigated, every opportunity to climb and leap will be seized upon, and everything will be done at a million miles an hour. This high-speed way of life reflects a very fast metabolism. A weasel must eat a quantity of food weighing a quarter to a third of its own body

weight every day to stay fit and well over its short life span (only 10 percent of wild least weasels make it to their third year), so nearly every waking moment is spent in the pursuit of prey—there simply isn't time to mull things over. Larger carnivores have less constrained energy budgets and much longer life spans, so they can live in a more measured manner. We see a similar approach to life in another group of very small mammals—the shrews. These insectivores include in their number the smallest mammal species on Earth (the 1⁄16-ounce Etruscan shrew), and they, too, know no fear. Their metabolism is even faster than the weasel's, with a heart rate regularly topping one thousand beats per minute. Consequently, they have to eat considerably *more* than their own body weight each day to survive, and they regularly kill insects and small vertebrates that match them in size.

For tiny hunters such as least weasels, extreme courage is therefore an evolutionary and metabolic requirement. We have long honored this trait in our legends about weasels. An Alaskan tale of a shape-shifting hero has him adopting the form of a least weasel to accomplish any task that requires extreme bravery. And the least weasel is said to be the only animal capable of tackling the dreaded wendigo of Native American folklore. Wendigos are described as colossal, horrific-looking monsters that kill and devour people, but according to legend a weasel can neutralize one by dashing into its anus—perhaps the most impressive of all its displays of fearless curiosity!

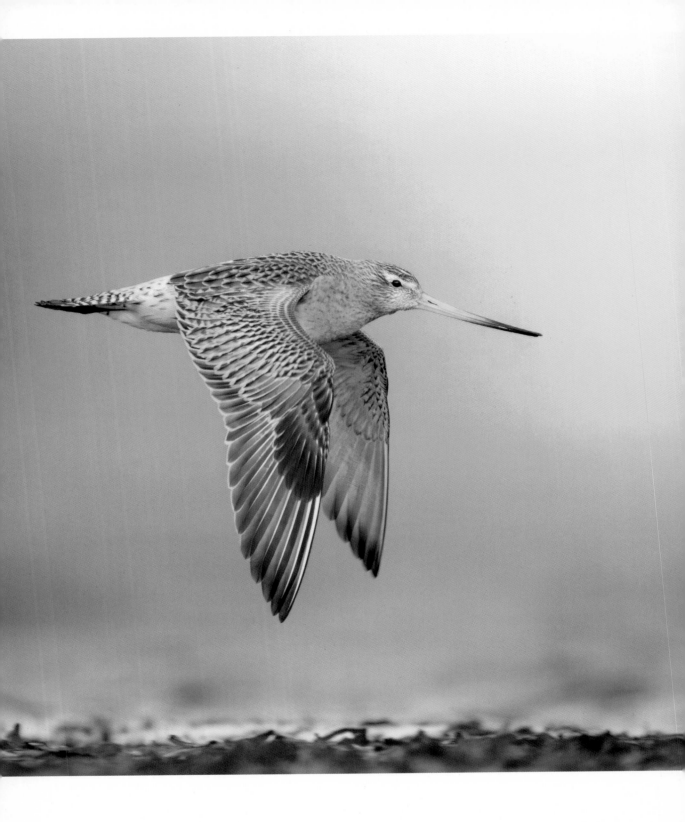

Victory isn't always about an all-guns-blazing struggle. For a bar-tailed godwit on its migratory flight, success hangs on gritty endurance over long days and long miles.

BAR-TAILED GODWIT *LIMOSA LAPPONICA*

A wing and a prayer

A wading bird flies over the Pacific. Under its wings, the sea inches by. You may have experienced similar on a long-haul flight—you glance out of the window occasionally but there's nothing much to see below, just endless water from one horizon to another. A few hours in and your enjoyment—or fear—of flying is long forgotten, and you are so bored you could cry.

Let's make things a bit worse for you. There are no movies on this flight. No music to listen to—not even a duty-free catalog to leaf through. Just you and your thoughts, and all that sea passing by so infinitely slowly beneath you. Holding out for that meal or complimentary coffee? Keep waiting—there is no catering on this flight at all. And actually, there isn't a plane either. You are flying with your own wings, and you cannot stop. Others might be able to rest by dropping down to float on the sea for a while but not you—you are a land dweller, and your body type is all wrong for marine floating. You just have to keep going. Now, finally, imagine that your flight isn't going to last six hours, or even twenty-four. Nowhere near. You'll be airborne for nine days. Or even more.

Let's forget all of that and teleport directly to a quiet estuary on the coast of New Zealand. A variety of shorebirds are here, walking or scampering across the mud and probing or pecking at the ground, seeking something delicious to eat. They run the gamut of shorebird shapes and sizes. Among them are bar-tailed godwits, which fall toward the bigger and longer-billed end of the spectrum. Each godwit weighs about 1 pound, has long legs, a very long bill, and plumage in a medley of streaky brown hues. They are not the most striking of the birds present, but when it comes to awe-inspiring physical prowess and breathtaking grit and determination, they are the undisputed kings and queens of this scene.

Before the advent of miniaturized, bird-friendly satellite-tracking gadgets, the migration of bar-tailed godwits was little known. The population of the species that breeds in Alaska (subspecies *bauri*) are long-distance migrants and spend their winters in New Zealand and eastern Australia. A lengthy journey, for sure, easily topping 6,000 miles, but the birds were thought to take a leisurely track, making their way down the east Asian coastline and stopping off whenever necessary for a rest and a refuel. However, tracking revealed that the actual journey is very different. They set out over the sea from their breeding grounds

and just keep going until they reach their destination, even if they happen to pass islands where stopping would be an option. On the return journey, they change things up, making at least one coastal stop-off on the way.

In 2007, out of a small group of tracked birds, the record breaker was a female, "E7," which flew nonstop for eight days from Alaska to New Zealand, crossing 7,260 miles of almost entirely open Pacific ocean. Studies continued, and in 2020 and 2021, a male, "4BBRW," was the record holder, with flights of 7,990 miles and 8,100 miles respectively. In 2022 the record fell once more, this time to "234684," which traveled 8,425 miles nonstop from Alaska to Tasmania in eleven days and one hour. The stats are all the more remarkable when we discover that 234684 was born in 2022, and made this epic journey aged just five months—its very first migration.

Mental toughness

The godwits show us that courageous behavior doesn't necessarily mean high drama and intense excitement. Feats of endurance are no less a demonstration of bravery and extreme risk-taking. Going eleven days without food might be physically and mentally possible for some humans, but it certainly wouldn't be fun, especially if they had to be constantly physically active. Eleven days without water, though? Humans can barely manage a week before dying, and that is in the most optimal conditions. Bar-tailed godwits clearly possess a physiology that makes this lengthy "dry fast" doable, but there's no doubt they are pushing the limits of what any bird could do.

For a feat like this, preparation is key, and the most important part of that is eating. Before they set off, bar-tailed bodwits gather at the central and southern Yukon–Kuskokwim Delta, where quantities of intertidal worms, mollusks, and the like can be hoovered up with abandon. After a few weeks of this feasting, they have achieved a body-fat percentage of 55 percent. At the start of the great binge, digestive organs such as the stomach, liver, kidneys, and gut increase in size, to help process all the extra food, but as migration day approaches, these organs shrink in size considerably (none of them will have much to do over the next week and a half). By contrast, the birds' muscles—in particular, the large pectoral muscles that power the flapping of their wings—increase steadily in size during the feeding period.

With fuel stores loaded, and flight power optimized, the godwits are ready to go. Once in the air, they must strive for maximal efficiency, so they depart when the prevailing wind is in their favor, and they select and constantly adjust their flight height to strike a happy medium between wind speed, temperature, and oxygen

availability. Studies on their bodily energetics show that if they took an alternative route along the coast, affording the opportunity for stop-offs, they would have to break their journey and refuel at least five times (adding more than 50 percent to the distance covered, as well as many extra days) before they could travel as efficiently as they do on the open ocean-crossing route. These numbers can be wobbled about a bit through conjecture about drag caused by the extra weight, but the overall picture is clear—it's better for their bodily economics to brave the sea crossing. Nevertheless, the feat is extreme, and at present no other shorebirds with the same breeding and wintering grounds are known to undertake it.

Is the sea crossing really the courageous choice, though? The main risk is obvious—running out of fuel and dropping, exhausted, into the sea to be devoured by some fortunate fish. The chances of being brought down by severe weather are not negligible either. However, other risks are actually avoided by staying at sea—no predatory birds hunt so far from land, and there's no danger of picking up a disease or parasitic infection while feeding with thousands of other birds. But what about the sheer monotony of doing nothing but overflying open sea for days? If we ever find a reliable way to measure an animal's capacity for tolerating boredom, hopefully the bar-tailed godwit will be the first test subject.

EMPEROR PENGUIN *APTENODYTES FORSTERI*
Icebound endurance

Every nature documentary set in the Antarctic shows the same scene—a huddle of emperor penguins under a dark winter sky, standing in stoic solidarity on the bare ice for two long months as the −40°F winds whip around them. It's a labor of love, or of reproduction at least, as each of these penguins is nursing a solitary egg that sits on his feet, tucked cozily under a fold of belly skin. The idea of all those penguin embryos, warm, safe, and growing within this utterly bleak scene, is moving, and we salute the fortitude of their devoted dads.

The moms, meanwhile, are out at sea, having a food fest of epic proportions. However, they have already gone through their own feat of endurance, making a 50-mile walk across the ice to reach the sea, after leaving their precious egg in the care of their mate. They are not built for walking—some smaller penguins can scamper and bound along, but the emperor is built for comfort rather than speed (on land at least) and its top pace is barely 2 miles per hour. That means the females must walk for days, through conditions nearly as unpleasant as those endured by their mates. Then, full of fish and squid, they must walk back, to be there in time to feed their newly hatched baby with the contents of their stomachs, while the hungry males (who will have fasted for four months in total, since first arriving at the colony) make their own long walk to the sea.

The emperor penguin is more superbly adapted to life in the water than any other bird. It can dive down to more than 1,480 feet, and spend thirty minutes underwater before needing its next breath. However, its avian evolutionary heritage means it still lays eggs that must be incubated on land, and this biological necessity forces it to put itself through the most extraordinary hardship. If animals could direct their own evolution, emperor penguins would be giving birth to live young rather than laying eggs within a few generations. As it is, this tie to the land places the species at high risk of extinction because climate change is reducing the sea ice that the penguins rely on to complete their reproductive cycle. And if the ice melts early in the season, before the chicks have developed their waterproof plumage and are ready to swim, they will drown, meaning their parents' long weeks of trekking, waiting, and hungering will have been for nothing.

Reunited. The return of his mate, to meet her newly hatched chick for the first time, means the end of a winter of extreme hardship for a father emperor penguin.

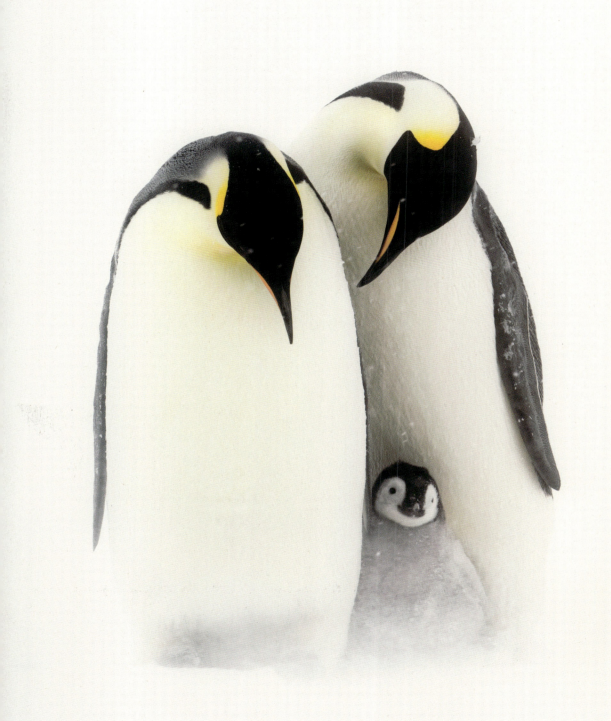

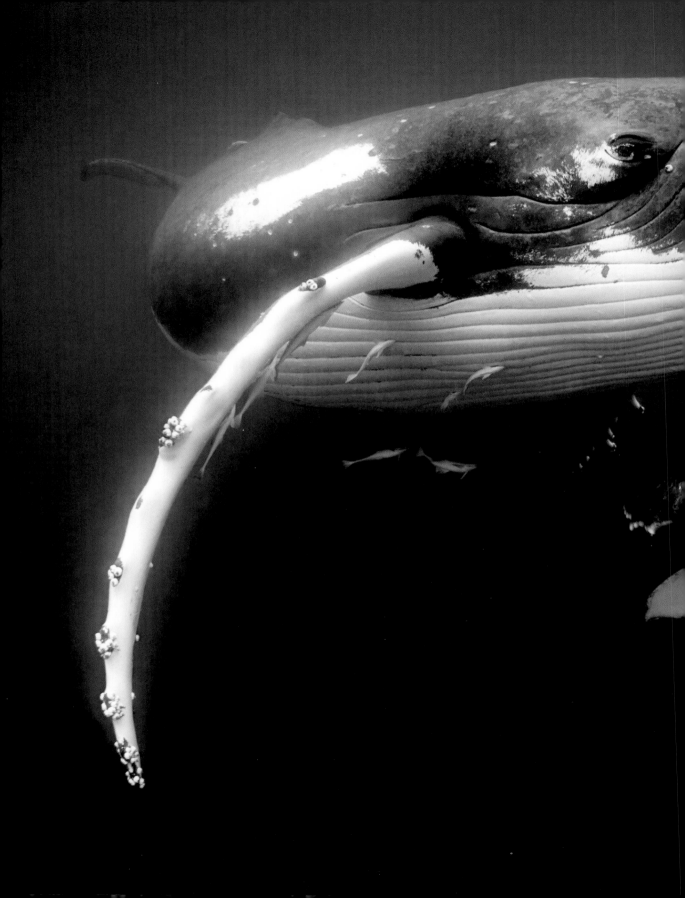

8

CARING
Above and Beyond

CARING ABOVE AND BEYOND

If there's one thing we humans prize even above courage, it's kindness. Conversely, we despise selfishness—taking without giving, whether it be resources, time, or simple consideration. We may also despise those who allow themselves to be exploited and cheated, time and time again, by a selfish person in their lives. Moral philosophers call it "the golden rule"—do unto others as you would have them do unto you. Kindness should be rewarded with kindness, but kindness should be withdrawn if consistently met with unkindness. A contract like this helps keep life harmonious in a social community, whether human or animal.

From this perspective, altruism is an illusion, in both human and animal behavior, and selfishness ultimately drives it all. This may be selfishness of the individual (giving is done in expectation of getting something back, sooner or later). It may also be selfishness of the genes (where an animal may sacrifice itself for its offspring or other relatives, so that the genes they share are more likely to make it to the next generation). But is there more to altruistic choices than a transactional tit-for-tat arrangement?

We would certainly like to think ourselves capable of acts of spontaneous kindness, even of self-sacrifice, toward complete strangers—without any requirement for reward or recognition. Now we wander into the realm of philosophy that deals with the existence (or not) of an objective, universal morality: We should choose to be kind whenever we can, simply because it's the right thing to do, even if we get nothing out of it ourselves. Then again, perhaps we are deluding ourselves that the warm glow attendant upon a generous act is "nothing," and that the self-esteem boost we receive improves our well-being and therefore our survival chances. If so, could that also be true for other clever and highly social animals?

Most examples of animal altruism are between family members, and so fit the "selfish gene" concept. The objective is to ensure the survival of your genes, and copies of your genes exist in your relatives' bodies too. In

other cases, generosity is reliably repaid over time—for example, vampire bats share blood meals with others that haven't managed to feed, but they give preferentially to individuals that have previously given to them.

However, we do see behaviors in nature that are hard to account for in this way. One example is spontaneous adoption, whereby an animal takes on the care of one or more infants that are unrelated to them, or even of a different species. Examples are abundant among captive animals—the cat who nurses a motherless puppy alongside her own kittens, or the dog that guides and guards a brood of ducklings. We find examples in the wild as well, such as the Kenyan lioness, Kamunyak, who attempted to adopt a succession of oryx calves and keep them safe from other lions (ultimately without success), or the bottlenose dolphin that cared for a lost melon-headed whale calf alongside her own baby.

Can we attribute these incidents to a surfeit of hormones, causing inappropriately targeted caring behaviors? Or could there be a more sinister explanation in some cases? Ostriches regularly "adopt" broods of chicks from other families, adding them to their own broods, but they always pick chicks that are younger than their own offspring. If a predator attacks, they are more likely to catch one of the younger, weaker, and slower chicks, giving the adoptive parents' own chicks a greater chance of survival.

Occasionally, we see adult animals acting protectively or demonstrating caring behavior toward other adult animals that are not part of their social group—sometimes not even members of their own species. These kinds of behavior amaze us perhaps more than any other, even though they are behaviors that we regularly engage in ourselves. We might puzzle endlessly over the evolutionary imperatives that may lie behind them, but perhaps we also need to consider the emotional experience of the caregiver, which may prove to be something we can truly relate to.

CAPE BUFFALO *SYNCERUS CAFFER CAFFER*
Headstrong heroes

Being a parent is tough, especially when you're surrounded by dangerous predators for whom your little one would make a perfect snack. There are many ways that evolution has helped to mitigate the risk—birds might raise their young in a well-hidden nest, cheetah cubs have a white topcoat that makes them look (at a glance) a bit like honey badgers (see page 168 for why predators might not go anywhere near something that looks like a honey badger), and many species produce such vast numbers of young that the odds are good that at least a few will survive. But a visibly vulnerable lone Cape buffalo calf must accompany its mother everywhere, so she must be prepared to defend it as best she can, even against a whole pride of lions. What she might have, though, is the backing of her herd.

Buffaloes are big and powerful animals, there are more of them in a herd than there are lions in a pride, and with a little organization they can mount a more-than-adequate defense. But that's not necessarily the clever or evolutionarily appropriate choice for them to make. They don't have the same genetic investment in the baby that the mother does, and by stepping in, they risk their own lives (and therefore the lives of any future young). Nevertheless, Cape buffaloes do come together to protect mothers and calves, and can do so very effectively. They might make a sort of bovine shield around mother and infant, blocking access for the lions with a circle of lowered, fearsomely horned heads. And, if the mother and calf do become surrounded, the herd may charge in as a group to try to scatter the lions, who may think twice about stalking a particularly courageous herd in future. Of course, lions are superb tacticians and may instantly switch plans, targeting one of the adults in the herd instead, so it's no easy choice to be brave. Anyone who has ever speculated that prey species could turn the tables on their predators with a little organization should keep an eye on lion-versus-buffalo dynamics—if evolution drives buffaloes to be braver, it will also drive lions to be cleverer.

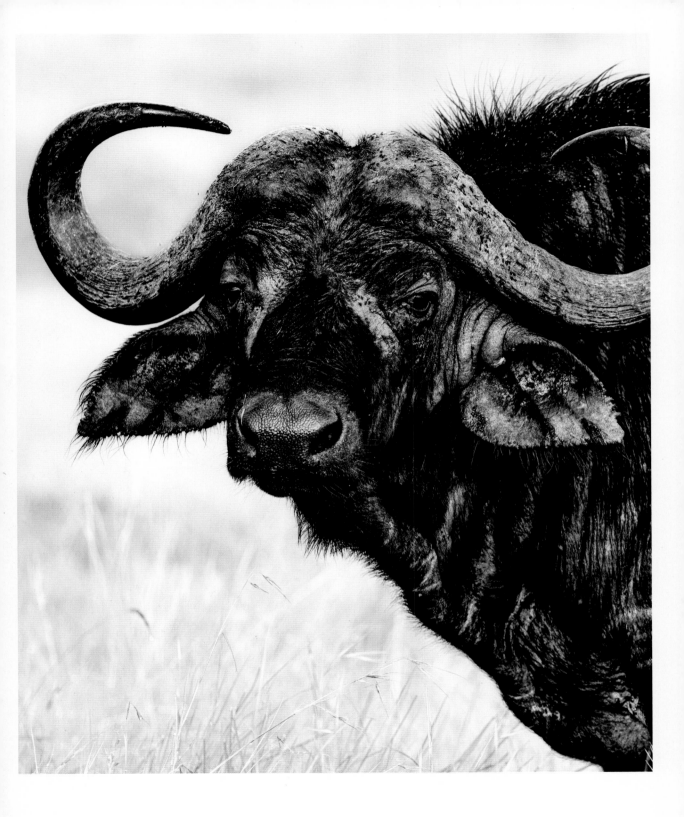

It might appear to be a placid grass-muncher, but the Cape buffalo is also a fierce and determined fighter when the chips are down.

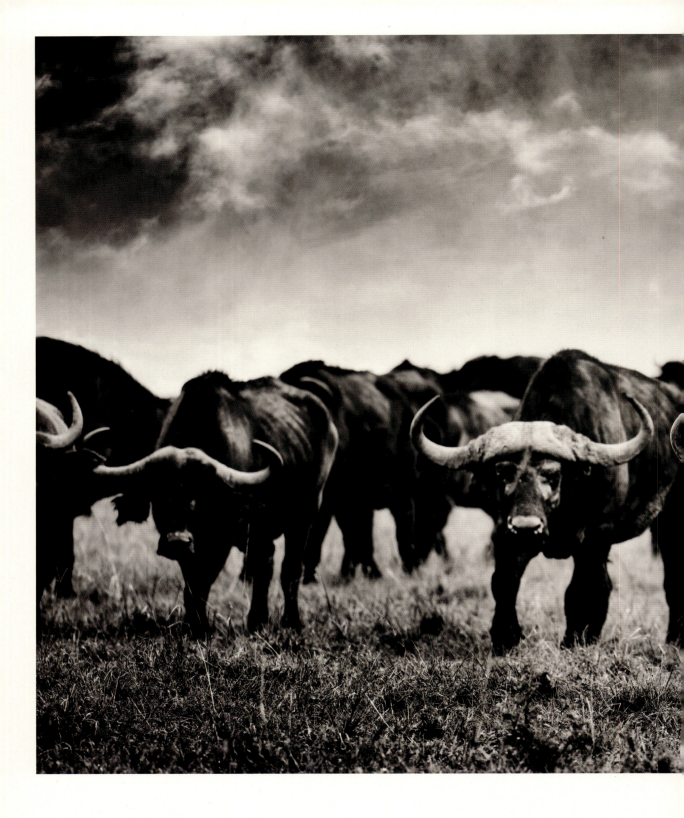

A wall of horns confronts any predator hoping to capture one of the baby Cape buffaloes in the center of this herd.

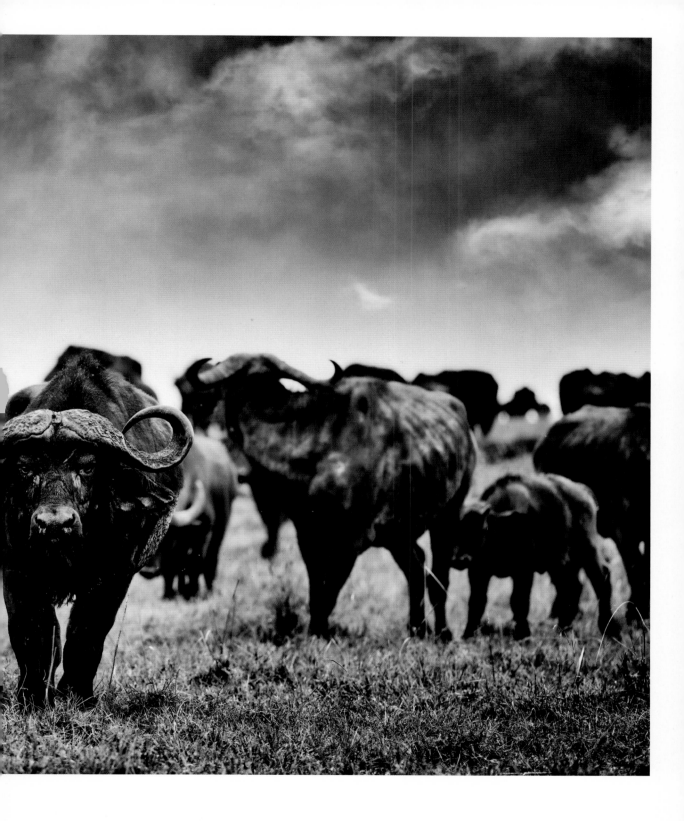

CAPE BUFFALO *SYNCERUS CAFFER CAFFER*

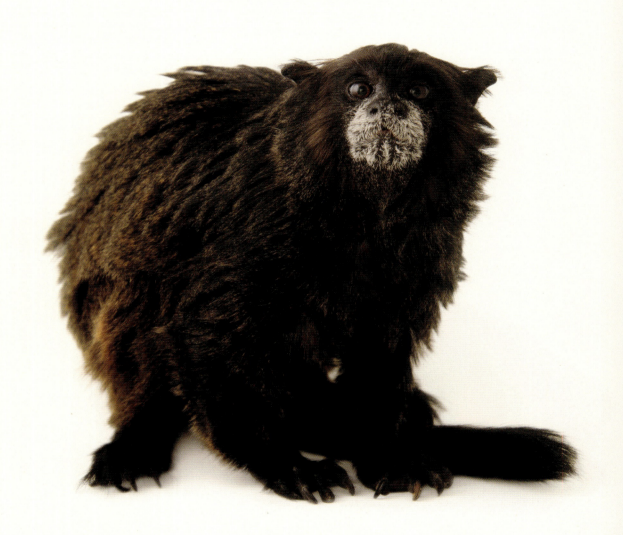

The tamarins and other American monkeys have an unusual and, some might say, impressively progressive approach to childcare.

BROWN-MANTLED TAMARIN *LEONTOCEBUS FUSCICOLLIS*

My two dads

Tamarins and marmosets are small monkeys, native to South America. They are ecologically similar to tree-dwelling squirrels. Many have colorful fur, sport arresting features such as huge pompadours or extravagant mustaches, and are much sought after (though profoundly unsuitable) as pets.

Brown-mantled tamarins and their relatives are unusual among mammals in being polyandrous (females mate with more than one male in a breeding season). A breeding female usually has two male partners, both of whom care for her young. In this case, the young are almost invariably a set of fraternal (nonidentical) twins, although they swap placental stem cells in utero, meaning that each has some DNA from its sibling (a form of genetic mosaicism). They may be fathered by either of the female's mates.

A mother tamarin must feed her own babies, but when feeding time is over it's time for dad—and dad—to step in. One tamarin can't safely carry two babies at once, so the mother gives one to each of her male partners until it's time for the next feed. When weaning begins, the dads provide the food. Over time, the babies form tighter bonds with their male caregivers than with their mothers.

Although they usually breed in polyandrous threes, tamarins live in groups, so the youngsters have social contact with many other individuals besides their parents. Infants spend most of their time with male relatives (or step-relatives), both adult and juvenile, tending to prefer their older brothers over their older sisters for both care and playtime. For tamarins, clearly it's necessary for males to be nurturers—indeed, when a male senses that the dominant female in his group is ovulating, he ramps up his childcare behaviors, to show her what an excellent parent he will make.

The biological fact that males can never be 100 percent sure of paternity drives certain unsavory male behaviors, from mate-guarding to infanticide. Tamarin dads, though, happily share parenting tasks even though they cannot be sure they are biologically related to the infant they are carrying. Any infant successfully raised to adulthood represents a chance of genetic investment, and the more help that the group as a whole can give to the mother, the better each youngster's chances of survival will be.

HUMPBACK WHALE *MEGAPTERA NOVAEANGLIAE*
Superhero of the seas

The humpback whale is one of the most distinctive and impressive of the world's cetaceans. It's a large species, usually some 50 feet long, with exceptionally lengthy pectoral fins. The leading edge of the fins and the head bear numerous bumps, or tubercules, which are full of nerve endings and probably have an important sensory role. Humpbacks can be hyperactive on the surface despite their great size, and they delight whale watchers with shows of breaching and whacking at the water with fins and tail. They are also known to be highly intelligent, with a complex communication system.

The marine biologist Nan Hauser knows humpback whales better than most, having often swum and dived with them around the Cook Islands, where she runs the Center for Cetacean Research and Conservation. Often the whales are curious and interactive when they meet her, but one individual ramped this up to an alarming level during a dive in 2017. The whale approached Hauser and insistently bumped her and tried to hold her under its pectoral fin. The encounter lasted ten minutes before a rather alarmed Hauser was able to get back onto her boat. She had feared the whale might crush or drown her with its apparently playful behavior, but on returning to the surface she saw something that made her reevaluate the whole experience—a large tiger shark swimming nearby. She realized that the whale's actions had shielded her from the shark, and she also discovered later that a second humpback had been close by the whole time, batting its tail at the shark and apparently trying to drive it away.

Similar apparent rescuing behavior in humpbacks has been observed before. In 2009, a group of researchers working in the Antarctic were filming a pod of orcas, which were using their trademark cunning and coordination to hunt a Weddell seal. The seal was on a floating chunk of ice, and the orcas created a wave to wash it off and into the water—just as a pair of humpback whales surfaced. The seal, by a lucky chance, landed on the chest of one of the humpbacks as it rolled onto its back, and the whale immediately arched its body out of the water, keeping the seal out of orca reach. It used a fin to keep the seal from slipping off, before "delivering" it to another ice floe.

The humpback whale seems to have a savior complex, regularly risking its own safety as it places itself between predator and prey.

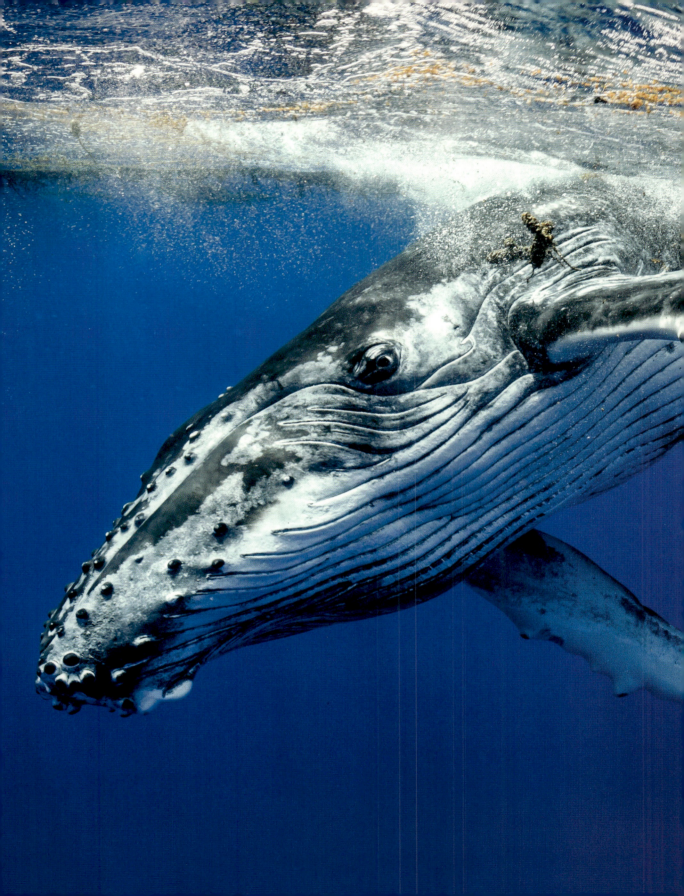

This incident led one of the observers, Robert Pitman, to seek out reports of other, similar encounters. He heard back from dozens of people who'd witnessed humpbacks interfering with orca hunts and, moreover, proactively taking the fight to them rather than happening to be in the right place at the right time. In a few cases, the hunt they were thwarting involved a humpback calf, but in nearly 90 percent of the reports, the orcas' prey was another species.

This looks very much like straightforward compassion to us, without expectation of reciprocal help in the future (it's hard to imagine a scenario where a seal could help a whale). If it *is* compassion, though, we might reasonably question the lack of compassion for the orcas, which waste their energy and lose their lunch. The humpbacks themselves are predators too, eating vast amounts of small fish and krill, so if they care for other living things it's clearly not universal. But not many humans, regardless of their own dietary choices, would enjoy the spectacle of a terrified seal about to be killed, so maybe the humpbacks, intelligent, highly social, and communicative as they are, can truly empathize with a fellow mammal in distress.

Preemptive strike

The more popular, and perhaps more likely, explanation is a little more prosaic. The orca's alternative name—"killer whale"—is not biologically accurate because orcas are classed as dolphins, but killers they certainly are. They are also whale killers. Even the greatest of all whales, the rorquals (of which the humpback is one) are on their menu, and if their pod is large enough, orcas may occasionally attack and kill adult rorquals as well as smaller, younger individuals.

Therefore, humpbacks have grounds for seeing orcas as archenemies, and it could be that orca-harassing behavior is an example of mobbing, just as small birds gang up on a bird of prey to chase it away. However, it's more extreme than this because humpbacks will actually interfere with an active hunt, while birds rarely mob unless they can be reasonably sure that the predator in question is not currently a threat (because it has just eaten, just made a kill, or just woken up). The orcas are in hunting mode and could, theoretically, switch targets and go after a humpback that gets in their way. By plunging in, though, the humpbacks send a strong message of fearlessness to their enemies; many predators think twice when a possible target turns the tables and makes an aggressive move. It would definitely be in the humpbacks' interests if as many orcas as possible could learn this lesson, so this could be driving the evolution of a sort of humpback behavioral subroutine that says, "If you hear orcas on the attack, get in their way."

Actions and feelings

Nan Hauser's story began not with an attacking orca but with a potentially dangerous shark. Dangerous to her, but not very dangerous to the humpback whales—perhaps just dangerous enough to trigger the same "get in the way" response that an orca does, if that is indeed what's going on in a humpback's mind. Or perhaps simply observing a large animal hunting a smaller one is enough to pull the behavioral trigger. This leads us to wonder where the limitations might be. Would a humpback intervene to save a penguin from a seal? Putting this to the test isn't really possible, but there are certainly grounds for further study. What we can't really begin to study is the emotions whales may experience as these events play out, but it seems unlikely, if not downright arrogant, to assume that only humans are capable of feeling the sharp (and highly motivational) sting of empathy when witnessing another creature in distress.

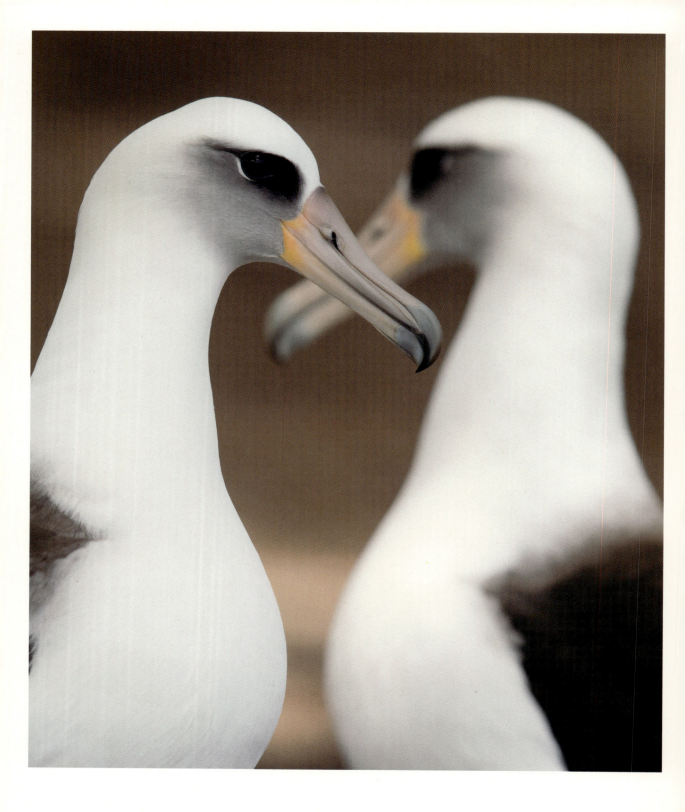

With more than 60 years of parenting experience under her belt, Wisdom the Laysan albatross has passed her nurturing genes on to dozens of offspring.

LAYSAN ALBATROSS *PHOEBASTRIA IMMUTABILIS*

A long-lived legacy

If you were given the chance to be reborn as an animal, you could do worse than to pick an albatross. You would travel the world in effortless flight, live for decades, and you and your mate would be bonded for life (and you'd still get to spend months away from them in between having your babies). As long as you had a taste for squid, and were reborn into an alternative world where plastic pollution was no longer an issue, you would have a lovely time.

At the time of writing, the ornithological world has recently celebrated the return of Wisdom, a female Laysan albatross, to her nesting site on Midway Atoll. She is part of a much-studied population of this smallish black-and-white albatross species that breeds on Midway. The ring she wears carries the code Z333, but it's not her original ring—that was fitted to her in 1956, and has since been replaced six times. She already had adult plumage when she was first found, so the most conservative estimate of her age in early 2023 was 71, making her the world's oldest known wild bird. For sixty of those years she was with her life-partner Akeakamai, though he has not been seen since early 2021.

Wisdom's longevity is remarkable, but so is her history as a mother. Albatrosses breed slowly, producing only one chick per year, and sometimes take a year off from breeding altogether. However, when they live as long as Wisdom has, that still adds up to an impressive number of offspring—probably more than thirty. The single egg needs to be incubated for sixty-five days, and then the fluffy, chubby lump of a chick needs to be tended and fed by both parents for another 160 days before it's ready to fly. To go through this process more than thirty times shows a rather mind-blowing level of devotion to the act of parenting. In 2011, Wisdom and her baby were among the survivors of a tsunami that killed more than two thousand other Laysan albatrosses, and she produced her most recent chick in the 2020–21 season, at the age of at least seventy.

Now, with Akeakamai gone, her reproductive years may be behind her, but she returns to the atoll anyway, perhaps hoping to pair up with another male and have a few more babies. Her age might count against her in such a quest, but her experience certainly won't.

SPINY PLUNDERFISH *HARPAGIFER BISPINIS*

Guardians of the deep

||||||||||||||||||||

Life in the Antarctic is tough. Or is it? If you're a cold-blooded animal, such as the spiny plunderfish, maybe you don't really feel the chill as such—but you're certainly affected by it. One of the ways in which Antarctic fish differ from their cousins that live in warmer waters is a much slower rate of development. The same goes for Arctic fish too. You may be familiar with the Greenland shark, a species that is found at the opposite end of the Earth in glacially cold polar waters, and lives longer than any other known vertebrate (up to five hundred years). The spiny plunderfish is only about 2¾ inches long when it's fully grown, but just like the Greenland shark it's exceptionally slow-growing, taking about four years to reach this size and finally be ready to breed. Its total life span is about nine years. By contrast, the fathead minnow, a temperate freshwater fish with an adult length of a slightly more impressive 3½ inches, takes about one year to grow to full size, spawn, then die of old age.

The genus name *Harpagifer* means "hook bearer," after the hook that *Harpagifer bispinis* has on its gill cover. Besides *Harpagifer bispinis*, there are eleven other species in the genus; all of them live in the Antarctic region and have a broadly similar ecology and anatomy. They are rather flattened fish with short, wide bodies and long, narrow tails, adapted for living among the rubble and rocks of the shallow seabed. The first of their two dorsal fins bears two to five sharp spines, giving them their English name. They are specialist feeders, consuming tiny crustaceans known as amphipods, but they are not dynamic hunters or voracious eaters, because survival in cold seas requires a grindingly slow metabolism. All in all, they can hardly be said to be especially attention-grabbing animals, in either their appearance or how they lead their lives, until you look a little longer and closer. For anyone studying the intricacies of *Harpagifer* life, patience is essential.

Most fish are not big on parental care. The most common piscine reproductive strategy is a scattershot approach—produce a vast quantity of eggs in the hope that their sheer numbers will allow at least a handful to avoid being eaten by predators. The eggs—and later, the fry—grow quickly, too. However, in Antarctic waters, rapid growth is not really an option. Therefore spiny plunderfish produce far fewer eggs than most other fish, and invest far more time trying to secure a good future for them.

Many spiny plunderfish devote a surprisingly large proportion of their short years on Earth to taking care of clutches of eggs that are not even their own.

This begins with the nest site, which is prepared in a sheltered crevice on the seabed. Females lay their eggs in this nest, producing a few hundred proportionately large and big-yolked eggs. These eggs then take their sweet time to hatch: up to five months. That would be a very long time to leave their fate to chance—even if they got lucky and avoided being found by a predator, fungal infection is almost inevitable and will destroy an entire clutch of eggs in just two weeks. But *Harpagifer* fishes guard their eggs for longer than any other fish species (as far as we know), keeping away intruders and diligently cleaning their eggs to protect them from fungal colonization. The presence of a guard is essential for the eggs to make it to the end of their development period, and both parents may be involved. Four or five months of round-the-clock guarding-and-cleaning duty for every breeding attempt is an unusually lengthy parental investment, especially for a little fish with only a nine-year life span, but there is more to this than parental care.

Whose eggs are they anyway?

In the winter of 1975, Robert A. Daniels studied the nesting behavior of *Harpagifer bispinis* at seven nests found in Arthur Harbour on the Antarctic peninsula. Studying fish as individuals is possible in this species—each has a unique color pattern—so Daniels could track which fish were guarding which nests. He found that the same seven females remained in place as guards on their respective nests throughout the observation period. However, when groups of fish were taken into captivity for a bit of experimental manipulation, an interesting development ensued. If a guard was removed from the tank that contained her nest, she would be replaced very quickly by another fish—usually a male. If he too was removed, another replacement (again, more often a male) would move in and take over.

This explains why, in wild conditions, males are sometimes found as guards even though the mother of the eggs will guard them throughout the incubation period if she can. It also makes sense that replacement guards would be males, as most females would be busy guarding their own nests. It doesn't explain, though, *why* these fish would step in so quickly and take on a nest full of eggs that may have nothing to do with them. Daniels carried out further manipulations to see whether this might be related to kin selection/selfish-gene theory, or to a mutually cooperative link between the nest mother and the guards. However, none of the experiments turned up any evidence that the replacement guards were related to either the removed mother or to the eggs. Nor was there any evidence that the new guards were acting out of reciprocity, having received help of some kind from other guards in the past, or having a reasonable expectation of help coming their way in the future.

So, can we really give serious consideration to the idea that the fishes' behavior may be an example of pure altruism—they see a nest made by a fellow *H. bispinis* standing unguarded and doomed, so they step in because it's the right thing to do? Described in such philosophical terms, it sounds absurd, especially in the context of a tiny fish with a tiny brain and a very slow and simple way of life. Surely it's more likely that something was missed in the experiments and there is *some* direct benefit to the guard. Maybe the fish benefit somehow from having more of their conspecifics around. Maybe guarding the nest carries no cost to them in terms of health and survival, so they may just as well guard it as not, and the behavior is down to chance. In the absence of evidence, we cannot be sure—but perhaps true altruism really does exist in nature, in a very unexpected form.

DOMESTIC CHICKEN *GALLUS GALLUS DOMESTICUS*

Pecking order

We domesticated the red junglefowl of Southeast Asia some eight thousand years ago, and today we share our planet with more than thirty billion domestic chickens. Chickens are highly social animals, and chicken keepers report that the relationships between the birds in their flocks become closer to a friendship network than the rigid structure that the term pecking order calls to mind. However, it was a study involving mother hens and their chicks that revealed something especially fascinating—biological signs of true empathy.

In a 2011 study carried out at the University of Bristol in the UK, hens and chicks were separated but were still able to see each other. The chicks were then subjected to extremely mild stress in the form of a puff of air being aimed at them (in the control groups, the air was aimed at the mother hens instead, or at neither mothers nor chicks). When they saw their chicks reacting to the air, the mother hens showed a range of physiological responses—their heart rates rose and their core body temperatures increased. They also showed signs of concern, clucking more insistently at their chicks and adopting a taller, alert posture. The response this experiment triggered was objectively measurable—compassion and fellow feeling revealed through changes in physiology. It's no stretch at all to suppose that the emotional state of the hens was similar to what we would feel if we saw our offspring in distress. It's thought-provoking for another reason too—the test subject being a species that we would probably place pretty low down on the scale of animals that might experience such feelings. If a chicken has true capacity for a powerful empathic response, what about a dog, or a dolphin, or an elephant?

A second phase of the study found that the fellow feeling actually went both ways. There was considerable variation between the level of distress shown by the mothers, and a chick's reaction to the aversive stimulus changed according to how intense its mother's response was—chicks whose mothers showed less distress recovered more quickly from their own stressed physiological state. So not only do hens literally feel their chicks' fears, they may be able to modify those fears by projecting a calmness that soothes them.

We might call someone a "mother hen" if they show excessive concern for others, but we would not necessarily guess that an actual mother hen empathises just as deeply as her human namesake.

9
CULTURE
Look, Listen, and Learn

CULTURE LOOK, LISTEN, AND LEARN

Working out how to craft and use tools facilitated a huge evolutionary step forward for our species. However, what really made this and other innovations count was a trait that our ancestral line had possessed for millennia before—the ability to learn from one another, so that new skills and practices could spread quickly through whole communities. This is the essence of culture, and without it we could never have become the dominant force on planet Earth that we are today.

The beauty of cultural transmission, compared to evolution through natural selection, is that it happens so quickly, and that the random element is all but eliminated. We can bring our own agency to bear, and decide collectively that the "best" ideas are the ones that spread. You might take issue with that last part, pointing out examples of frankly unwise behaviors that sometimes spread in viral style through certain human demographics. However, most cultural transmission does involve behaviors that benefit the majority, and that's true in animal culture as well. The term "meme" was first coined by evolutionary biologists in the 1970s to describe the transmission of cultural behaviors through populations, like genes. Just like genes, the memes that are most advantageous to their users will spread and prosper while others will die out. Today, a meme for most of us is a funny picture on the Internet, but these too will either spread virally or quickly disappear without trace, depending on how much they make us laugh.

To revisit what's become a pretty familiar theme in this book by now, culture is by no means restricted to "higher" animals, though it's certainly well documented among them. Jane Goodall's work with common chimpanzees, for example, revealed that "termite fishing" (poking a stick into a termite nest so that the aggressive termites will bite into it, allowing them to be extracted and eaten) is a skill that has arisen in certain chimp communities, and is passed on through the

generations. Other primates are also well known for showing strong cultural transmission, as are cetaceans and clever birds such as corvids. But since the start of the millennium, a wealth of research has revealed evidence of cultural learning in more unexpected quarters, including fish and insects. So powerful is this process that it makes sense for natural selection to strongly favor any innate tendency to watch and learn from the success of others, and any tendency to intentionally teach useful behaviors to others as well.

Just as cultural transmission can drive the progress of a community, so a defined social structure can uplift its potential achievements far above the sum of its parts. An animal society goes beyond a social group in that the roles within it are more defined, more limited, and more consistent. The success of such a society hangs on the balance between those roles, and each individual playing its part within its role. Membership of a particular component of the society is usually predetermined and unchangeable. We see this in its most realized form among social insects, where different roles may even come with dramatically different anatomy. However, cultural transmission can also operate within these apparently rigid social structures, making them even more powerful and effective.

A willingness and an ability to learn can open up great opportunities for human and animal individuals alike, and what we gain we can pass on to our offspring and others close to us. Unfortunately, some of the wonderful new ideas that we humans have spread among ourselves have had unforeseen and very damaging consequences for our home planet, as well as for virtually every other living species. Could any other animal besides *Homo sapiens* bring about similar problems through the phenomenon of cultural transmission? It seems unlikely, but perhaps only because we got there first, and did so comprehensively. What is certain is that as surely as cultural transmission got us into our current predicament it will also enable to get us out of it.

JAPANESE MACAQUE MACACA FUSCATA
The ways of water

We think of monkeys as inhabiting hot and steamy tropical regions, and generally this is the case. However, if asked to call to mind an iconic image of monkeys in the wild, a fair few of us might find our thoughts heading somewhere much chillier. The Japanese macaque, or "snow monkey" as it's sometimes nicknamed, lives farther north than any other primate (except us). It's found only in Japan (and is Japan's only monkey). It has a wide distribution across the country, including some of the smaller islands, and although it doesn't quite reach the extremely cold northern island of Hokkaido, it does occur right up to the far north of the main island of Honshu—and in fact, snowy conditions are the norm for much of Honshu through the long winter months. The most famous population of Japanese macaques resides at Jigokudani Monkey Park, which occupies a valley within central Honshu's Joshinetsu Kogen National Park. This forested upland region sees snowfall for four months of the year, which is when the monkeys head down into the park to enjoy its manmade *onsen* (hot spring), filled with geothermally heated spring water.

The macaques make an arresting and memorable sight, crowded together in the steamy water—their thick, silvery-blond fur frosty at its tips because of the chilly air, and their usually pale pink faces rosier from the heat of the water. They lounge and close their eyes, looking as blissed out as any human might on a fancy spa break. Many tourists come to see them, and the park keepers provide them with food, so the macaques are free to do little other than keep warm in the water and eat. It's not known when this behavior first started (hot-spring bathing is not known in other populations, so it may be a relatively recent innovation), but the reasons to continue doing it are self-evident.

Another cultural trend among Japanese macaques was, however, observed from its inception, within a different population. These monkeys live on Kōjima, a small, hilly, and heavily wooded island in the far south of Japan, a short distance from the larger island of Kyushu. A field-study site was established on Kōjima in 1947 to carry out research into the behavior of the monkeys there, and primatologists have since learned a great deal about how cultural transmission works in this species.

When one Japanese macaque has a great new idea, it won't be very long before all of her friends and relations have got on board with the plan as well.

215

The first key observation came in 1953, when researchers watched a young female monkey, named Imo, take a sweet potato from supplies that they had distributed on the beach. Rather than sit down and eat it right away, Imo carried it to the water and washed off the sand before tucking in. She was observed to do this with all of her potatoes, and over the coming months, more and more of the monkeys picked up the same habit. This same inventive young monkey also worked out that, if she threw handfuls of wheat (also provided by the researchers) into the water, the grains would float and could be scooped up, while sand and dirt sank.

The observers were able to see how these phenomena spread through the group, along demographic lines. Imo initially taught the techniques to her siblings and her mother, then she and her siblings went on to teach them to their regular same-aged playmates. Along the way, one of Imo's siblings discovered that playing in the shallows was good fun, and gradually the group as a whole lost its previous strong fear of the water and began to engage in splashing games together. Today, the monkeys on Kōjima still carefully wash their sweet potatoes (even if they're not dirty—they seem to have acquired a taste for a dash of sea salt!), throw their wheat in the sea, and play in the waves, but the behaviors are no longer taught, they are ubiquitous, and young monkeys pick them up simply through day-to-day observation.

Shaking up the system

Japanese macaques are highly social and form large troops of several hundred individuals, which no doubt predisposes them to high levels of cultural transmission. These groups exhibit a strong and stable dominance hierarchy among females, with male positions in the hierarchy being more volatile, and more often contested with physical fights. The top-ranked individuals, including the alpha of the group, are invariably male, but the group will include high-ranking individuals of both sexes. The daughters of high-ranking females are accorded a high rank automatically, one step below their mother's, while males tend to move up the ranks with age, with those in their late teens tending to be at the top of the tree (at around the age of twenty they are usually defeated by younger males, and fall back down the tree again).

However, even something as apparently fundamental as a dominance hierarchy is not immune from change, if the right monkey comes along to change it. This is exactly what happened among the large macaque group living at Takasakiyama Natural Zoological Garden, on Kyushu, when one exceptional female got ambitious. Nine-year-old Yakei began her campaign by attacking her own mother, displacing her from the top of the female hierarchy. Next, she

turned her attention to the four males who outranked her. The alpha male, Sanchu, was thirty-one—exceptionally old still to be holding that position—which also suggested that the three below him were perhaps not the youngest or best fighters either, so Yakei had picked the perfect time to launch her campaign. After deposing Sanchu, she became the new leader of the troop, and the first female leader observed within the group during seventy years of study.

Could the innovation of female leadership be passed on through the generations at Takasakiyama? It could—but it probably depends on how it goes for Yakei. Any of her future daughters will be well placed to take on the role, especially if they inherit her willingness to challenge their own mother. However, there is an extra complication for female leaders. Yakei's takeover occurred in 2021, but as that year ended, the new queen faced her most serious test, as mating season began. Male macaques are persistent suitors over this four-month period, and it seemed possible that Yakei would struggle to hold her rank while fending off multiple male advances. However, she emerged still holding the top spot, while also pregnant with twins. Reports have since revealed that, while one twin didn't make it, the other is thriving—and perhaps keeping a close eye on its mother to work out how best to steal her crown a few years down the line.

FRUIT FLY *DROSOPHILA MELANOGASTER*

Received wisdom

The fruit fly is one of the most important species of all those that we use as laboratory animals. It's been particularly instructive in teaching us about how genes work, both individually and in clusters, but we've also recently discovered some interesting and unexpected things about *Drosophila* behavior, too.

These flies have patterned wings which the male shivers at a female as a form of courtship display, while simultaneously tapping her on the rear with a foreleg. If the female is sufficiently enchanted by this, she will mate with him. It turns out, though, that female fruit flies will use other information when assessing males as possible mates, and that they attain this through watching other females and making a note of their choices. This surprising example of insect cultural transmission was revealed by an experiment carried out at the Université de Toulouse in 2018. It involved allowing virgin female fruit flies to watch other fruit flies mating. Some of the males in these pairings had been artificially colored with green or pink powder. A virgin female that saw a female, older than herself, mating with a male, would pick a similarly colored partner for herself when later given the choice of a green, pink, or naturally colored eligible bachelor—trusting that the more senior female had made a good choice that could safely be copied. A subsequent study that reversed the roles of the sexes, where males watched other males picking between artificially colored green and pink females, produced similar results—males would copy the choice made by the male they had watched (though they copied less consistently than the females).

This study shows not only that true cultural transmission can occur in insects, but it offers a possible explanation for how female mate preferences could potentially drive males to evolve a spectacular but impractical appearance. Perhaps, early on in the evolutionary history of the Indian peafowl, one male with a longer-than-average tail just happened to enjoy particular success with lots of females, in front of lots of other females. Mate-copying preferences for longer-tailed males might then have spread as a cultural virus through the population, and pushed male evolution toward the fabulously adorned creature that is the peacock today.

When poised to make one of the biggest decisions of your life, such as which fruit fly to mate with, it always helps to observe those older and wiser than you.

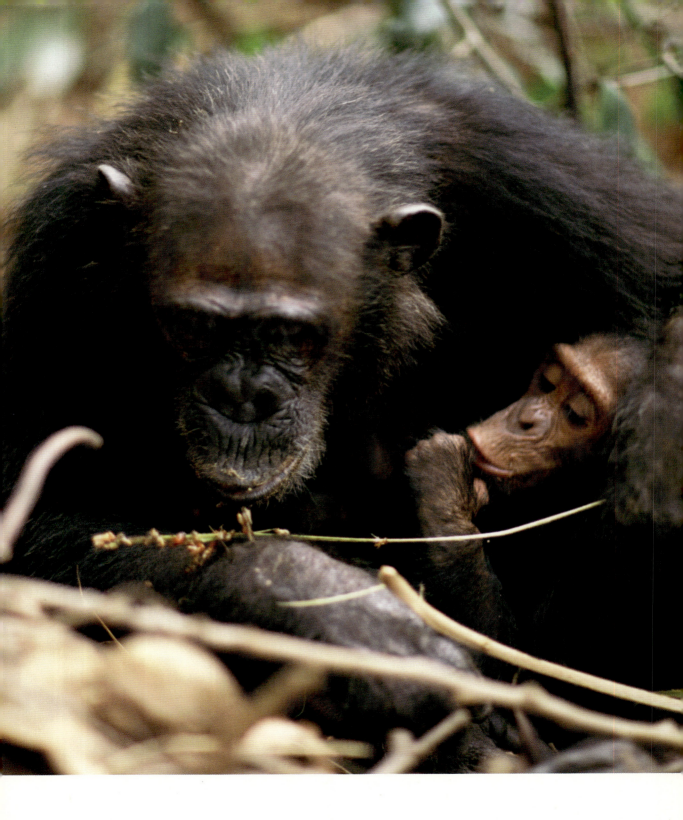

For a young chimp, its mother's embrace provides not only comfort, but also countless learning opportunities as she goes about her daily life.

COMMON CHIMPANZEE *PAN TROGLODYTES*
Learning and teaching

One of the earliest and best-known examples of cultural transmission in an animal concerned the common chimpanzee. Jane Goodall, studying the chimps of Gombe Stream National Park, Tanzania, in the 1960s, observed them modifying sticks to "fish" for termites—itself a remarkable example of tool creation and use. She and other researchers went on to discover that the techniques are passed through the group culturally, by observation, and that different groups have their own particular cultural quirks in how they make and use their fishing rods. These are not related to external factors, such as the plants available as stick sources, or the topography of the local termite nests.

As with bonobos, there is a strong tendency for this and other aspects of cultural identity to retain its between-group distinctiveness, despite opportunities for change. Female chimps generally leave their natal group and join another when they are ready to breed, bringing with them the traditions of their natal group. However, they drop those habits over time, instead fitting in with the new group.

All in all, studies of wild common chimpanzee communities have identified dozens of sets of behaviors that show obvious cultural variation, some involving tool use but others concerned with grooming and other social-connection behavior, and still more around courtship "dos and don'ts." This all amounts to a large collective pool of knowledge. It seems counter-intuitive to us that some ideas are not universal. After all, some styles of termite-fishing must surely work better than others, and the natural movement of chimps between groups does give them the opportunity to see alternative methods in action. A study that sought to explore this presented different groups of wild chimps with feeding opportunities that could be fulfilled only with particularly advanced tool use. Here, in some cases, the successful innovative behaviors were passed on from group to group, following a "majority decision" within one group to switch to the method they saw being used by members of another group. This was more likely to happen if the groups concerned were already quite tolerant of each other socially. This supports the idea that cultural differences are important in maintaining a strong group identity—even perhaps at the expense of a better way of life.

ORCA ORCINUS ORCA
Local customs

A very tall, bladelike black dorsal fin suddenly arcing out the water reveals the presence of probably the sea's most feared predator. It's highly likely you will then see several other, similar, fins breaking the surface, because this is a killer that loves company, and its social nature is what enables it to take its diverse array of hunting abilities to the next level. Through teamwork, orcas can take on any other sea animals, from the mightiest sharks to the hugest of their fellow whales, and triumph. We should be glad that, for whatever reason, they choose not to attack us when we enter their watery world.

Orcas might be known now and then as "killer whales," but taxonomically they belong with the dolphins. Strictly speaking, however, taxonomically the dolphins themselves are a subgroup of toothed whales, so it's probably best to just call them orcas. Whatever you call them, they are unmistakeable, with their bold black-and-white pattern and that impressive dorsal fin. As sleek, streamlined, and fast as they are, they might seem hampered as manipulators of their environments compared to us, with our dextrous hands, but an orca can achieve an awful lot, with its heavy body; powerful pectoral fins and tail; a blunt head concealing up to fifty-six long, sharp, interlocking teeth; and its 13 pounds of top-notch, strategizing brain. Team that orca up with another, and a couple more, and you have an almost unstoppable force of nature.

One of the most intriguing things about orcas' hunting practices is how much they vary between groups. Orcas occur throughout the world ocean, but different groups stick to different places, and some groups have developed specific techniques for hunting a certain prey type in particular conditions. It's now becoming clear that these groups differ from each other in many other respects, too. They also avoid breeding with each other, even where overlapping ranges lead to regular encounters. These groups are so distinct from each other that biologists now use a more precise term for them—"ecotypes."

So far, ten ecotypes have been described, five each in the northern and southern hemispheres, and there are likely to be more. Some have been observed more extensively than others, but their differences include family behavior (for example, how long calves stay with their mothers), the size of their home range, prey preferences, and hunting methods. There are also anatomical differences.

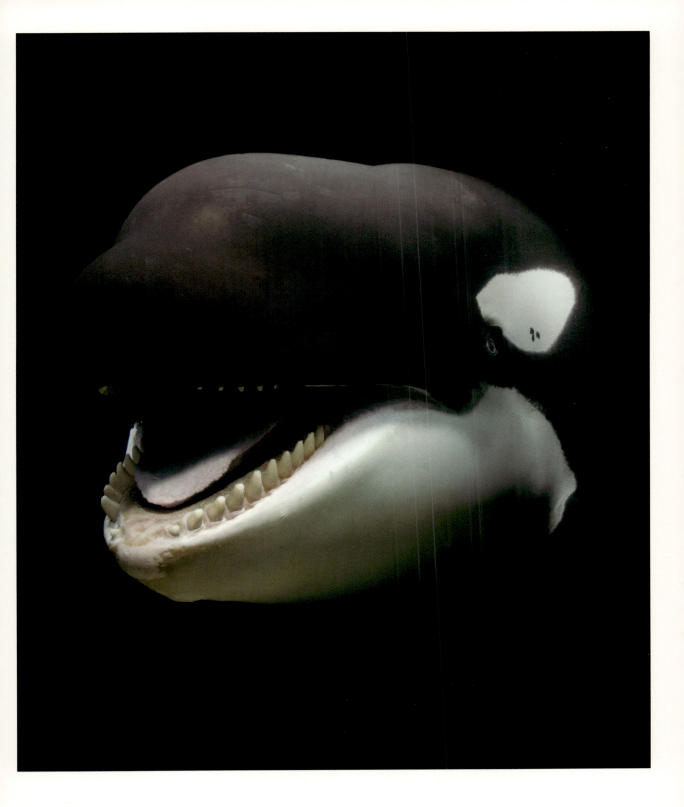

Cultural evolution is driving a wide range of physical changes in the world's many and varied orca populations.

For example, North Atlantic Type 1 orcas are primarily fish eaters—a preference that causes heavy wear to their teeth—while North Atlantic Type 2 orcas prey on minke whales and other cetaceans, and have bigger and sharper teeth (they are also significantly larger, with different facial markings). In the southern hemisphere, Type B (large) and Type B (small) orcas are generally similar but differ in size and diet, with the large form hunting seals and the small form preferring penguins. Each group has its own unique vocal dialect, too, taught mother to calf, and used to communicate many things. Just like our own languages, these sets of sounds are prone to change, when random errors made by youngsters, as they learn to copy the sounds, end up sticking.

We recognize differences like these as being hallmarks of the process of speciation—over many more generations and further refinement through natural selection, these ecotypes may reach a point where they cannot breed with each other (they are already at the point where they don't really want to!). The process by which one lineage divides rather rapidly into many more, each adapted to a different way of life, is known as adaptive radiation, and we can see many examples worldwide—most famously, the Galápagos finches described by Charles Darwin. Thought to have descended from a single species that reached the Galápagos Islands from mainland Ecuador, the finches have diversified into some fourteen distinct species, differing in size, bill shape, and diet, and each exploiting a different ecological niche. Because these isolated islands are of volcanic origin and relatively young, the only land plants and animals they support are those that managed to get there via a sea crossing, so they represent a sort of natural laboratory in which a random selection of species has been placed, managing to adapt to their surroundings over many generations and a relatively rapid natural selection process. Many species of Galápagos flora and fauna are found on one island only, gradually having become more and more distinct from their closest relatives on other islands due to the lack of opportunity to interbreed.

Culture-driven evolution

Things are a little different with orcas, though. They have evolved in the world ocean over many millions of years, without any physical barriers to the global population interbreeding. These fantastically clever and communication-focused mammals, which live in stable groups and enjoy a long life span, have a naturally high rate of cultural transmission. Hunting tricks such as washing seals off ice floes or herding fish into an easily attacked "bait ball" are passed down through family groups through watching and learning. Cultural transmission explains the growing behavioral differences between the ecotypes, but the associated differences in anatomy and physiology can only be down to diverging genomes.

This makes the orca the only species we know of (so far) whose genetic evolution is being driven by cultural factors—besides ourselves. Human examples include the proliferation of genes that allowed us to tolerate lactose after we had started farming cattle—with cow's milk a newly available food option, natural selection favored those whose genes enabled them to drink it without discomfort.

Similarly to us, orcas also show rapid cultural transmission of play behavior, with no obvious survival benefit—we have the "ice bucket challenge," and orcas have the "dead salmon hat" challenge. Young orcas in particular are very curious and inventive, and appear to be enthralled by novelty, leading them to try all manner of strange behaviors. In 1987, a young female orca in a northwestern Pacific pod was observed swimming about with a dead salmon balanced on her head. For some reason, this behavior caught on rapidly, and, within six weeks, dozens of other orcas within that pod, and others in the locality, were also spotted wearing dead salmon hats. Just a few weeks later, the viral trend appeared to have burned itself out and was not observed again.

Another recent, less fun, orca trend has been boat-ramming. In 2022, there were several reported episodes of young male orcas headbutting sailboats in the waters of southern Europe, and in at least two instances causing an unmanned boat to sink. In May 2023 an orca group almost sank a sailing boat off southern Spain, and there were at least twenty other less serious "interactions" between orcas and small boats in that month alone, in the Strait of Gibraltar. Boat owners are hopeful that this, too, will prove a short-lived trend, because there isn't much tangible reward in it for the orcas. But experimentation like this is how new and effective hunting techniques can be born, too. We would do well to keep a close eye on orcas and their fads, lest the next one prove more costly to us than a sunken boat.

WHITE-CROWNED SPARROW ZONOTRICHIA LEUCOPHRYS
A national anthem

A skilled birder can identify a songbird just as easily by hearing it as by seeing it. This would not be possible if every individual of a species made up its own song completely on the fly, as it were, but having a consistently recognizable song across time and space is good for the birds, as well as the birders. It is mainly male birds that sing, and it has long been known that young male songbirds learn their songs primarily from their fathers. They may embellish it with additions of their own (we have already seen how the superb lyrebird does this, to a staggering degree), but core elements are passed along the generations—copied by males, and understood by all.

In some cases, there are regional variations within a species's song that are clear enough for a human ear to discern. The white-crowned sparrow, a delightful North American songbird, is one such species that has distinct singing "dialects." Observers have also noticed that some of these dialects are changing, gradually but decidedly, over time. The sparrow's song combines simple (SS) and complex (CS) syllables, and the nature and ratios of these are distinct enough for biologists to have defined twelve separate dialect groups within a well-studied population along the northwest Pacific coast. In general, SS are shared closely within a dialect, while CS are more varied, and include more brand-new or improvised phrases. (The song's final trilled phrase is universal across all populations.)

Comparing recordings from these groups that were made 30 years apart, ornithologists discovered that the groups' SS elements had changed considerably less than the CS elements (and the terminal trill was unchanged). Their conclusion is that the various different segments of the songs evolve independently of each other. A sparrow copies the SS phrase more or less directly from its father, and confirms its place within its dialect group. CS is its opportunity to be more experimental or adaptable (for example, higher-frequency sounds carry better in noisier environments), and the "best" elements of CS will be copied from others. Song form in this bird is, therefore, an example of natural cultural evolution, with some new ideas being discarded and others kept and tweaked by each new generation.

The proudly delivered song of a white-crowned sparrow carries refrains that have passed through many generations, embellished with its own individual touches.

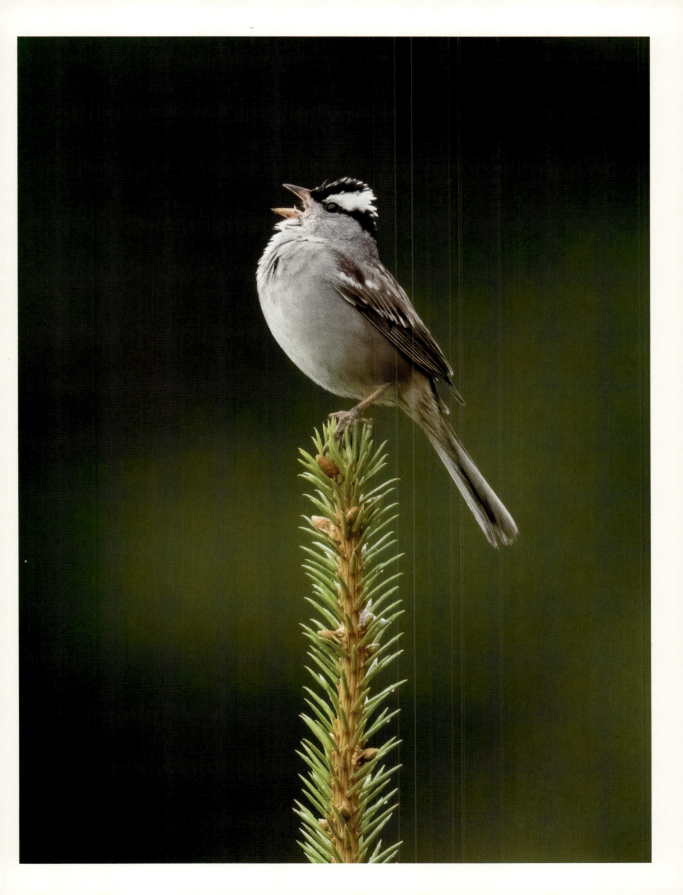

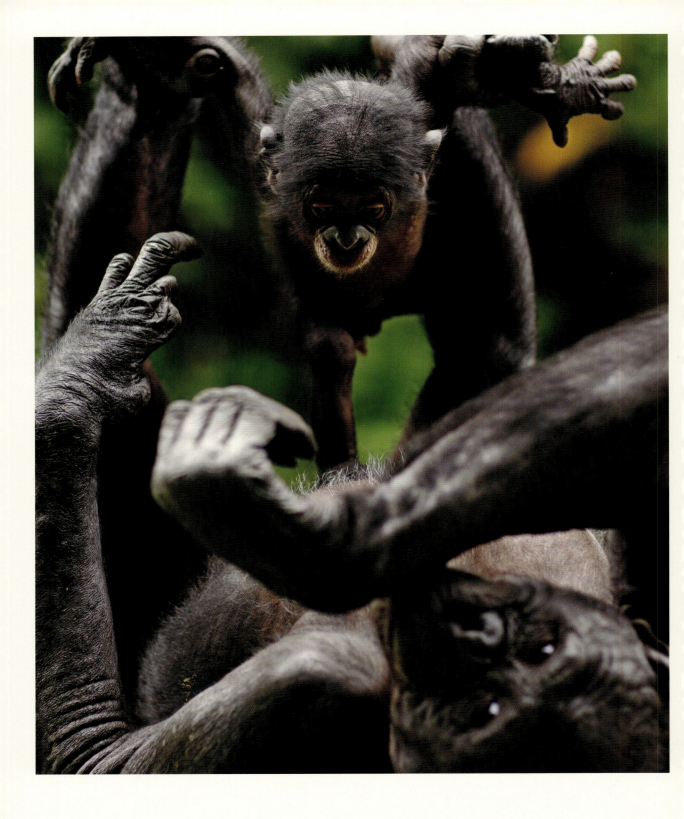

Bonobos may be lovers rather than fighters, but groups still retain their separate cultural identity through polite adherence to their traditional ways.

BONOBO *PAN PANISCUS*

Our ways are not yours

A relative newcomer to the wider public consciousness, the bonobo (or pygmy chimpanzee) is the smaller, sweeter-natured, more social, and (let's face it) much more sexual cousin of the better-known common chimpanzee. It is similar in appearance but has darker hair and skin, pinker lips, and is generally smaller. Both species live in Central Africa and both count as our closest living animal relatives. You might also argue that they represent two aspects of the human psyche—the gentle, thoughtful bonobo on one hand, and the loud, combative common chimp on the other. Most of us would agree that the bonobo's character is the one to aspire to, even if we are a little embarrassed by the way most of their social activity involves frequent no-strings sex with one another.

Because they seem, on the face of it, less active, innovative, and dynamic than common chimps, bonobos were long supposed to be less clever as well. However, detailed study has revealed that their cognitive abilities, though different, are not inferior. They are more cautious than common chimps and less capable of using tools, but they do better in any task where success comes through social skills, such as correctly assessing the mental states of others in their group. Their brains have higher concentrations of neurons in regions that (in humans, at least) are concerned with empathy and social anxiety, and they also show more connections between brain regions involved in aggression and in impulse control, suggesting they may be better at regulating their feelings than the volatile common chimp.

Despite their peaceful ways among themselves, bonobos (like common chimpanzees) are predators—very willing and able to hunt, kill, and dismember smaller mammals if they can get hold of them. The revelation that common chimps are hunters was a bit of a shock to the world—not only that they catch, kill, and eat baby monkeys, but the extreme and vocal excitement that accompanies these hunts. There's a similar decibel level when one troop meets another, but this is powered mainly by fear and anger rather than the thrill of the chase.

Bonobos have a much more low-key response when one group meets another. Shrieking aggression is not the norm—indeed, they may even share food or initiate sex with complete strangers. However, they know which group they belong to, and one of the differences discovered between two particular overlapping bonobo groups that have been studied in the Kokolopori Bonobo

Reserve, in the Democratic Republic of the Congo, is a preference for hunting different kinds of prey. One of the study groups specialized in hunting duikers, which are small forest antelopes. The other preyed on anomalures—small arboreal rodents that can glide between treetops. These two prey types clearly call for two different hunting strategies, and the members of each group learned from their elders how to execute those strategies. Even though the two groups regularly hunted in the same places at the same times, they almost always stuck to their preferred prey. The duiker hunters also sometimes hunted squirrels, showing that they were not averse to climbing trees when in pursuit of prey, but they seldom pursued anomalures. All of this strongly implies that the behavior comes down to a cultural, rather than ecological, difference between them.

Free love, with a little bit of hate

As mentioned, bonobo society practically revolves around sex. Males and females mate with each other fairly indiscriminately, whether the female is in estrus or not, but both sexes also regularly engage in homosexual activity, and even infants may initiate sexual behavior with adults. Incestuous sexual relationships also occur; the only combination that seems to be taboo is between mother and son, although a mother bonobo will help her son to gain more opportunities to mate with females in estrus. All of this rampant activity is thought to be a way of dampening down aggressive impulses, but it has other benefits, too. Common chimpanzees live in a harem-like system where most matings involve the one dominant male, and, if he has any reason to doubt that he is the father of a particular infant, he will kill it. By mating regularly with almost every male in the group, a female bonobo ensures that none of them can have any certainty about paternity, and infanticide is very rare.

Sex is also a way of building friendship, and friendships between bonobos (both same sex and opposite sex) can be loving and enduring. Females will not tolerate forceful advances from males and they recruit female friends to help deter them. Unimpressed by shows of force, they are more likely to build friendships—and have babies—with males that are gentle and respectful.

Bonobo life is certainly highly equitable, but we shouldn't suppose that it's entirely free from conflict. In the common chimp, males are far more aggressive than females, but female bonobos (especially older individuals) tend to be slightly more aggressive than males, and female bonobos are also generally more aggressive than female common chimps, especially in captivity, where possessiveness over food regularly leads to clashes. Female bonobos are dominant over males in general and are also more likely to lead hunts, and to be the innovators of new and useful behaviors such as tool use.

They are also more likely to be murderers, it seems—although there are only two documented cases of one bonobo killing another, both involved a female or females attacking a male.

Culture clash

For two such physically similar species, bonobos and common chimps have certainly evolved some very significant differences in terms of culture and behavior, and similar variations between different bonobo populations may be driving further diversification. Common chimps are already known to be genetically quite diverse, with at least four distinct subspecies described. However, the future for bonobo evolution may be limited by factors beyond their control (though not beyond ours)—the IUCN Red List classes them as an endangered species, with a small range and a population of probably fewer than fifty thousand individuals. Common chimps, too, are endangered, though are faring a little better numbers-wise with about three hundred thousand, but both species are continuing to decline, thanks to a combination of habitat loss, bushmeat hunting, and the spread of certain diseases.

These two apes, our two closest living cousins in the natural world, are fascinating and fascinatingly different. Despite numerous biologists putting in many hours of field research, we are still barely scratching the surface of understanding them—as individuals and as societies—yet they have so much to teach us. Thankfully, the focus has shifted over the decades from exploiting their humanlike qualities by training them to perform in absurd circus acts to the deep study of their natural behaviors in wild settings, but protecting them and their habitats has to be prioritized. No animal, especially when it's as sensitive and clever as a bonobo or common chimp, can be its true and natural self when it's aware that its life and its family's future are in grave danger.

SELECT BIBLIOGRAPHY BOOKS/ARTICLES

Ari, C., and D. P. D'Agostino, "Contingency Checking and Self-Directed Behaviors in Giant Manta Rays: Do Elasmobranchs Have Self-Awareness?" *Journal of Ethology* 34 (2016): 167–74

Battley, P. F., et at., "Contrasting Extreme Long-Distance Migration Patterns in Bar-Tailed Godwits," *Limosa lapponica. Journal of Avian Biology* 43, no. 1 (2012): 21–32

Bertram, J. E. A., "New Perspectives on Brachiation Mechanics," *Yearbook of Physical Anthropology* 47 (2004): 100–17

Channon, A. J., et al., "The Extraordinary Athletic Performance of Leaping Gibbons," *Biol Lett* 8, no. 1 (February 23, 2012): 46–9

Courchamp, F., and D. Macdonald, "Crucial Importance of Pack Size in the African Wild Dog *Lycaon pictus*," *Animal Conservation Forum*, 4, no. 2 (2001): 169–74

Daniels, R. A., "Nest Guard Replacement in the Antarctic Fish *Harpagifer bispinis*: Possible Altruistic Behavior," *Science* 205, no. 4408 (August 24, 1979): 831–3

Davies, N. B., *Cuckoos, Cowbirds and Other Cheats*, London: T & AD Poyser Ltd, 2000

De León, A., E. Mínguez, and B. Belliure, "Self-Odour Recognition in European Storm-Petrel Chicks," *Behaviour* 140, no. 7 (July 2003)

Delmore, K., et al., "The Evolutionary History and Genomics of European Blackcap Migration," *elife* 9 (April 21, 2020)

Derryberry, E. P., et al., "Patterns of Song Across Natural and Anthropogenic Soundscapes Suggest That White-Crowned Sparrows Minimize Acoustic Masking and Maximize Signal Content," *PLoS ONE* 11, no. 4 (April 29, 2016)

Edgar, J. L., J. C. Lowe, E. S. Paul, and C. J. Nicol, "Avian Maternal Response to Chick Distress. Published online ahead of print," *Proceedings of the Royal Society B* (October 22, 2011)

Gibbs, H., et al., "Genetic Evidence for Female Host-Specific Races of the Common Cuckoo," *Nature* 407 (September 14, 2000): 183–6

Goumas, M., I. Burns, L. A. Kelley, and N. J. Boogert, "Herring Gulls Respond to Human Gaze Direction," *Biol. Lett.* (August 30, 2019)

Grubb, T. C. Jr., 1979. "Olfactory Guidance of Leach's Storm Petrel to the Breeding Island," *The Wilson Bulletin* 91, no. 1 (1979): 141–3

Hare, J. F., K. L. Campbell, and R. W. Senkiw, "Catch the Wave: Prairie Dogs Assess Neighbours' Awareness Using Contagious Displays," *Proc. R. Soc. B.* (2014)

Hoffman, S., "Ape Fracture Patterns Show Higher Incidence in More Arboreal Species," *Discussions* 8, no. 2 (2012)

Hunger, C., *How Stella Learned to Talk. The Groundbreaking Story of the World's First Talking Dog*, London: Pan Macmillan, 2021

Hutchison, L. V., and B. Wenzel, "Olfactory Guidance in Foraging by Procellariiformes," *Condor* 82 (1980)

Ibáñez-Álamo, J. D., et al., "Nest Predation Research: Recent Findings and Future Perspectives," *J Ornithol* 156 (Suppl. 1; 2015): 247–62

López Caicoya A., M. Colell, and F. Amici "Giraffes Make Decisions Based on Statistical Information," *Scientific Reports* 13, no. 1 (May 2023)

Luncz, L. V., and C. Boesch, "Tradition Over Trend: Neighboring Chimpanzee Communities Maintain Differences in Cultural Behavior Despite Frequent Immigration of Adult Females," *American Journal of Primatology* 76, no. 7 (July 2014): 649–57

Marler P., and M. Tamura, "Song 'Dialects' in Three Populations of White-Crowned Sparrows," *Condor* 64 (1962): 368–77

———, "Culturally Transmitted Patterns of Vocal Behavior in Sparrows," *Science* 146, no. 3650 (December 11, 1964)

Mather, J., "The Case for Octopus Consciousness: Temporality," *NeuroSci* 3, no. 2 (May 3, 2022), 245–61

Mills, S. C., and I. M. Côté, "Crime and Punishment in a Roaming Cleanerfish," *Proc Biol Sci* 7; no. 277 (1700) (June 23, 2010): 3617–22

Mizutani, A., J. Chahl, and M. Srinivasan, "Motion Camouflage in Dragonflies," *Nature* 423, no. 604 (June 5, 2003)

Nagel, T., "What Is It Like to Be a Bat?" *The Philosophical Review* 83, no. 4 (October 1974)

Nelson, D. A., K. L. Hallberg, and J. A. Soha, "Cultural Evolution of Puget Sound White-Crowned Sparrow Song Dialects," *Ethology* 110 (2004): 879–908

Panksepp, J., "Beyond a Joke: From Animal Laughter to Human Joy?" *Science* 308, no. 5718 (April 1, 2005): 62–3

Papageorgiou, D., et al., "The Multilevel Society of a Small-Brained Bird," *Current Biology* 29, no. 21 (November 4, 2019)

Papastamatiou, Y. P., et al., "Social Dynamics and Individual Hunting Tactics of White Sharks Revealed by Biologging," *Biol. Lett* 18, no. 3 (March 2022)

Pascual-Garrido, A., "Cultural Variation Between Neighbouring Communities of Chimpanzees at Gombe, Tanzania," *Scientific Reports* 9, no. 8260 (June 2019)

Pepperberg, I. M., *The Alex Studies: Cognitive and Communicative Abilities of Grey Parrots*, Cambridge, MA: Harvard University Press, 1999

Prior, H., Schwarz, A., Güntürkün, O. 2008. "Mirror-Induced Behavior in the Magpie (*Pica pica*): Evidence of Self-Recognition," *PLoS Biol* 6 (August 19, 2008)

Rapaport, L. G., "Progressive Parenting Behavior in Wild Golden Lion Tamarins," *Behav. Ecol.* 22, no. 4 (June 2011): 745–54

Rickitt, Richard, *Beekeeping for Gardeners*, London: Bloomsbury, 2023

Ruano, F., et al., "*Rossomyrmex*, the Slave-Maker Ants from the Arid Steppe Environments," *Psyche* (June 19, 2013)

———, et al., "Dufour's Gland Secretion as a Repellent Used During Usurpation by the Slave-Maker Ant *Rossomyrmex minuchae*," *Journal of Insect Physiology* 51, no. 10 (October 2005): 1158–64

Sakai, S. T., et al., "Big Cat Coalitions: A Comparative Analysis of Regional Brain Volumes in Felidae," *Frontiers in Neuroanatomy* 10 (October 20, 2016)

Samuni, L., F. Wegdell, and M. Surbeck, "Behavioral Diversity of Bonobo Prey Preferences as a Potential Cultural Trait," *elife* 9 (September 1, 2020)

Sändig, S., H-U Schnitzler, and A. Denzinger, "Echolocation Behaviour of the Big Brown Bat (*Eptesicus fuscus*) in an Obstacle Avoidance Task of Increasing Difficulty," *J. Exp. Biol.* 217, no. 16 (2014): 2876–84

Smith, J. D., et al., "The Uncertain Response in the Bottlenosed Dolphin (*Tursiops truncatus*)," *Journal of Experimental Psychology:* General 124, no. 4 (December 1995): 391–408

Thurber, J. M., R. O. and Peterson, "Effects of Population Density and Pack Size on the Foraging Ecology of Gray Wolves," *Journal of Mammalogy* 74, no. 4 (November 30, 1993): 879–89

Towner. A. V., et al., "Fear at the Top: Killer Whale Predation Drives White Shark Absence at South Africa's Largest Aggregation Site," *African Journal of Marine Science* 44, no. 2 (October 9, 2022): 139–52

van Leeuwen, E. J. C., et al., "Social Culture in Bonobos," *Current Biology* 30 (March 23, 2020): R261–2

Watts, H. E., and K. E. Holekamp, "Hyena Societies," *Current Biology* 17, no. 16 (August 21, 2007)

Whitehead, H., L. Rendell, R. W. Osborne, and B. Würsig, "Culture and Conservation of Non-Humans With Reference to Whales and Dolphins: Review and New Directions," *Biological Conservation* 120, no. 3 (December 2004)

Whiten, A. "Does Culture Shape Hunting Behavior in Bonobos?" *elife* 9 (September 1, 2020)

———, et al., "Collective Knowledge and the Dynamics of Culture in Chimpanzees," *Philos. Trans. R. Soc. Lond. B. Biol. Sci.* 377, no. 1843 (January 31, 2022)

Williams, H., "Mechanisms of Cultural Evolution in the Songs of Wild Bird Populations," *Front. Psychol.* 12 (April 26, 2021)

Yong, Ed, *An Immense World*, London: Penguin, 2023

SELECT BIBLIOGRAPHY WEBSITES

"African Wild Dog," African Wildlife Foundation, www.awf.org/wildlife-conservation/african-wild-dog (accessed December 2022)

"Alex, the Talking Parrot," British Library, available at www.bl.uk/the-language-of-birds/articles/alex-the-african-grey-parrot (accessed September 2022)

"An Evolutionary Magic Trick Is Popping Up Everywhere," *The Atlantic* (November 20, 2022), www.theatlantic.com/science/archive/2022/11/supergenes-dna-genetics-evolution/672176/?utm_source=apple_news

"Brown-Mantled Tamarin Monkey," http://knowledgebase.lookseek.com/Brown-Mantled-Tamarin-Monkey.html (accessed January 2023)

"Chimps Beat Humans in These Cognitive Tests," https://bigthink.com/life/chimpanzees-beat-humans (accessed May 21, 2023)

"Computational Principles Underlying Neural Circuit Dynamics and Behavior," www.janelia.org/lab/leonardo-lab (accessed October 2022)

"Dance Language of the Honey Bee" (August 20, 2019), https://bee-health.extension.org/dance-language-of-the-honey-bee/

"Echo's Family Tree," PBS Nature (February 8, 2008), www.pbs.org/wnet/unforgettable-elephants-echos-family-tree/4488

"*Eciton burchellii*," www.antwiki.org/wiki/Eciton_burchellii (accessed November 2022)

"Elephants Grieve, They Even Have Funerals" (October 8, 2018), https://brigitteganger.medium.com/elephants-grieve-a8fe4a0d62e2

"Grevy's Zebra (*Equus grevyi*) Fact Sheet: Behaviour and Ecology," San Diego Zoo Wildlife Alliance Library, https://ielc.libguides.com/sdzg/factsheets/grevyszebra/behavior (accessed April 2023)

"How Young Killer Whales Became Hooligans" (September 29, 2022), www.atlasobscura.com/articles/killer-whale-orca-trends?utm_medium=atlas-page&utm_source=facebook&fbclid=IwAR3NADc_CUvdPHLbFEgsi8R3L4ilFOg2Ppzag4BcYvkWuYy0ofLkUF4L8EQ

"Humpback Whale Tries To Save Diver From Tiger Shark," www.youtube.com/watch?v=_bK8fGMJRLI

"I Saw Humpback Whales Save a Seal From Death by Killer Whale," *New Scientist* (October 12, 2016), www.newscientist.com/article/mg23230950-700-i-saw-humpback-whales-save-a-seal-from-death-by-killer-whale

"Inky's Daring Escape Shows How Smart Octopuses Are," *National Geographic* (April 14, 2016), www.nationalgeographic.com/animals/article/160414-inky-octopus-escapes-intelligence

"Killer Whales," NOAA Fisheries, www.fisheries.noaa.gov/species/killer-whale#populations (accessed January 2023)

"Koko," www.koko.org/about/gorilla-koko (accessed September 2022)

"Magpies' Unexpected Reaction to GPS Trackers May Have Revealed Altruism in the Birds" (February 8, 2022), www.npr.org/2022/02/28/1083581139/magpies-unexpected-reaction-to-gps-trackers-may-have-revealed-altruism-in-the-bi#:~:text=Transcript-,Researchers%20tried%20to%20attach%20tracking%20devices%20to%20magpies%20for%20a,of%20altruism%20in%20the%20birds

"Male Jaguar Rivals Pair Up For Years in Unexpected Bromances" (December 13, 2022), www.livescience.com/male-jaguar-bromances

"Plains Zebra (*Equus quagga*) Fact Sheet: Behavior and Ecology," San Diego Zoo Wildlife Alliance Library, https://ielc.libguides.com/sdzg/factsheets/plains_zebra/behavior (accessed April 2023)

"Primate Cognition," *Nature*, www.nature.com/scitable/knowledge/library/primate-cognition-59751723 (accessed May 21, 2023)

"Primate Cognition," Max Planck Institute, www.eva.mpg.de/psycho/primate-cognition (accessed May 21, 2023)

"Queen of the Corvids: The Scientist Fighting to Save the World's Brainiest Birds," *The Guardian* (June 19, 2022), www.theguardian.com/environment/2022/jun/19/queen-of-corvids-the-scientist-fighting-to-save-the-worlds-brainiest-birds

"Saddleback Tamarin," New England Primate Conservancy, https://neprimateconservancy.org/saddleback-tamarin (accessed January 2023)

"Snow Leopard Drags Blue Sheep ...," www.youtube.com/watch?v=GgDHvl1wD20 (accessed January 2023)

"Social Behavior" (on the study of lion prides), University of Minnesota, https://cbs.umn.edu/lion-research-center/all-about-lions/social-behavior (accessed October 2022)

"South Asia Elephant Dies of Grief," BBC News (May 6, 1999), http://news.bbc.co.uk/1/hi/world/south_asia/337356.stm

"Sperm Whales in 19th Century Shared Ship Attack Information," *The Guardian* (March 17, 2021), www.theguardian.com/environment/2021/mar/17/sperm-whales-in-19th-century-shared-ship-attack-information?fbclid=IwAR36qpP593B4hVfHzotcXO-MJUGWEq7NhCzRwv9SShCQ9cIQHFdLoREMOxo

"These Mighty Shorebirds Keep Breaking Flight Records—And You Can Follow Along," *Audubon* (October 8, 2021), available at: www.audubon.org/news/these-mighty-shorebirds-keep-breaking-flight-records-and-you-can-follow-along

"Weasel on Woodpecker: How I Snapped the Photo," www.youtube.com/watch?v=Qw-OOdfogUQ (accessed December 2022)

"Whale Clans Use Vocalizations to Mark Their Culture" (September 12, 2022), https://phys.org/news/2022-09-whale-clans-vocalizations-culture.html

"What Is Consciousness Like for Other Animals and How Did It Evolve?" *New Scientist* (July 7, 2021), www.newscientist.com/article/mg25033420-700-what-is-consciousness-like-for-other-animals-and-when-did-it-evolve/

"Why Dolphins Are Deep Thinkers," *The Guardian* (July 3, 2003), www.theguardian.com/science/2003/jul/03/research.science

PHOTOGRAPHY CREDITS

The publisher is grateful to the following for their kind permission to reproduce their photographs.

2 *Burrowing Owl with Kaleidoscope Eyes* © Melissa Groo; **9** black-tailed prairie dog, Zoo Atlanta © Joel Sartore/Photo Ark; **12–13** *Chimpanzee Dreaming*, Totti, common chimpanzee © Peter Delaney; **17** endangered chimpanzee, Singapore Zoo © Joel Sartore/Photo Ark; **18** Clark's nutcracker, School of Biological Sciences, University of Nebraska-Lincoln © Joel Sartore/Photo Ark; **23** endangered Asian elephant © Joel Sartore/Photo Ark; **24** bottlenose dolphin, Loro Parque in Puerto de la Cruz, Tenerife, Spain © Joel Sartore/Photo Ark; **29** domestic pig, Xu Wen, Guangdong province, China © Staffan Widstrand/Wild Wonders of China/naturepl.com; **30** common raven © Melissa Groo; **35** European herring gull © Melissa Groo; **37** mudflat octopus, SeaWorld San Diego © Joel Sartore/Photo Ark; **40–41** big brown bat, Nebraska Wildlife Rehab © Joel Sartore/Photo Ark; **45** endangered silvery Javan gibbon, Gibbon Conservation Center © Joel Sartore/Photo Ark; **48** European storm petrel, Ireland © T. Muukkonnen/blickwinkel/Alamy Stock Photo; **52** *Graceful Gaze*, giraffe © Peter Delaney; **55** big brown bat roosting, central Washington © Michael Durham/naturepl.com; **58** great white shark, Mexico © Masa Ushioda/Blue Planet; **62** *Wild at Heart*, wild horse © Peter Delaney; **67** Australian emperor dragonfly, Mulyangarie Station, South Australia © Gerhard Koertner/Alamy Stock Photo; **68–9** *Zebra Dance*, Burchell's zebra © Peter Delaney; **73** blue whale, Indian Ocean, off Sri Lanka © Alex Mustard/naturepl.com; **74** black-tailed prairie dog, USA © Tom Vezo/naturepl.com; **79** *Dazzle*, Burchell's zebra © Peter Delaney; **81** superb lyrebird, Healesville Sanctuary © Joel Sartore/Photo Ark; **82** western honeybee © Ingo Arndt; **87** pod of sperm whale, Dominica, Caribbean Sea © Franco Banfi/naturepl.com; **88** Domestic dog © Greig Reid/500px/Getty Images; **92** common bottlenose dolphins, Roatan, Honduras © Jurgen & Christine Sohns/FLPA/Nature in Stock; **95** endangered Congo gray parrot, Dallas Zoo © Joel Sartore/Photo Ark; **96–7** *Bonds of Love*, African elephants © Peter Delaney; **101** army ant workers, Barro Colorado Island, Panama © Mark Moffett/naturepl.com; **102** African wild dog © Melissa Groo; **107** white-backed magpies, Oklahoma City Zoo © Joel Sartore/Photo Ark; **109** *Motherhood, Lioness and Cubs* © Peter Delaney; **110–11** *Bonding*, Kalahari black-maned lions © Peter Delaney; **115** vulturine guineafowl, Lincoln Children's Zoo © Joel Sartore/Photo Ark; **118** federally endangered jaguar, Omaha Henry Doorly Zoo © Joel Sartore/PhotoArk; **121** *The Caress*, African elephants © Peter Delaney; **122–3** *Deepest Slumber*, African elephants © Peter Delaney; **126–7** oceanic manta ray, Revillagigedo Islands, Mexico © Alex Mustard/naturepl.com; **131** rough harvester ants, Springs Preserve © Joel Sartore/Photo Ark; **135** giant manta ray, Socorro, Baja California, Mexico © Ken Kiefer/Cultura Creative Ltd/Alamy Stock Photo; **136** male silverback Western lowland gorilla, Bai Hokou, Dzanga Sangha Special Dense Forest Reserve, Central African Republic © Fiona Rogers/naturepl.com; **141** Eurasian magpie, Germany © Juergen Kosten/imageBROKER/Getty Images; **142** fancy rat, Capital Humane Society © Joel Sartore/Photo Ark; **145** common bottlenose dolphins, Northern New Zealand © Richard Robinson: **146–7** *Lingering*, spotted hyenas © Peter Delaney; **151** juvenile common cuckoo, Budapest Zoo © Joel Sartore/Photo Ark; **153** *Eyes Wide Open*, spotted hyena © Peter Delaney; **154** red ant worker, Surrey, England © Kim Taylor/naturepl.com; **157** endangered Mexican gray wolf, Wild Canid Survival and Research Center © Joel Sartore/Photo Ark; **158–9** *High Altitude Pursuit*, Himalayan wolf chasing a Tibetan gazelle © Haiyuan Tong; **163** bluestreak cleaner wrasse, East of Eden, Similan Islands, Thailand © Alex Mustard/naturepl.com; **164–5** common ravens, Kuikka Lake, Kuhmo, Finland © Frans Lemmens/Nature in Stock; **169** honey badgerk, Fort Wayne Zoo © Joel Sartore/Photo Ark; **170** common raven, Utah © Melissa Groo; **175** snow leopard © Abeselom Zerit/500px/Getty Images; **176–7** *Eye to Eye*, snow leopard with the carcass of a blue sheep © Xiaoyun Luo; **178** least weasel, Western North Carolina Nature Center © Joel Sartore/Photo Ark; **182** bar-tailed godwit, Chesil Beach, Dorset, England © Gary Spicer/Nature in Stock; **187** emperor penguins and chick, Atka Bay, Antarctica © Stefan Christmann/naturepl.com; **188–9** humpback whale mother and calf, Vava'u, Tonga © Tony Wu/naturepl.com; **193** *Widowmaker*, cape buffalo © Peter Delaney; **194–5** *Out of the Storm*, Cape buffalo © Peter Delaney; **196** brown-mantled tamarin, Cafam Zoo in Melgar, Colombia © Joel Sartore/Photo Ark; **199** humpback whale © Renee Capozzola; **202** Laysan albatross pair, Kauai, Hawaii © Melissa Groo; **205** Magellan plunderfish, Antarctic Peninsula, Antarctica © Jordi Chias/naturepl.com; **209** Plymouth Rock domestic chicken, Lincoln, Nebraska © Joel Sartore/Photo Ark; **210–11** bonobo female and baby, Lola Ya Bonobo Sanctuary, Democratic Republic of Congo © Anup Shah/naturepl.com; **215** male Japanese macaque, Rome Zoo © Joel Sartore/Photo Ark; **219** virilis fruit flies, Cincinnati Zoo © Joel Sartore/Photo Ark; **220** female chimpanzee, Gombe NP, Tanzania © Anup Shah/naturepl.com; **223** killer whale, SeaWorld in San Diego © Joel Sartore/Photo Ark; **227** white-crowned sparrow © Melissa Groo; **228** bonobo female baby and mother, Lola Ya Bonobo Sanctuary, Democratic Republic of Congo © Anup Shah/naturepl.com.

INDEX

A
adaptive radiation 224
adoption 191
African bush elephant 120–25
African gray parrot 94–95
African wild dog 102–5
alarm calls 8, 70, 71, 75–77
albatross 202–3
altruism 190–91, 198, 207
Antarctic fish 204
ants 100–101, 130–33, 154–5
army ants 100–101
Asian elephant 22–23
attachment (emotional) 11, 120
Australian emperor dragonfly 66–67
Australian magpie 106–7

B
badgers 168–9
bar-tailed godwits 182–5
bats 54–57, 70
bee colonies 83–85
bee-eaters 149
bees 82–58
bereavement 120, 125, 138
big brown bats 54–75
bird song 80, 226 *see also* alarm calls
black-capped chickadee 20–21
black-tailed prairie dogs 74–77
blue whales 72–73
bluestreak cleaner wrasse 162–3
bonding 98–125 *see also* parenting
bonobos 229–31
bottlenose dolphin 24–27, 92–93, 144–5
brachiating 44, 46
brain structure 8, 10, 32
brainpower 12–39
breeding "helpers" 98–99
brood parasitism 150, 155
brown-mantled tamarins 196–7
buffalos 192–5

C
calculation 40–67
California twin-spot octopus 36–37
Cape buffalos 192–5
caring 188–209
cephalopods 36, 39
cetaceans 25
cheetahs 21, 98
chickens 8, 208–9
chimpanzee 8, 16
chimpanzees 220–21, 229–31
Clark's nutcracker 18–21
cleaner fish 162–3
"Clever Hans effect" 139

cognition 14–15
communication 69–95
consciousness 127–45
cooperative behavior 26, 98–99, 106
cooperative hunting 71, 104–5, 112, 119, 160
courtship rituals 71, 80, 218
crows 21 *see also* Clark's nutcracker; ravens
cuckoos 150–151
cultural transmission 210–31

D
dancing 71, 80, 82–83, 84
delayed gratification 33
dog–human interaction 89–91
dogs 161
dolphins 144–4 scattercaching 5
domestic chickens 208–9
domestic dogs 88–91, 161
domestic horse 62–65
dopamine release 65
dragonflies 66–67

E
echolocation 54, 56–57, 86
ecotypes 222
elephants 120–25
emotional attachments 11, 120
empathy 201, 208
emperor dragonfly 66–67
emperor penguins 186–7
endurance 183–5, 186
Eurasian magpie 140–41
European robin 51
European storm petrels 48–51
eye contact 34, 91

F
face reading 91
face-pulling 91
"false belief" task 27
family groups 98, 108, 112–13, 124, 160
fancy rats 142–3
fennec foxes 21
flies 218–19
"floating object" task 22
"friendships" 8, 99, 116–17, 230
fruit fly 218–19

G
Galapagos finches 224
gendered behavior 108, 112–13, 152, 186
giant manta ray 134–5
gibbons 44–47
giraffes 52–53
godwits 182–5
goldcrest 32
goldfish 8
gorillas 136–9
gray herons 180
gray wolves 156–61
great tits 167
great white shark 58–61
grebes 70, 71
Grevy's zebra 78
grieving 120, 125, 138
group behavior 99, 114, 116–17, 160 *see also* family groups; packs; pride of lions
guineafowl 114–17

H
herons 180
herring gulls 34–35
honey badgers 168–9
honeybees 82–85
hornbill 98
horses 62–65
human-animal communication 27, 34, 64, 89–91, 93, 137–9
humpback whales 60, 198–201
hunting behavior 103–5, 119, 160–61, 174, 222, 230 *see also* cooperative hunting
hyenas 151–2

I
Indian peafowl 218
infrasound 72, 125

J
jaguars 118–19
Japanese macaque 214–17

K
keas 33, 53
kestrels 148
kleptoparasitism 148

L
language skills 76–77, 94, 137–9
laughing 143
Laysan albatross 202–3
Leach's storm petrel 50
least weasels 178–81
leopards 164–7
lions 108–12, 168, 192
lyrebird 80–81

M
macaques 214–17
magnetoception 51
magpies 10, 11, 106–7, 140–141
manipulating skill 22, 38
manta rays 134–5
mating behavior 78, 80, 197, 218, 230 *see also* courtship rituals
matriarchy 112–13, 152
meerkats 99
memes 210
memory 16, 20–21
metacognition 27
migratory birds 51, 183–5
mind-reading 27, 33 *see also* empathy
mirror test 130, 132, 134, 140
mobbing 171–2, 200
monkeys 214–17
motion camouflage 66

N
navigating skill 50–51, 59 *see also* echolocation
nest guarding 206–7
numeracy 40–67

O
octopus 36–37
orcas 8, 60, 198, 200, 222–5
ostriches 191
oxpeckers 149

P
packs 103–4, 156, 160
parasites 148
parenting 70, 71–72, 192, 197, 203, 206, 208 *see also* adoption; shared parenting
parrots 33, 94–95
pathfinding 16, 50–51
peacocks 218
pecking order 208
penguins 186–7
peregrine falcons 171, 172
pigeons 21
pigs 28–29
play 38, 106, 171, 225
Polaris attack 60
prairie dogs 8, 74–77
pride of lions 108, 112–13
probability assessment 53
pygmy chimpanzee 229–31

Q
queen bees 84–85

R
ratels 168–9
rats 142–3
ravens 8, 30–33, 170–73
"rescue behavior" 106
resilience 164–87
risk assessment 63–64
risk taking 167, 171, 173, 174

S
scattercaching 20
self-knowledge 144
self-recognition 130, 134, 140
sense of smell 50, 51, 58, 78
sexual dimorphism 108
sexual selection 80
Seychelles warblers 106
shared parenting 112, 113, 120, 124, 149, 197
shrews 181
sign language 137–9
slave-making ants 153–4
smell maps 51
snow leopards 164–7
snow monkeys 214–17
social learning 22 *see also* cultural transmission
social motivation 28
social structure 83, 100, 213, 216 *see also* family groups; group behavior
sonar 86
sound maps 54
southern ground hornbills 98
sparrows 226–7
spatial memory 16, 20–21
sperm whales 86–87
spiny plunderfish 204–7
spotted hyena 151–2
squirrels 74–77
statistical inference 53
storm petrels 48–51
superb lyrebird 80–81
synchronized performance 93

T
"talking animals" 139
tamarins 196–7
Theory of Mind 10–11, 27, 128
tool use 28
triangulation 20
tubenoses 50

U
uncertainty principle 144

V
vampire bats 8
Visayan warty pig 28
vocalizations 104, 125, 143, 224 *see also* alarm calls; bird song; whale "song"
voice commands 89–90, 93
vulturine guineafowl 114–17

W
waggle-dancing 82–83
weasels 178–81
Western honeybee 82–85
Western lowland gorilla 134
whale "song" 72
whales 15, 60–61, 72–73, 198–201
white-crowned sparrow 226–7
wild dogs 102–5
winning 146–63
wolf packs 156, 160
wolves 89, 156–61

Z
zebras 78–79

PHOTOGRAPHER DIRECTORY

INGO ARNDT was born in Frankfurt am Main, Germany. Since 1992 he has been working as a professional wildlife photographer, traveling the globe and capturing animals and their habitats. With his images Arndt hopes to increase awareness in his audience of the magnificence of nature.

Arndt's photographs have been published in *National Geographic*, *GEO*, *Terra Mater*, and *BBC Wildlife* and he has been the recipient of numerous awards, including Wildlife Photographer of the Year and the GDT European Wildlife Photographer of the Year.

RENEE CAPOZZOLA is a conservation-oriented, award-winning underwater photographer who specializes in wide-angle and split-level images. Capozzola believes that striking images help increase awareness of our fragile marine ecosystems and encourage others to help protect our oceans.

Her images have won numerous prestigious international awards, including Underwater Photographer of the Year 2021, USA Photographer of the Year in the 2019 World Shootout, and first place in the 2021 and 2019 United Nations World Oceans Day Photo Competitions.

She currently serves as a Photographer-In-Residence for Ocean Geographic and a Brand Ambassador for SEACAM.

STEFAN CHRISTMANN is a nature photographer and filmmaker from Germany. He was an expedition photographer and camera assistant for the BBC Natural History Unit and part of the team that planned and produced the "Emperor *Penguins*" episode for *BBC Dynasties* (narrated by Sir David Attenborough), which aired globally in 2018.

His unique images of Antarctica and of the emperor penguin colony of *Atka-Bay* have been published in *National Geographic* and *BBC Wildlife* magazine as well as in many other publications worldwide. These images have also won many international photography awards, including the prestigious *Wildlife Photographer of the Year Portfolio Award* in 2019 and the *Ocean Photographer of the Year Collective Portfolio Award* in 2021.

PETER DELANEY quit a career in finance to pursue a dream of traveling Africa in a Land Cruiser. And along the way, he found his passion, the life of a wildlife photographer. From navigating the forests of Bwindi and climbing the peaks of Kilimanjaro to meandering along the red dunes of the Kalahari, Delaney started photographing Africa: "Africa became the new chapter in my life, and I have dedicated the last fifteen years to capturing this diverse continent."

The Irish native exchanged the Emerald Isle for a more colorful life in George, South Africa, to continue his travels through the magnitude of Africa and pursue his passion. "The continent fascinates me like no other: not only the richness of its wildlife but also the incredible landscapes and passionate people," he says. Delaney's work has been featured in numerous publications and has won many awards, including the prestigious BBC Wildlife Photographer of the Year no less than three times.

"It may be a cliché, but it is true—photography has become my life. No matter where I am, my mind's eye is creating nature photography images. It has taught me to see the world in a different light, and for that, I am eternally grateful."

MELISSA GROO is a wildlife photographer, writer, and conservationist with a passion for educating people about the marvels of the natural world. She believes that photography can be both fine art and a powerful vehicle for storytelling, and considers herself a "wildlife biographer" as much as a wildlife photographer. It is her mission to raise awareness and change minds about not only the extrinsic beauty of animals but their intrinsic worth.

Groo is a contributing editor to *Outdoor Photographer* and *Audubon* and advisor to the National Audubon Society on photography content and ethics in bird photography. In 2020, the Cornell Lab of Ornithology released *Bird Photography with Melissa Groo*, an online masterclass of forty videos featuring her instruction. Groo's association with the Lab dates back to her time in the Bioacoustics Research Department from 2000–5 observing and recording elephant communication in the African plains.

Groo's work has appeared on the covers of *Audubon*, *Smithsonian*, *Natural History*, and *Outdoor Photographer* magazines and in *National Wildlife*, *Living Bird*, *Natural History*, and *National Geographic*. She has received awards and honorable mentions in national and international photography competitions including Audubon (2015 Grand Prize winner), Nature's Best, and NANPA. In 2017 the Melissa Groo Gallery was installed at Audubon's Kiernan Hall in Greenwich, Connecticut.

ALEX MUSTARD is widely regarded as one of the world's leading underwater photographers. He has been taking photographs underwater since he was nine years old and has

worked as a full-time underwater photographer since 2004. He has a PhD in marine ecology.

His work has received many awards, including Wildlife Photographer of the Year (awarded in nine different categories and appearing in fifteen different books of winning pictures). Mustard is also a six-time category winner in the British Wildlife Photography Awards. His 2007 book *Reefs Revealed*, won the International Grand Prize for the best book of underwater photographs and, in 2013, he was named GDT European Wildlife Photographer of the Year for his image *Night Moves*—the first underwater photographer to win this prestigious award.

He has published several books and his work has been included in many of the publications accompanying the BBC's landmark nature series *Life On Earth*, *Blue Planet*, *Our Planet*, *Planet Earth*, and *Wild Isles*.

RICHARD ROBINSON is an award-winning photojournalist, specializing in, but not limited to, the marine environment. With a twenty-five-year career in magazines and newspapers, he has captured some of the most memorable images of New Zealand's biggest news and sporting events.

Using his talents to highlight the plights of our oceans, he gives voice to our endangered species and is known for his unique and haunting images of life below the waterline.

Winner of the 2014 Press Photographer of the Year and New Zealand Geographic Photographer of the Year in 2013 and 2010 respectively, Richard is a long-term contributor to *New Zealand Geographic* magazine, working on assignments that have taken him as far south as the Subantarctic islands, and to New Zealand's most northern territory, the Kermadecs.

JOEL SARTORE is an award-winning photographer, speaker, author, conservationist, and the 2018 National Geographic Explorer of the Year. He is a regular contributor to *National Geographic*, *Audubon*, *Geo*, *The New York Times*, and *Smithsonian*.

Sartore specializes in documenting endangered species and landscapes around the world. He is the founder of the Photo Ark, a twenty-five-year documentary project to save species and habitat. "It is folly to think that we can destroy one species and ecosystem after another and not affect humanity," he says. "When we save species, we're actually saving ourselves."

Sartore's books include *Photo Ark: A World Worth Saving*, *Photo Ark Vanishing: The World's Most Vulnerable Animals*, *Birds of the Photo Ark*, and *RARE: Portraits of America's Endangered Species*. He and his work have been the subject of many national broadcasts including National Geographic's *Explorer*, *NBC Nightly News*, the *CBS Sunday Morning Show*, *ABC's Nightline*, NPR's *Weekend Edition*, *PBS Newshour*, *Fresh Air* with Terry Gross, *60 Minutes*, and *The Today Show*.

ANUP SHAH is a wildlife photographer based in Kenya and England who has been working for more than thirty years. His images have appeared in *National Geographic* and many other nature magazines and calendars.

Shah was featured in *The World's Top Wildlife Photographers* book in 2004 and in *Horzu* magazine in 2010 as one of the five best wildlife photographers in the world. He is also one of the ten "Masters" featured in the book *Masters of Nature Photography* published by the Natural History Museum, London, in 2013.

Shah is the co-author of *The Circle of Life: Wildlife on the African Savannah* and *African Odyssey: 365 Days*, both published by Abrams.

TOM VEZO was an award-winning, professional wildlife photographer who traveled the world capturing images of the natural environment. Best known as one of the top bird photographers in the United States, he also photographed landscapes, mammals, and other natural subjects. His work is widely published in magazines including *Audubon*, *Birder's World*, *National Geographic*, *National Wildlife Federation*, *Nature Conservancy*, and *Natural History* and he has produced the books *Wings in the Wild*, *Birds of Prey in the American West* and *Wings of Spring* (which won the National Outdoor Book Award for 2006 in the category of Design and Artistic Merit).

His was the winner of the 1998 and 1999 *Nature's Best* magazine photo contest for "Wildlife" in the professional category, and in 1997 he received honorable mention in the BBC Wildlife Photographer of the Year contest.

STAFFAN WIDSTRAND is one of Sweden's most renowned nature photographers. He has received multiple awards in international photo competitions, including Wildlife Photographer of the Year, the GDT European Nature Photographer of the Year, and Emirates Wildlife Photographer of the Year.

ACKNOWLEDGEMENTS

I have long harbored a keen interest in animal behavior and cognition, and have been very lucky to have the support and backing of a great publishing team at UniPress and Abrams throughout the process of planning and writing this book. In particular, I would like to thank Kate Shanahan for commissioning this title, and for bringing her tremendous experience and enthusiasm to bear as we worked together in the early stages. Blanche Craig then took over the management of the project and has been a calm and unfailingly helpful guiding hand, while Jenny Manstead's input on design and content has also been invaluable. My thanks are also extended to Alexandre Coco for creating the wonderful design, and to editor Angela Koo and proofreader Jessica Spencer for their attention to the text. On a more personal note, thank you very much to the friends and colleagues who gave me feedback on ideas and sections of text, and helped me to stay sane through the trickier parts of the writing process. Finally, this book would not be possible without the wonderful global community of biologists, whose work is allowing us to build an ever more advanced understanding of the workings of animal minds, in their enormous diversity. It is thanks to their curiosity and ingenuity that our own species learns more every day about how our fellow animals think, feel, and live.

FRONT COVER
Peter Delaney, *Heart of Darkness*, black-and-white photograph of a Kalahari black mane lion.

BACK COVER
Anup Shah, bonobo female and baby, Lola Ya Bonobo Sanctuary, Democratic Republic of Congo.

PAGE 3
Melissa Groo, *Burrowing Owl with Kaleidoscope Eyes*.

Batesian mimicry describes a harmless animal resembling a dangerous one; hoverflies that look like wasps are a familiar example. Burrowing owls use this strategy behaviorally, giving a rattlesnake-like hiss to keep intruding animals away from their nesting tunnels.

Published in 2024 by Abrams, an imprint of ABRAMS.
Copyright © UniPress Books Limited
www.unipressbooks.com

All rights reserved. No portion of this book may be reproduced, stored in a retrieval system, or transmitted in any form or by any means, mechanical, electronic, photocopying, recording, or otherwise, without written permission from the copyright holder.

Library of Congress Control Number: 2023940771

ISBN: 978-1-4197-6849-1
eISBN: 979-8-88707-046-9
Printed and bound in China

10 9 8 7 6 5 4 3 2 1

This book was conceived, designed, and produced by UniPress Books Limited
From UniPress:
Publisher: Jenny Manstead
Project manager: Blanche Craig
Editor: Angela Koo
Designer: Alexandre Coco
Picture researcher: Caroline Hotblack
Proofreader: Jessica Spencer

Abrams books are available at special discounts when purchased in quantity for premiums and promotions as well as fundraising or educational use. Special editions can also be created to specification. For details, contact specialsales@abramsbooks.com or the address below.

Abrams® is a registered trademark of Harry N. Abrams, Inc.

195 Broadway, New York, NY 10007
abramsbooks.com